— THE NEW ART OF —
CAPTURING
LOVE

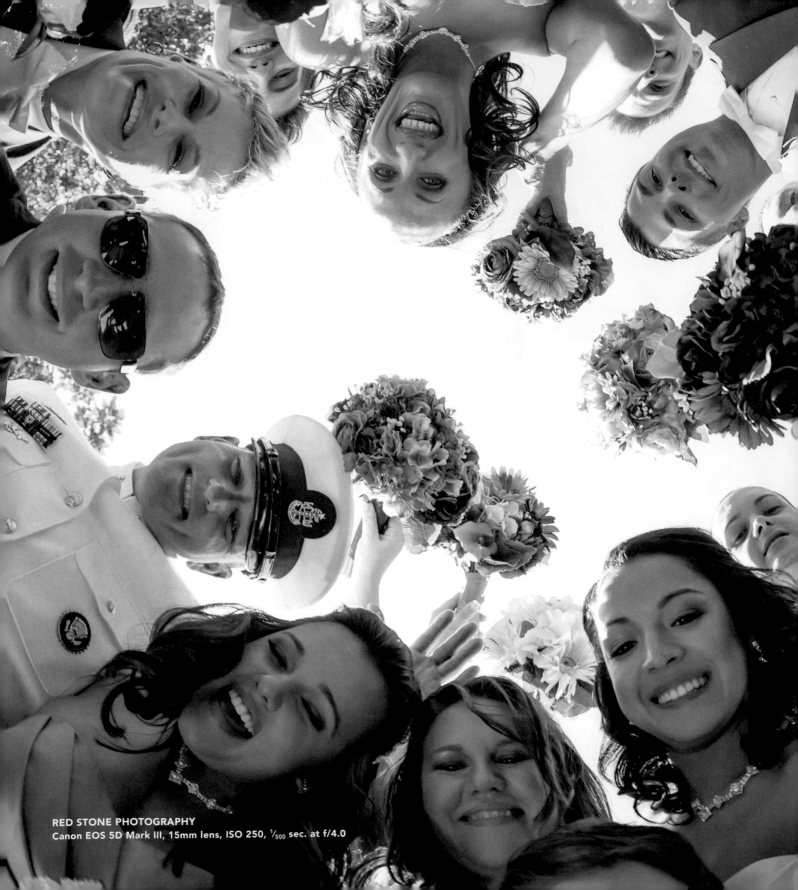

THE NEW ART OF
CAPTURING LOVE

The Essential Guide to Lesbian and Gay Wedding Photography

Kathryn Hamm and Thea Dodds

Foreword by Martie Maguire
of the Dixie Chicks and Court Yard Hounds

AMPHOTO BOOKS
an imprint of the Crown Publishing Group
New York

For Bryan and our daughters, Kyra and Aubrie
—Thea

For my beloved, Amy, and my mother, Gretchen. Without whom . . .
—Kathryn

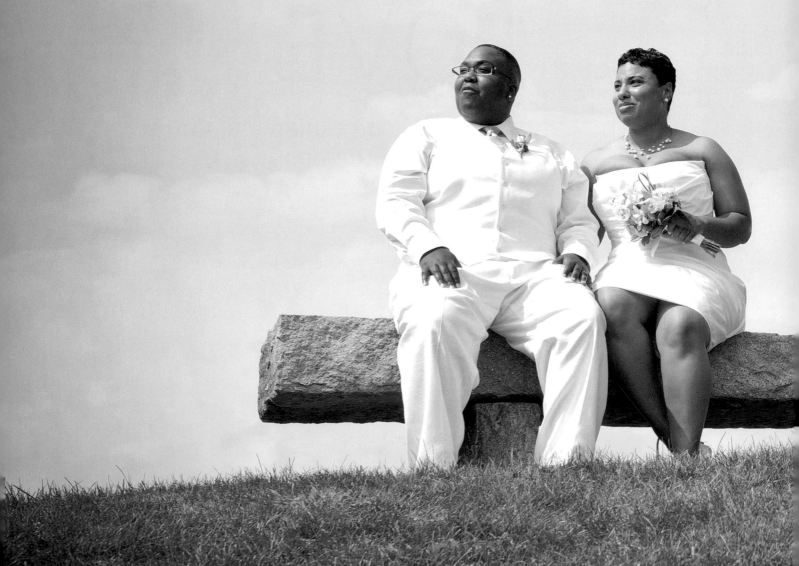

CONTENTS

KRISTIN CHALMERS PHOTOGRAPHY
Nikon D700, 24–70 lens, ISO 400, $\frac{1}{60}$ sec. at f/2.8

PREFACE

The moments that matter most can come quite unexpectedly. And often, time slows down just enough to help you record more deeply the moment as it is unfolding. It's as if a bright spotlight appears on something you may not have recognized, or perhaps you had seen but could not yet articulate. But there it is, right in front of you, asking for your attention and care. These are moments of significance, because once seen, they move from passing to indelible.

I've had a number of those moments in my life; notably and topically, the moment of my coming out to myself, realizing that "oh, wow, I like women. I mean, *really* like women." I also count the moment when something crystallized for my straight mom, who founded our groundbreaking business, GayWeddings.com, back in 1999. Defying the odds and opinions, she built the first online wedding boutique dedicated to serving same-sex couples after realizing that there were many couples in need of specialty products and services but unable to find them.

And newest to my count: receiving a call from photographer Thea Dodds, who is now not just my business partner and coauthor but also my friend. She had called with an idea she wanted to share. "Weddings are changing," she said, "and photography education needs to change, too." During that call, Thea revealed to me her thoughts on wedding photography in general and how same-sex couples are underserved by the accepted (predominantly heterosexual) industry standards for engagement and wedding portraiture. In turn, this led me to reflect on many of the photography submissions we had received for GayWeddings.com: plenty of couples in love, and plenty of good shots, but not many *great* shots. Most of the submissions were missing something—a subtle, but essential, something.

As we spoke, thanks to Thea's expertise, I understood more fully what it was that I couldn't quite put my finger on. It was this: what works in wedding photography for John and Barbara won't necessarily work for Jack and Michael, let alone Jill and Louise. In that moment, time slowed, that bright spotlight appeared, and an indelible moment became a new mission—a mission to ask professional photographers, the wedding industry, magazine editors, and educators to reconsider the long-standing assumptions about engagement and wedding portraiture and who the twenty-first-century client is.

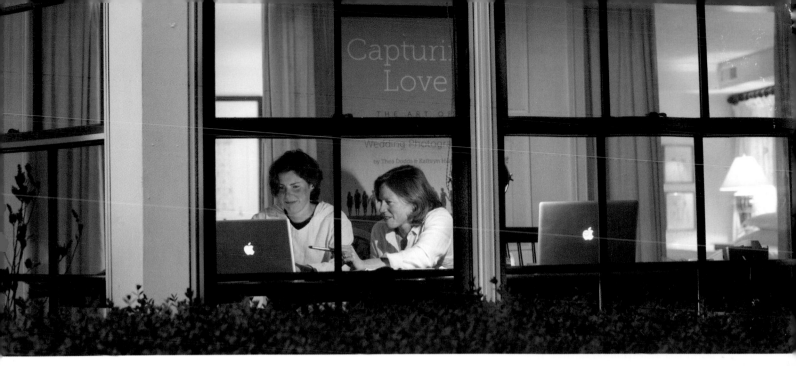

Thea and Kathryn working on this book at the Inn at Perry Cabin in St. Michaels, Maryland.

But before we dig into the background of basic portraiture techniques, the backstory on same-sex couples, and the significance of their wedding and commitment rituals, let me take a quick moment to say a little something about how this book came to be. Many of the beautiful photographs and concepts in this book were curated for our first book, *Capturing Love: The Art of Lesbian and Gay Wedding Photography*, which Thea and I self-published in January 2013. When we began the project, we knew that our book would be groundbreaking in that there was no other book like it on the market. What we didn't realize was that our finished book would also be the most comprehensive published collection of photos of same-sex couples in love, featuring the work of thirty-eight photographers and images of forty-six couples from the United States, Canada, Italy, and the United Kingdom.

In May 2013, *Capturing Love* was picked up by Amphoto Books. As a result, Thea and I found ourselves in the delightful position of being able to improve and expand on our first effort. We dug back into our deeply padded folders of images and revised and synthesized the content based on our many inspired conversations with photographers, couples, and readers. Now, in *The New Art of Capturing Love*, we are proud to unveil even more examples of authentic same-sex engagement and wedding photography, with even more accessible guidance for photographers

on how they can take their galleries of same-sex couples portraiture from good to great.

Thea and I are indebted to the many talented photographers who enthusiastically shared their work with us. We hope you'll take a moment to learn more about them in the contributors section (see page 203). And, of course, this book would not be what it is without the many vibrant and loving couples who hired these photographers to document their engagements and unions, and then had the courage to let the light of their love shine beyond the boundaries of their personal moments.

In choosing these photographs, we sifted through thousands of engagement and wedding images before selecting those that illustrate key points about the art of photographing same-sex couples while also answering three critical questions in the affirmative: Are these images authentic? Do these images reflect intimacy? Are these images believable?

Yes, these are real couples and real moments, with as diverse a range of expression as of physical characteristics. This diversity is so important because the LGBTQ (lesbian, gay, bisexual, transgender, queer) community is incredibly diverse in so many ways. And as we begin our conversation, square one is understanding that a one-size-fits-all approach to working with same-sex couples will not be effective.

It is true that, in any photograph, if an authentic moment can be captured, the photograph has the potential to be transcendent. These are the images photographers want to

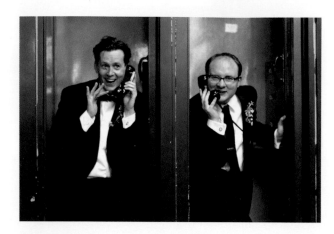

Rob and Doug, a Chicago-based couple, enjoy a playful moment with a phone booth at their reception.

ARIELLE DONESON PHOTOGRAPHY
Canon EOS 5D Mark II, 50mm lens, ISO 640, $\frac{1}{100}$ sec. at f/1.2

include in their clients' albums, and couples want to display proudly at home, in the office, or on a holiday card. It's not rocket science, but there is an art to creating, inspiring, and capturing such moments, and this is the vital work and responsibility of the photographer.

We are grateful to have this opportunity to bask with you in the love of couples excited to embrace the privilege and responsibility of marriage, and who are blazing a path right along with us. To the extent that we can help to inspire and expand the market's readiness to better accept and serve same-sex couples, we will have achieved our purpose.

—KATHRYN HAMM

INTRODUCTION

Every wedding is steeped in tradition. No matter how unique, religious, or traditional the wedding, there is a fundamental structure—a purpose—guiding each exchange of vows. That is, a couple stands before its witnesses to exchange a promise of commitment, resulting (for most couples) in a civil marriage license.

In engagement and wedding photography, the same dynamic holds true. No matter the job at hand, there is a structure—a purpose—guiding each session. A photographer is hired to document a relationship or a moment of celebration or love and, to do so, follows a given set of "rules" or best practices. If all goes well, the result is stunning images, a valuable keepsake for the couple, a feeling of pride for the photographer, and perhaps even publication in a magazine or popular blog.

But when it comes to "capturing love," especially when a same-sex couple is the subject, rules were also made to be broken. Reassembled. Reinterpreted. Revised. Repurposed. This is the gift that same-sex couples have introduced into the wedding trends of today. Same-sex couples adhere to many wedding traditions but also discard rituals that do not pertain to them and adjust others to become more relevant.

The dynamism and variety of same-sex weddings have had a ripple effect throughout the industry, and as a result, today's photographers need to be aware of how *any* prospective clients—straight, gay, or otherwise—want to approach their weddings. Applying an ill-fitting frame of reference to what should be a moment of authentic expression can have awkward results. A successful photographer must understand and anticipate this—and have the professional wisdom to nudge authentic and intimate moments into being, and then translate them artistically with well-framed and purposeful clicks of the shutter.

We hope that this guide will inspire new insights, deeper questions, and creative solutions for photographing same-sex couples. And for those of you looking to share your inspiring photographs or see more examples of outstanding same-sex engagement and wedding photography, please visit our website: www.capturingloveguide.com.

GETTING YOUR TERMS, ER, STRAIGHT

As photographers make the leap to new ways of thinking about engagement and wedding photography, it's also important to understand what the LGBT or LGBTQ community is and what it isn't. The community is as broad and diverse as one might imagine, and while the community has many shared objectives geared toward seeking partnership recognition and equality, it's important to know that being an "L" isn't the same as being a "G"—and neither of those are the same as being a "T."

That's why, for the purposes of this book, we refer to "same-sex couples," meaning those who identify as being in a relationship with someone of the same sex. In other words, the individuals in these couples identify as lesbian, gay, bisexual, transgender, or queer, but unless otherwise noted, we're referring to couples whose cake toppers will depict two women or two men—albeit with some variation in gender presentation possible.

So, while we talk about being "LGBT-friendly" or "LGBTQ-inclusive"—which is increasingly common in today's wedding industry—it is important to keep in mind that many transgender and bisexual individuals are in heterosexual relationships for which many of the traditional rules of wedding photography for opposite-sex couples might apply just fine. Further, some identify more broadly as "queer" or

Getting Behind the Lens

Throughout this book, you'll find "Behind the Lens" anecdotes to further illustrate the moments of love captured and curated in our collection. Some of these sidebars share the photographer's perspective and some, details of the couple's love story. In either case, we hope to add just a little more insight into the stories of the *Capturing Love* family.

The Tech Specs

In this book, you'll see shorthand descriptions of the technical specifications for each image. This information, most likely more meaningful to photographers than engaged couples, includes (in this order) camera type, information about the focal length of the lens, ISO (sensitivity of the camera to light), shutter speed, aperture, and, if applicable, film type (for nondigital images).

"genderqueer," making it all the more important that you check your assumptions about gender roles at the door and learn more about the couple and how they identify before your session.

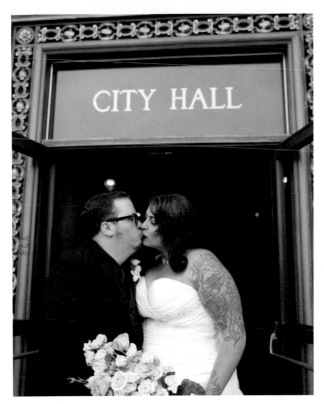

Coyote and her husband, Tony, who identify as a queer couple, were legally married on October 12, 2012, at City Hall in San Francisco.

WEDDINGS TO THE PEOPLE
Canon EOS 5D Mark II, 24–70mm lens, ISO 100, ¹/₂₅₀ sec. at f/2.8

Timnah (bisexual, genderqueer, and female) and Jay (bisexual, transgender, and male) identify as a "deeply queer" couple rather than as a same-sex or opposite-sex couple.

WEDDINGS TO THE PEOPLE
Canon EOS 5D Mark II, 70–200mm lens, ISO 100, ¹/₂₅₀ sec. at f/3.5

He Said, She Said, Ze Said

Trans-supportive, but not sure what to say? Don't assume. Ask! Simple questions—like "As a couple (or individual), how do you identify?" or "What are your preferred gender pronouns (PGPs)"—asked thoughtfully early in a conversation can help to break the ice and prevent awkward or offending moments.

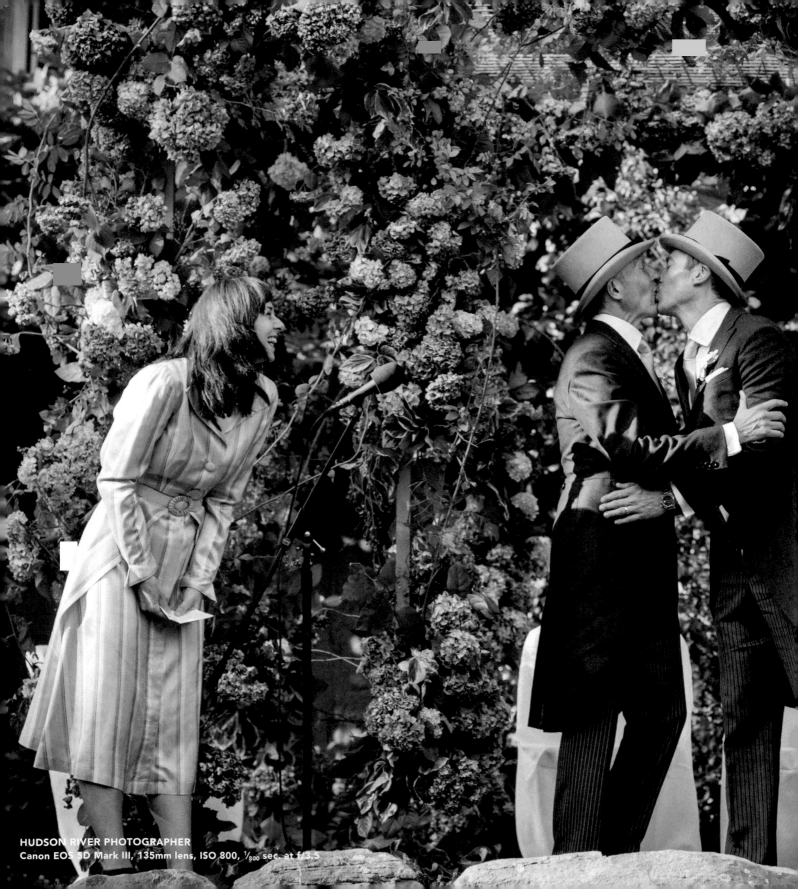

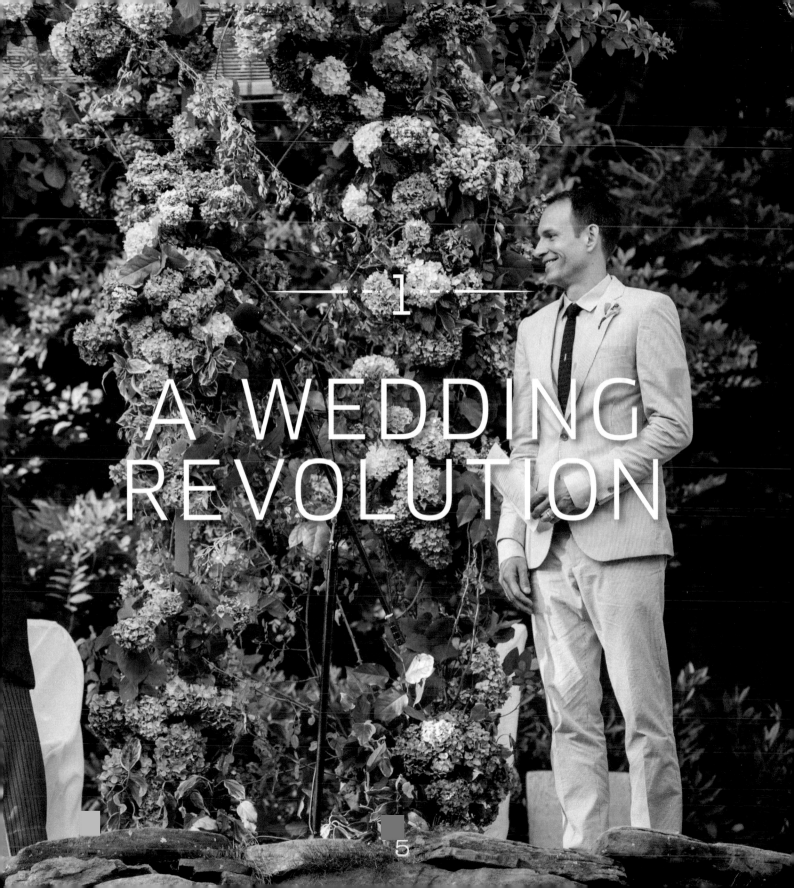

1

A WEDDING REVOLUTION

I N THE CANON OF POSE BOOKS FOR photographing couples, one can find, almost without exception, heterosexual couples and traditional wedding moments: a man and a woman, a tux and a wedding gown, wedding parties divided by gender, a bouquet toss, the first dance, and so on. This is "heteronormativity" in action—a worldview grounded in heterosexuality as the norm—and it is so deeply ingrained in our culture that we may not even realize that we have a biased foundation informing our expectations and wedding-planning experiences. Because of this, even well-meaning, open-minded, and seasoned photographers can end up applying recommendations specific to opposite-sex couples to all of their clients, regardless of sexual orientation.

As a result, during their sessions, photographers may find themselves asking things of same-sex couples that are awkward at best and offensive at worst. For example, it's awkward to see two men on their wedding day posed as siblings or platonic friends, and it can be downright offensive if a photographer recommends poses that presume that one member of the couple is the "man" (the masculine one) and the other is the "woman" (the feminine one).

Undoubtedly, the suggestions of traditional pose books can be a helpful starting place but an overreliance on outdated traditions, techniques, and poses can be problematic if a photographer shows up unprepared for two brides in pants, a mixed-gender wedding party, a dance between a groom and his father, or a reception without staged wedding moments like the cutting of the cake.

That's why photographers must first understand that a "new lens" is needed when planning for and photographing same-sex couples. With fresh eyes and a deeper understanding of poses that work for same-sex couples—as well as those that don't. Then the important work of capturing authentic, intimate moments can begin.

IS IT REALLY SO DIFFERENT?

While it can be said that beautiful wedding photography is beautiful wedding photography regardless of sexual orientation, it cannot also be said that the *process* of creating beautiful wedding images is the same (see, for example, page 13 for the "Top 5 Myths About Same-Sex Wedding Photography"). Traditional wedding photography relies on basic assumptions built around a white gown and a tux (or dark suit), masculine and feminine gender roles, and expectations of the physical differences between a man and a woman. Generally speaking, these assumptions do not translate well to most same-sex couples. For example, while a dip pose (a wedding-playbook standard) might easily translate to the average straight couple, the pose could fall flat—literally and figuratively—for a same-sex couple.

Let's consider the two primary types of differences between opposite- and same-sex couples: physical differences and cultural differences. *Physical* differences are those we

Being a Beginner

Since I'm a fifteen-year wedding photography veteran with over two hundred weddings under my belt (and the coauthor of this book), you might expect me (Thea) to be an expert on photographing gay weddings. But that hasn't always been the case. In 2005, I photographed my first same-sex wedding and realized that although I had plenty of professional experience to lean on, in many respects I felt like a beginner. It was the first same-sex wedding I had ever photographed, the first with no wedding gown and no groom, and the first where the ceremony kiss turned out to be the first time the couple had ever kissed in front of their families. After multiple attempts to position them using the poses I had been taught to use for (straight) couples, I realized that I was getting a result that was off the mark. The couple ended up looking like friends or siblings, not a married couple. I knew then that I needed to better understand what is needed when working with same-sex couples in order to photograph them as well as I photograph opposite-sex couples.

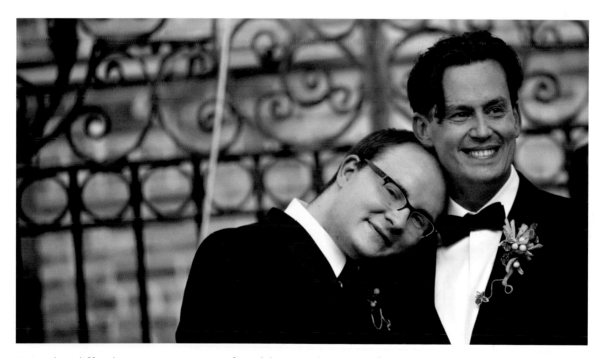

It can be difficult to capture a comfortably posed image of two individuals who are the same height, wearing the same attire. Look for the nonstaged moments when a couple reverts to an unguarded expression and offers its own, best fit.

ARIELLE DONESON PHOTOGRAPHY
Canon EOS 5D Mark II, 70–200mm lens, ISO 200, $\frac{1}{125}$ sec. at f/2.8

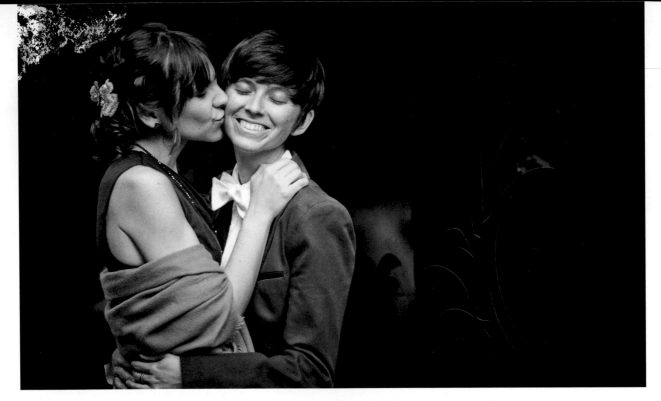

If two women wear a suit-and-dress combination, they should not necessarily be assigned the overtly masculine and feminine roles outlined in traditional pose books. The subtleties of their authentic connection might be lost.

SARAH TEW PHOTOGRAPHY
Canon EOS 5D Mark II, 85mm lens, ISO 2000, $\frac{1}{250}$ sec. at f/1.2

can see, such as gender pairing (two brides or two grooms) and attire selection. As we discussed earlier, many photographers, through no fault of their own, operate with a set of outdated assumptions when photographing a wedding: that there will be a man (a masculine partner) and a woman (a feminine partner), that there will be contrasting attire (a tux or dark suit and a white dress), and that there will be a height and strength difference (the man will be taller and stronger than the woman). And these physical or observable elements are the foundations for the engagement and wedding poses found in

most photography books. Other physical, or observable, differences include the following:

- Same-sex couples often get ready for the ceremony together.

- There might be no wedding gown to feature—or there might be two to share the spotlight.

- Double bouquet and boutonniere pairings and placement can introduce new challenges.

- There might be one aisle, two aisles, or no aisle at all.

- Wedding parties might be imbalanced in number, of mixed gender, or informal.

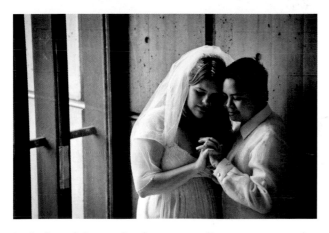

Isabel and Amanda share a sunlit moment on the day of their legal elopement in Boston.

KRISTIN CHALMERS PHOTOGRAPHY
Nikon D700, 70–200mm lens, ISO 1250, $\frac{1}{80}$ sec. at f/3.5

Cultural differences refer to elements beneath the surface, such as gender identity and expression, family and "coming out" experiences, ages of the couple and the length of their relationship, and approach to the wedding experience (whether legal or nonlegal). Photographers might assume that same-sex couples approach their weddings just as most opposite-sex couples might: getting engaged and immediately telling excited parents, then planning a wedding that follows the same basic format that their parents used. For the LGBTQ community, however, this is often not the case. Though some same-sex couples—especially if they are a younger couple—may have been engaged within the first few years of being together, most have an entirely different timeline and set of experiences, expectations, joys, and fears that are related to the development of their identities as members of a marginalized group, coming out experiences, and relationships. If you overlook these key differences in your clients' backstory, you will not only miss out on who they are, but you might inadvertently betray their trust and comfort level. Other cultural differences include the following:

- Same-sex couples might not have supportive family.
- Same-sex couples might not be comfortable with public displays of affection.
- Same-sex couples might not be marrying legally.
- Same-sex couples may have married the same person multiple times (without ever divorcing or separating).
- Same-sex couples may have been together for decades before tying the knot.
- Same-sex couples are more likely to have creative and personally meaningful ceremonies.
- A City Hall wedding means something entirely different for a same-sex couple.

Of course, same-sex couples aren't the only ones who deserve and require personalized attention. Considering thoughtfully the physical and cultural differences that exist for each and every couple—regardless of sexual orientation—and preparing in advance of the engagement or wedding session will better serve all couples and their individual needs.

WHY DOES IT MATTER?

Same-sex weddings have been estimated to be worth approximately $1.5 billion by M. V. Lee Badgett of the Williams Institute, a think tank at UCLA Law specializing in independent research regarding sexual orientation and gender-identity law. With the advent of new federal benefits available to any legally married same-sex couple, and with same-sex marriage legal in more states than ever, the once small, quiet niche of same-sex weddings has exploded, becoming the only expanding market in the increasingly crowded engagement and wedding photography industry. There is a demand for good photographers who understand the needs of same-sex couples. So it's critical to prepare yourself—not only to create superlative wedding and engagement galleries but to stay current with the evolving marketplace and legal landscape as it pertains to same-sex couples.

Further, understanding the needs of same-sex couples and the best techniques for photographing their engagements and unions matters because

- With more social acceptance and inclusive resources available than ever before, same-sex couples have the luxury of a higher standard of criteria (beyond the "gay-friendly" litmus test) when booking photographers.

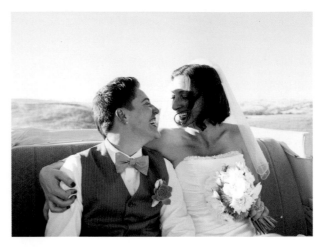

In this iconic wedding image (with a twist), one can almost hear the flapping of a Just Married sign and the rattle of tin cans being pulled behind the couple's convertible.

WEDDINGS TO THE PEOPLE
Canon EOS 5D Mark II, 24–70mm lens, ISO 3200, $\frac{1}{60}$ sec. at f/2.8

- With so many ceremony variations and evolving traditions available to same-sex couples, the more local knowledge, support, and open-mindedness a photographer brings to a session, the better a couple will be served and the better the resulting images will be.

- With marriage equality a reality in more and more states, wedding professionals who do not educate themselves on the legal realities and who treat same-sex couples differently from different-sex couples may run the risk of being sued or receiving negative online reviews for discriminatory practices.

Given all this, *The New Art of Capturing Love*—with its groundbreaking revelations and scope of representative couples—is essential not only for photographers but for the many same-sex couples who need and deserve to see examples of themselves in an arena in which they have long been invisible.

SO WHAT'S A PHOTOGRAPHER TO DO?

Start by revisiting the rules of traditional wedding and engagement portrait techniques in chapter 2, and then develop an expanded skill set to better serve *all* couples in today's dynamic wedding market. And that's what you'll find here: a groundbreaking and instructive guide that not only highlights some of the best same-sex engagement and wedding photography from the past few years but also offers valuable and practical solutions to incorporate into your next engagement session or wedding.

Just remember: It's okay to be a beginner. Regardless of your level of comfort in this subject area, an openness to learning more, making mistakes, proposing solutions, and asking respectful and thoughtful questions will bring improved results to your work.

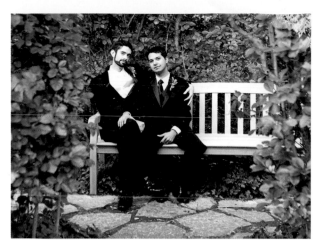

Two grooms enjoying a secluded, quiet moment on their wedding day.

DAWN E. ROSCOE PHOTOGRAPHY
Canon EOS 5D Mark II, 24–70mm lens, ISO 3200, $\frac{1}{60}$ sec. at f/2.8

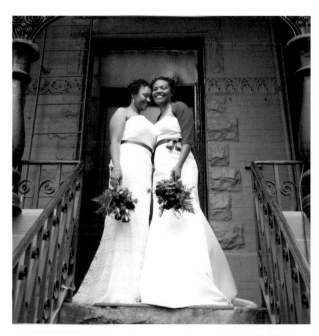

Kelly and Kelly traveled to Washington, DC, to become legally married, even though their marriage is not recognized in their home state.

KAT FORDER PHOTOGRAPHY
Nikon D800, 24–70mm lens, $\frac{1}{500}$ sec. at f/3.2

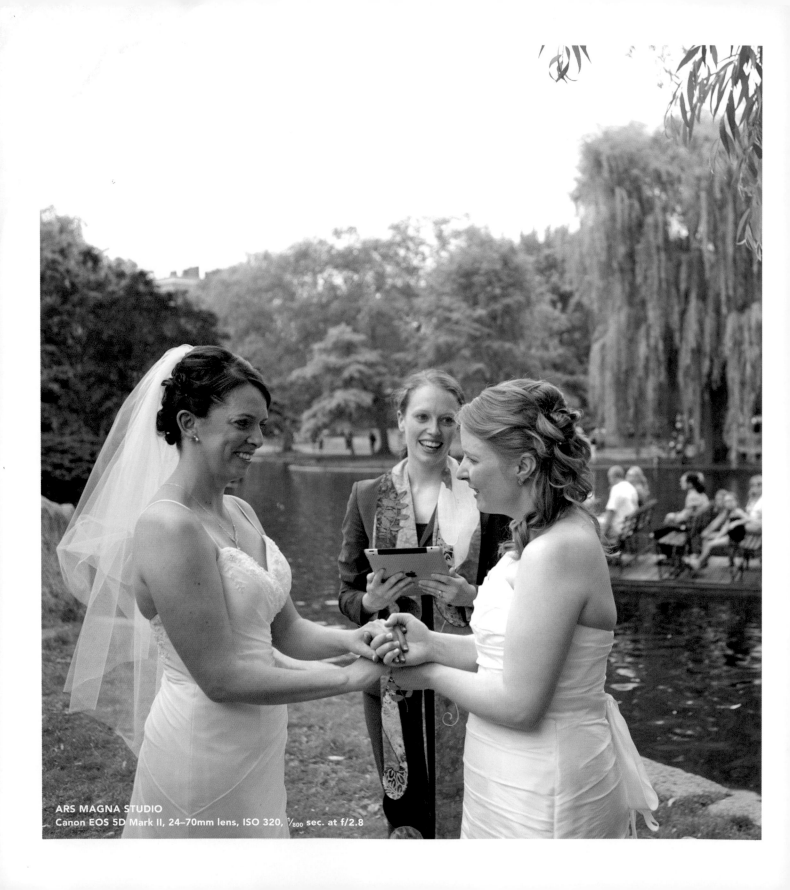

ARS MAGNA STUDIO
Canon EOS 5D Mark II, 24–70mm lens, ISO 320, $^1/_{800}$ sec. at f/2.8

Top 5 Myths About Same-Sex Wedding Photography

1 **Photographing a heterosexual couple is the same as photographing a same-sex couple.**
Traditional wedding photography relies on basic assumptions built around a white gown and a dark tux, masculine and feminine gender roles, and expectations of the physical differences between a man and a woman. Generally speaking, these assumptions do not translate well to same-sex couples, who may both be wearing black tuxes or white dresses or both be of similar build.

2 **It's enough to be a "gay-friendly" photographer when marketing your services.**
In the early days of gay weddings, most same-sex couples were relieved to find any photographer who identified as gay-friendly. This is changing, and changing quickly. Increasingly, same-sex couples want vendors who are not only gay-friendly but gay-wedding-competent. From the standpoint of booking a photographer, the difference can mean an album of wedding photos that are good or an album that's great.

3 **A self-identified LGBTQ photographer is always the best person for the job.**
To be sure, there can be advantages to "keeping it in the community." But a specific sexual orientation or gender identity does not a qualified photographer make. A solid portfolio of same-sex engagement and wedding photography, references, and compatibility are even more important to doing the job well.

4 **The professional photography industry is doing enough to prepare photographers for same-sex weddings.**
Though more educational seminars than ever have introduced the importance of understanding same-sex couples and their needs, most professional wedding vendors—including photographers—do not have the training to understand the nuanced differences between straight and gay weddings.

5 **Same-sex couples are only getting married and booking photographers in states where it's legal.**
Same-sex couples have been having commitment ceremonies for many years now, and the advances in marriage recognition and the growing ease with which LGBTQ persons can be "out" mean that couples are more likely to have weddings (whether legally recognized or not) and receptions in their hometowns, with an option to travel for out-of-state marriage licenses if they desire.

2

BREAKING THE MOLD

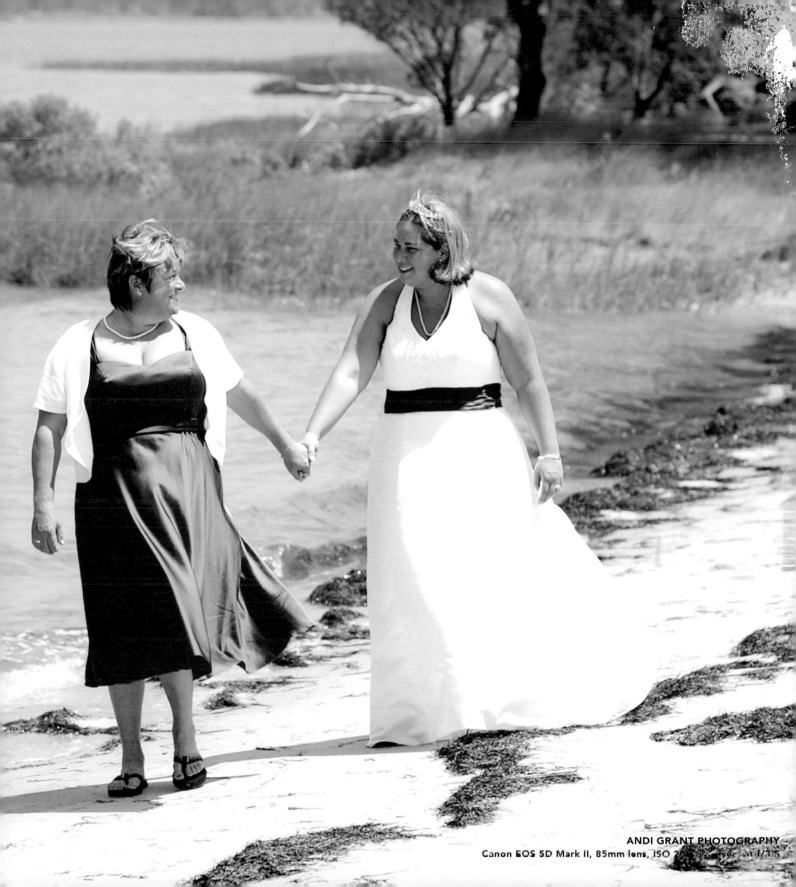

THIS GUIDE WON'T DWELL ON THE current "best practices" in engagement and wedding photography, but it will lean on them. And though it won't propose one definitive answer for every situation, it will offer a path toward a deeper understanding of working with same-sex couples to produce the best outcome for all involved.

This journey begins with understanding that traditional standards have held up over time because of habit and effectiveness. The pose books, lectures, and workshops currently available for reference and inspiration can be helpful because many of the suggestions *do* work, and the techniques can be successful. These same books and workshops can also be limiting, however, if they only reinforce old habits without deeper reflection and adaptation.

Though newer educational resources for wedding and engagement photography show an increasing amount of diversity (more interracial couples, more mature couples, more ethnic representation), they are largely representative of outdated assumptions that the wedding market consists only of Caucasian brides and grooms who express themselves in traditionally gender-normative ways.

Today's couples can be parents, can have divorced parents, can have six grandparents, can have blended ethnic or religious backgrounds—and they can be same-sex couples. But couples like these are hard to find in the canon of photography reference books. Thus, while it's important to be mindful of the proven techniques for photographing couples, be prepared to reject rules that don't apply and adapt to the changing needs of your clients.

KNOW THE RULES

Many of what we refer to as the "foundations of photography" are woven through this guide and will be important to recognize when you see examples of them working—or being insufficient—for some couples. As a quick review, here is our short list of foundation keepers—rules of composition that never get old.

Use the Rule of Thirds. The Rule of Thirds is a compositional technique in which a grid of three imaginary horizontal lines and three imaginary vertical lines are laid across an image, and the subject is placed at the intersection of any two lines. The Rule of Thirds can be used to emphasize your subject and give it maximum impact.

One can easily imagine the intersection of the horizontal and vertical lines in this image, where the couple is framed in the middle horizontal third and the right vertical third.

EMILY G PHOTOGRAPHY
Canon EOS 5D, 70–200mm lens, ISO 250, $\frac{1}{500}$ sec. at f/2.8

Good light is good photography. An otherwise perfectly composed image in poor light looks like a snapshot. Do your homework and understand how to manipulate natural and artificial light with choices in angling, composition, camera setting, and gear.

The thoughtful use of rim light in this image brings a romantic and private feel to an otherwise public moment.

ARS MAGNA STUDIO
Canon EOS 5D Mark II, 70–200mm lens, ISO 1600, $\frac{1}{100}$ sec. at f/2.8

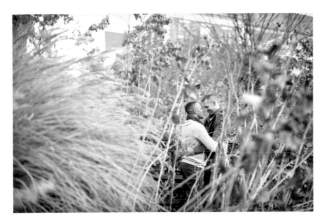

A unique perspective adds to the story. When framing a shot, consider an ant's-eye view or a bird's-eye view, a wide shot or a tight shot, or create an additional frame by looking through something.

One can frame shots through natural or landscaped objects, but it never hurts to consider bringing a few theme-related props to frame your subjects.

DE NUEVA PHOTOGRAPHY
Nikon D700, 50mm lens, ISO 400, $\frac{1}{640}$ sec. at f/2.2

A little tilt goes a long way. Playing with angles adds visual tension and drama, and can enhance a photo's narrative. But a blatant or overcompensated tilt can also distract a viewer from the photo's intent. When it comes to a tilt, a little goes a long way.

The tilt adjustment in this image accentuates the natural backdrop of the session but also helps to frame the grooms in a more intimate and creative way than the distance might otherwise convey without a tilt.

BRIAN PEPPER & ASSOCIATES
Canon EOS 5D Mark II, 70–200mm lens, ISO 400, $\frac{1}{500}$ sec. at f/2.8

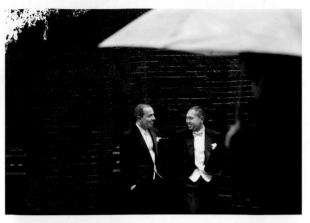

Lead the viewer's eye. Use lines and natural angles to draw the viewer's eye through the frame toward the featured subject.

Even if your eye is drawn first to the passerby and his umbrella framing the grooms, you'll want to follow his gaze to where he's looking: right at the happy couple.

LESLIE BARBARO PHOTOGRAPHY
Canon EOS 5D Mark II, 28–70mm lens, ISO 800, 1/100 sec. at f/2.8

Work it, girl—with a three-quarter turn. It's more visually dynamic for a person to turn his or her body slightly away from the camera and then look back toward the camera to create depth and dimension in the face.

In addition to capturing a flattering perspective of the front-most bride, the positioning of the brides allows for a creative way to present with variety two brides wearing white dresses.

AUTHENTIC EYE PHOTOGRAPHY
Canon EOS 5D Mark II, 70–200mm lens, ISO 400, 1/125 sec. at f/3.2

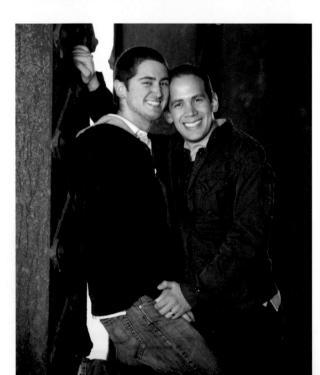

Finish strong! Always finish an image with a thoughtful and visible placement of the hands and feet. Give the hands something to do or help them find a place to rest, and avoid a mess of arms and hands.

If a couple hasn't naturally found a visually appealing placement for a hand or foot, help them with a thoughtful suggestion like "Please lean in to him lightly, and place your right hand on the wall behind his head and your other hand on top of his."

CARLY FULLER PHOTOGRAPHY
Canon EOS 5D Mark II, 70–200mm lens, ISO 200, 1/4 sec. at f/2.8

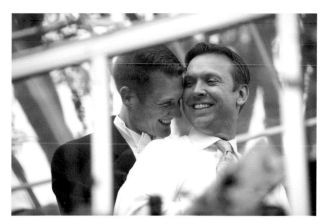

If a photo doesn't show the hands, crop the elbows out as well.

AUTHENTIC EYE PHOTOGRAPHY
Canon EOS 5D Mark II, 70–200mm lens, ISO 400, $\frac{1}{125}$ sec. at f/3.2

Where you crop matters. The three traditional crops are full body, just above the knees, and just above the elbows. Avoid cropping the top of the head, the hands, or the feet.

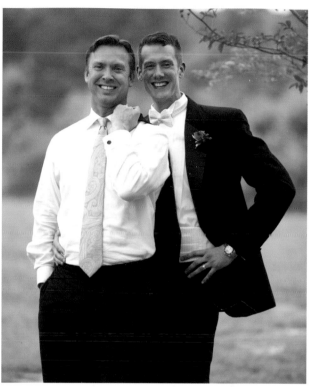

If a photo doesn't include the feet, it shouldn't show the knees.

AUTHENTIC EYE PHOTOGRAPHY
Canon EOS 5D Mark II, 70–200mm lens, ISO 400, $\frac{1}{125}$ sec. at f/3.2

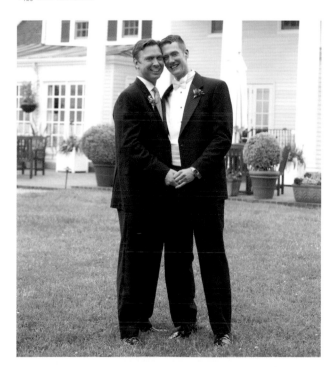

This full-body crop leaves room on all the edges for any additional cropping that may happen, depending on print size.

AUTHENTIC EYE PHOTOGRAPHY
Canon EOS 5D Mark II, 70–200mm lens, ISO 400, $\frac{1}{4}$ sec. at f/4.5

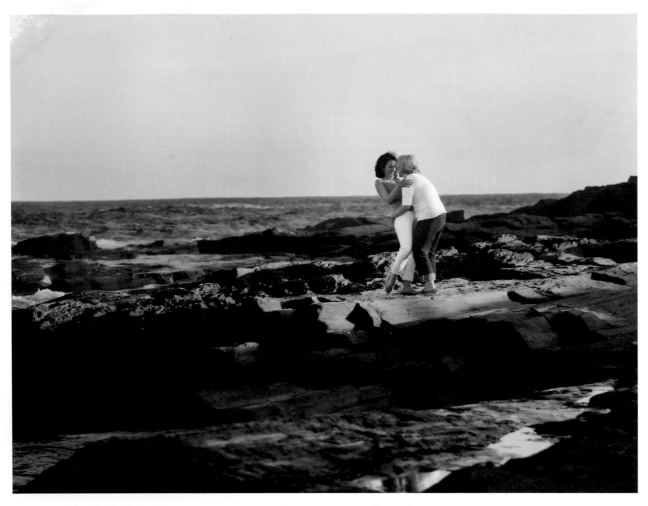

Using a telephoto lens for an environmental portrait can allow the couple to have a private moment during a session.

AUTHENTIC EYE PHOTOGRAPHY
Canon EOS 1D Mark II, 70–200mm lens, ISO 400, $\frac{1}{800}$ sec. at f/4.5

KNOW WHAT YOU'RE ASKING

Beyond understanding lighting and camera techniques, photographers do what they do well by knowing how to pose individuals and couples in a flattering way. Placing different couples in the same poses provides different results. These "differences" can be a challenge but can also help take an image from ordinary to extraordinary. Posing subjects is a bit like working a jigsaw puzzle. Find the right piece and things

will "click" into a place that is natural for the couple. But remember, working effectively with same-sex couples means being mindful of the physical and cultural differences present for any given couple.

One of the best ways to think about this is to know what you are asking of a couple. Is what you are asking a bad physical fit for them? Is it inadvertently offensive or insensitive? Experienced photographers know that it takes time for any couple to relax, feel less self-conscious, and "be themselves" with a lens trained on them. In working with same-sex couples, this dynamic can be complicated further. Are they comfortable showing physical affection in a public setting? Are *you* comfortable with a same-sex couple in a loving embrace? Thankfully, more same-sex couples than ever feel comfortable being themselves in public—and more members of the general public are accustomed to seeing same-sex couples hold hands or embrace, too.

To aim for more authentic results, start by establishing a rapport with your couple, and then follow a progression of poses, with slight physical adjustments made to capture the couple's love in the most flattering and authentic light (literally and figuratively!).

POSING TWO WOMEN OR TWO MEN

To begin, think about posing a same-sex couple following one of four simple patterns: with the individuals side by side, front to front, front to back, and back to back. In any of these combinations, the couple might be walking, sitting, or leaning, but just about everything else is a variation of one of these examples.

Then, being mindful of the physical and cultural differences, consider how you might photograph the couple in a pose in one of four variations that reflect action, placement, intimacy, or any other important detail. The pose types, while generally self-explanatory, are as follows:

1 **Active poses:** Poses in which the couple is in motion, most often in a side-to-side formation.

2 **Placement poses:** Poses that rely heavily on the placement of the two individuals in relationship to each other.

3 **Intimate poses:** Poses that involve physical contact like kissing and nuzzling.

4 **Detail shots:** Images that rely on something other than positioning two bodies to communicate the couple's relationship.

Regardless of approach, the challenge is to find a variety of poses that are visually interesting and flattering to the individual couple while also staying true to the love, intimacy, and authenticity of the moment. And we believe that building from an active and responsive flow tailored to the individual couple will help you attain those authentic results much more quickly and easily than placing them in the heteronormative poses that dominate pose books.

INSPIRATION GALLERY
quick tips for improving posing

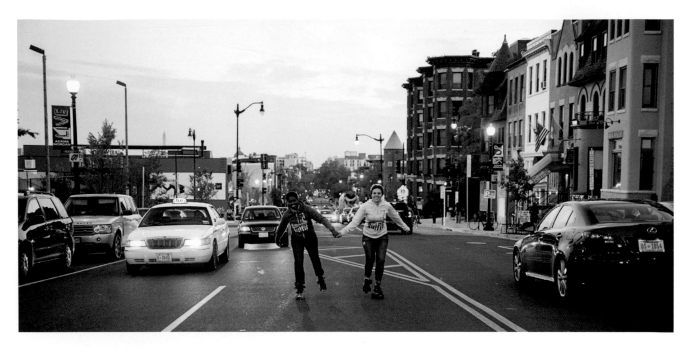

Include a warm-up and a little playfulness. [ABOVE] It can be hard work to look natural. Ironic but true. To help a couple behave "naturally" in front of the camera, have fun with them. Go easy on the first few poses, and if they're able, ask the couple to hold hands and walk together, which most couples can do with ease, regardless of strength or body type. The resulting images may not be polished or perfect, but they will help create a rapport for the poses to come.

MAGGIE WINTERS PHOTOGRAPHY
Nikon D700, 24–70mm lens, ISO 640, $\frac{1}{160}$ sec. at f/2.8

Find the best pose for your clients. [OPPOSITE] Be mindful of body basics when directing hand placement. For example, one common pose for a man and woman is to rest the woman's hand lightly on the man's chest. It may be tempting to use this pose on a same-sex couple, too, but tread with care. Do the masculine and feminine roles implied in this pose apply to this couple? Or does this pose used on two women border on groping? Hands can be placed on the cheek, chin, forearm, or hip—just be mindful of arm length and extension. A slight bend is best, and one should never force a wrapping hug if the wrapper's arms fit awkwardly around the wrapee.

ARS MAGNA STUDIO
Canon EOS 5D Mark II, 50mm lens, ISO 640, $\frac{1}{60}$ sec. at f/2.0

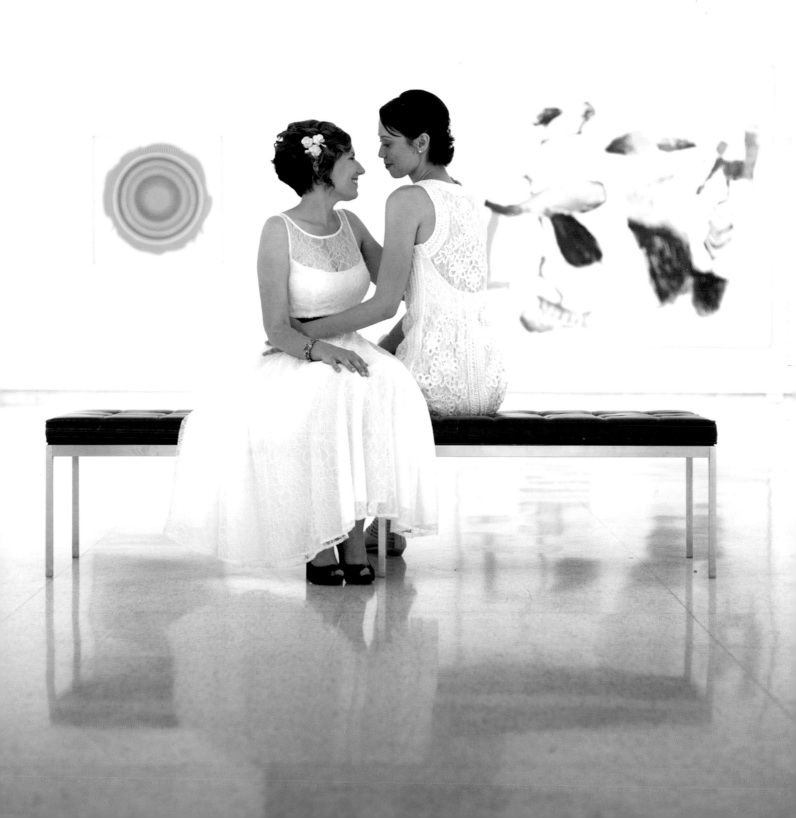

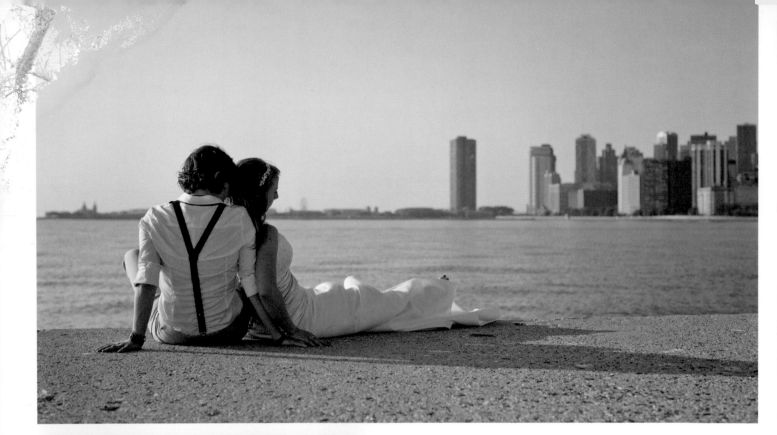

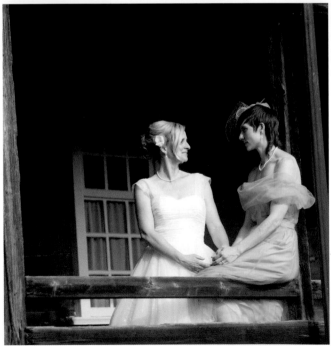

Layer from there. [ABOVE] Layer the subjects' bodies slightly, one "on top of" the other, to reduce a forced or stacked appearance but still bring the subjects physically closer. It's usually easiest to put the taller and/or broader person behind the shorter/narrower one. With close attention to detail, there are many ways you can use layers to hide physical imperfections without making it look as if the subject is hiding.

IT'S BLISS PHOTOGRAPHY
Canon EOS 5D Mark II, 50mm lens, ISO 200, $\frac{1}{2500}$ sec. at f/4.0

Turn a challenge into an asset. [LEFT] Don't get stuck trying to fit a square peg into a round hole; look for the square hole or the round peg and innovate. For example, if you have a couple who can't physically dip or lift each other to replicate one of your favorite poses, be prepared to work around it seamlessly.

AUTHENTIC EYE PHOTOGRAPHY
Canon EOS 5D Mark II, 70–200mm lens, ISO 1600, $\frac{1}{1600}$ sec. at f/3.5

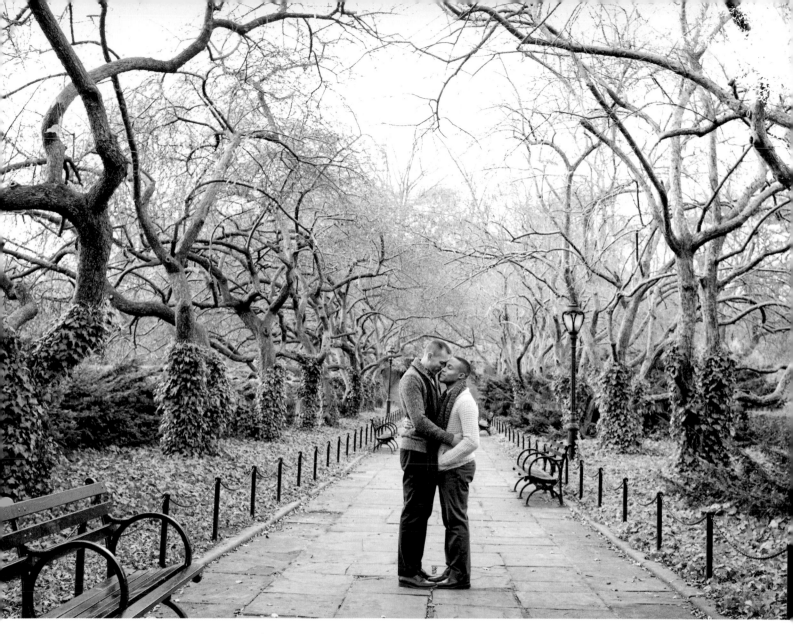

Use symmetry to your advantage, but don't overdo it. When you're working with two people of the same gender who might have similar features and be dressed in the same style and/or color, it's easy to fall back on the age-old standby of symmetry as an overriding concept. But don't be tempted to take the symmetry shortcut in every shot. Instead, while you should feel free to play with symmetry (as many same-sex couples appreciate the irony of a two-bride or two-groom wedding), push yourself to create an authentic and visceral message about the couple's relationship and its place in the world.

DE NUEVA PHOTOGRAPHY
Nikon D700, 35mm lens, ISO 1000, $\frac{1}{160}$ sec. at f/4.0

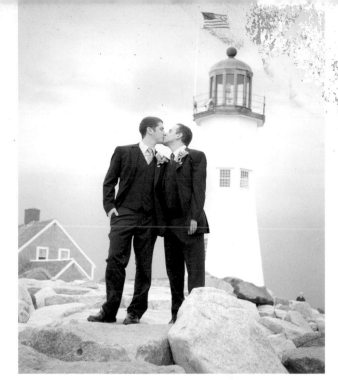

Be mindful about PDA. [ABOVE] Is the couple comfortable showing public displays of affection? Don't underestimate the reality of a habit of caution for some same-sex couples. One doesn't have to look hard to find LGBTQ individuals who have been bullied or worse and, as a result, may not be comfortable showing public affection with a partner.

CARLY FULLER PHOTOGRAPHY
Canon EOS 5D Mark II, 24–105mm lens, ISO 400, $\frac{1}{60}$ sec. at f/4.0

Understand gender expression. [LEFT] Look beyond attire selection to embrace how each individual and couple self-identifies. Don't presume that in every couple there is a "masculine one" and a "feminine one" and that, as such, they should be assigned to the standard male-female poses. Get to know the couple and how they are comfortable expressing themselves to better understand how to pose them.

SARAH TEW PHOTOGRAPHY
Canon EOS 5D, 35mm lens, ISO 640, $\frac{1}{125}$ sec. at f/2.5

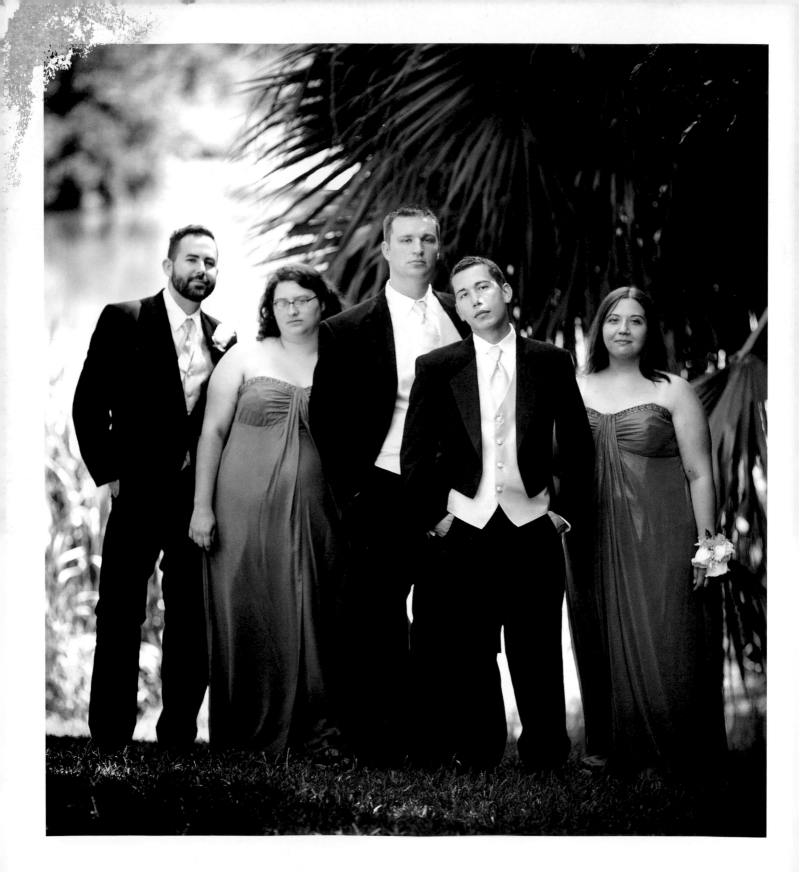

Be creative with group shots. [OPPOSITE] Same-sex couples typically have some sort of wedding party, but the attendants assembled can vary widely from tradition. There are mixed-gender wedding parties, imbalanced wedding parties, costumed wedding parties, and family as wedding party—not to mention no wedding party at all. You name it, same-sex couples have done it. Learn more about who your clients want to feature and how they want to feature them before the event, and use that understanding to create meaningful and authentic group shots.

JIMMY HO PHOTOGRAPHY
Canon EOS 5D Mark II, 135mm lens, ISO 640, 1/800 sec. at f/2.2

Be mindful of the role of family. [ABOVE] Though more parents than ever are excited about their gay son or lesbian daughter's wedding, there are still many parents who aren't supportive and either aren't invited to the wedding or have declined the invitation. Be sensitive about this reality, asking open-ended and respectful questions about what a couple envisions for the inclusion of family members, while also remembering that those who do attend may provide some of the most moving and authentic moments of love to be captured.

JIMMY HO PHOTOGRAPHY
Canon EOS 5D Mark II, 85mm lens, ISO 2000, 1/200 sec. at f/2.0

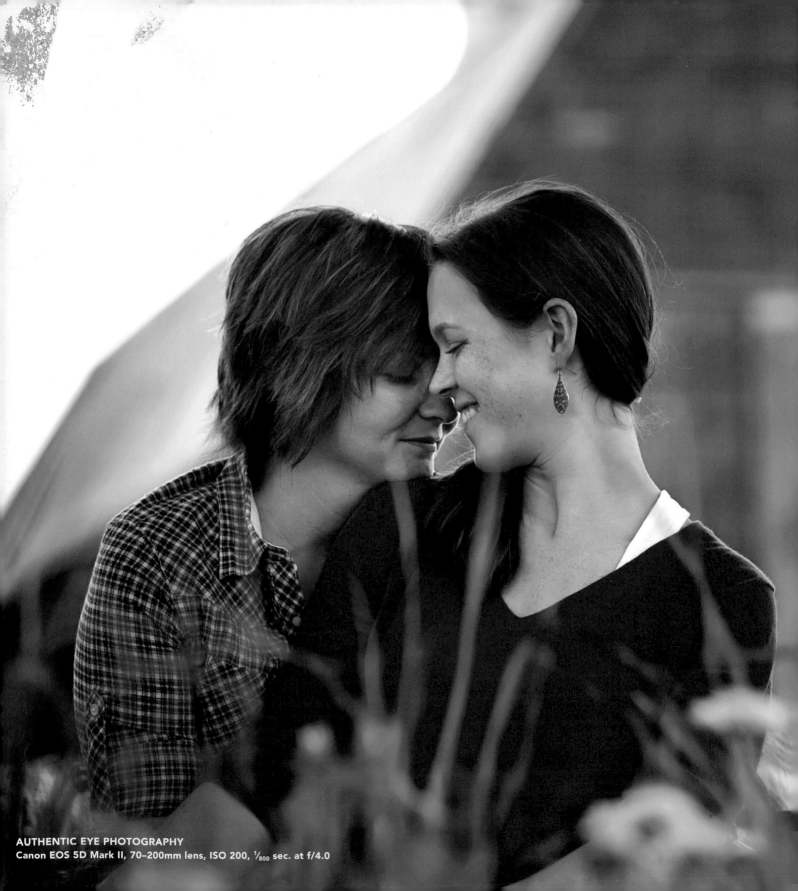

AUTHENTIC EYE PHOTOGRAPHY
Canon EOS 5D Mark II, 70–200mm lens, ISO 200, 1/800 sec. at f/4.0

—·3·—
ENGAGEMENTS

TEN YEARS AGO, FEW SAME-SEX couples were considering public ceremonies, and even fewer had access to legal partnership recognition. When couples did forge ahead into uncharted territory, most of their energy was spent finding gay-friendly vendors and worrying about whether or not family would show up. Engagement sessions were not yet a gleam in the collective LGBTQ eye, let alone the reality that they now are in the blogosphere.

But as same-sex weddings have become more widely accepted, more couples have begun following the traditional marriage prescriptions: engagement on bended knee (or Jumbotron), engagement parties, bachelor and bachelorette parties, wedding showers, weddings, and big receptions. You know, the Works. These changes require that photographers take a deeper look at their skill sets and the services they offer same-sex couples. Couples, too, should become more knowledgeable about the kinds of skills, style sense, and creative talents available to them when hiring an engagement and wedding photographer.

If used well, an engagement session can provide fruitful inspiration for wedding-day

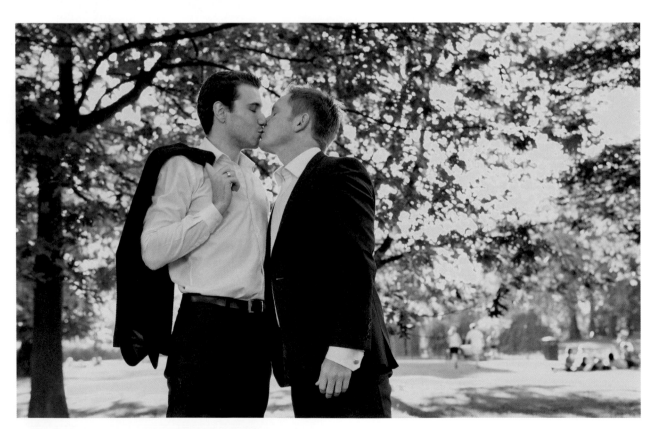

Cesar and Peru celebrate their engagement in Regents Park in London.

PURPLE APPLE STUDIOS
Canon EOS 5D, 24–70mm lens, ISO 320, $\frac{1}{250}$ sec. at f/4.5

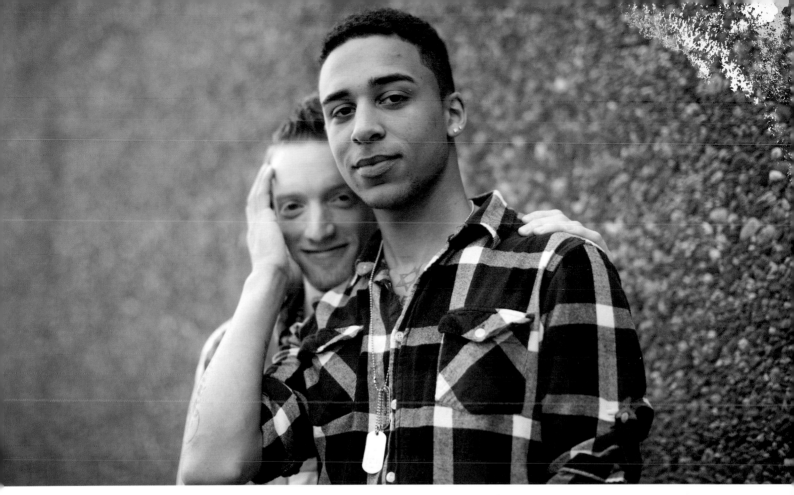

A young couple at a casual, early spring portrait session in Washington, DC.

AUTHENTIC EYE PHOTOGRAPHY
Canon EOS 5D Mark II, 50mm lens, ISO 200, $\frac{1}{1250}$ sec. at f/1.6

planning. The initial meetings and conversations offer a chance to get better acquainted with the couple, establish a connection, and build rapport so that you and your clients can become a team working toward a shared set of goals and clear expectations.

In-person meetings with both partners offer the best opportunity to get acquainted and consider any observable differences that will impact the session, such as height, body type, or other physical differences. Equally important is the chance to learn more about how each individual expresses himself or herself most comfortably (especially with regard to gender expression), how each partner relates to his or her beloved, and how their coming out experiences have impacted them and their family relationships.

THE UMBRELLA CONNECTION
one unbroken circle

The walking shot is an engagement and wedding standard because it allows the opportunity for a couple to look natural in a pose, regardless of differences such as gender expression, sexual orientation, or height. The pose also provides an opportunity for deeper insight: often, how a couple walks together can say a lot about their closeness and how they interact.

It is not uncommon for a photographer to ask a couple to hold hands and invite them to "walk toward me." This is a wonderful, action-oriented technique that can put a couple at ease before introducing more complicated poses. If the session is taking place in a public space, be sure to offer the invitation in a gentle, nonpresumptive manner that gives the couple room to decline.

Believe it or not, some same-sex couples may not be comfortable holding hands in public. Or, even if they are, there might be a deeper background story or experience that could have them take pause and first gauge their comfort with the situation before proceeding. For those who "came out" when identifying as gay or lesbian was less accepted, or who currently live in a less accepting area, it's quite possible that the simple act of holding hands can feel unsafe.

An umbrella as a prop offers a great workaround to connect a couple without physical touching. The umbrella replaces the need for the couple to hold hands because the act of sharing it brings them together, with a circle (the universal symbol of eternity) above their heads.

behind the lens

First used in 1978 on a flag for a San Francisco gay pride march, the rainbow has become one of the most widely recognized symbols of LGBT pride. Including a rainbow umbrella in a same-sex engagement session will strike a historical and playful chord for most, but be forewarned: Not all same-sex couples will want to include this symbolism in their celebrations and photo sessions.

KRISTINA HILL PHOTOGRAPHY
Canon EOS 5D, 85mm lens, ISO 100,
$1/320$ sec. at f/2.5

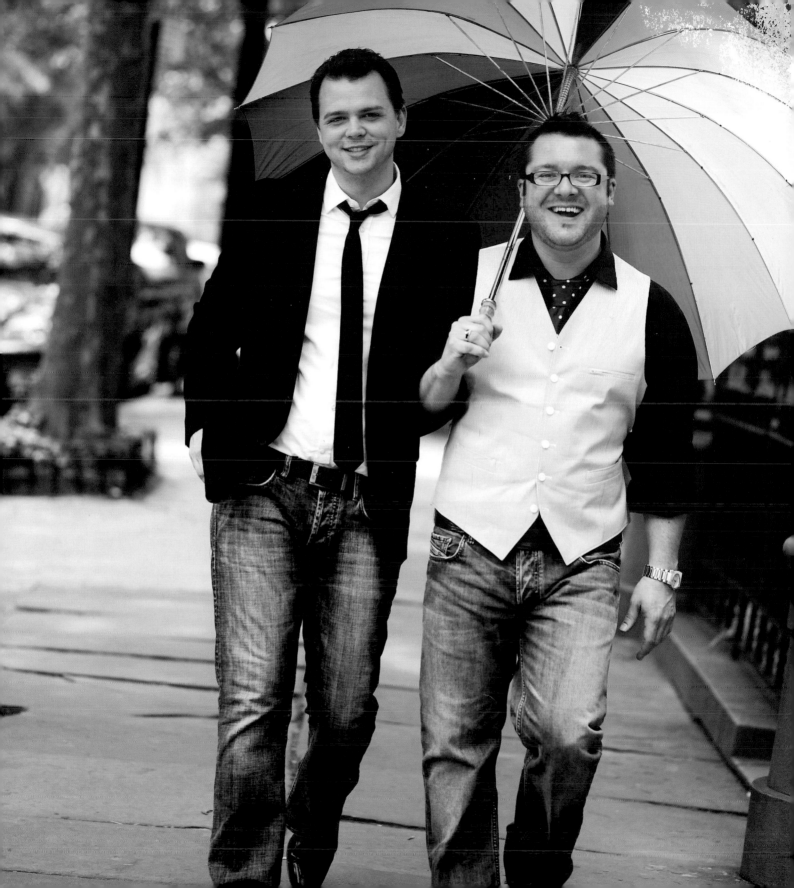

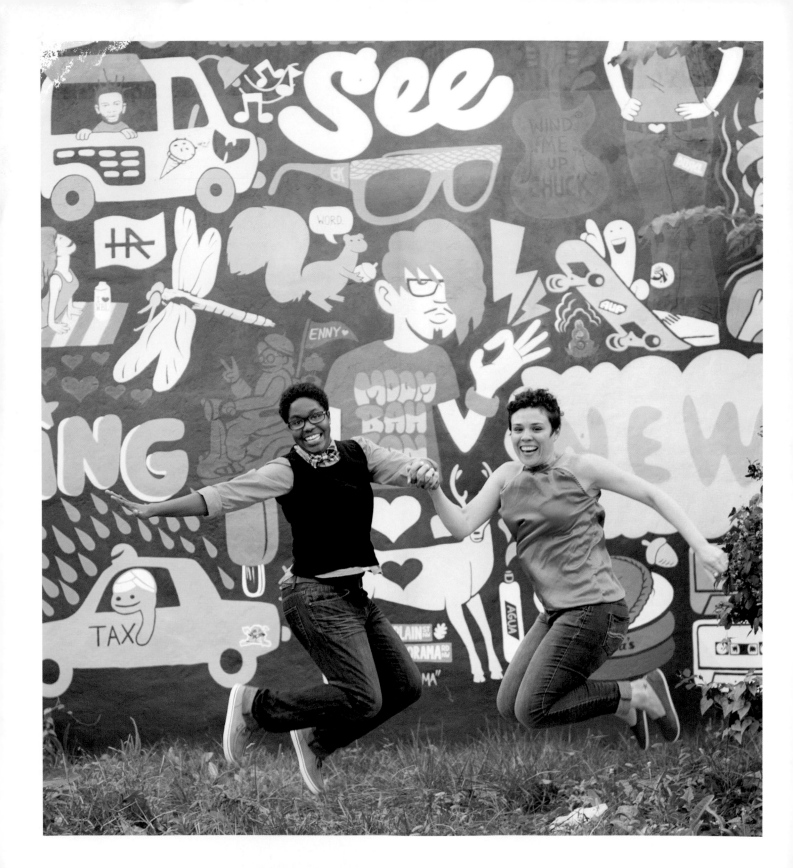

JUMP!
lovers' leap

Many photographers follow a "pose flow" in their sessions, with each pose efficiently setting up the next. This technique can work beautifully if you are true to the flow and the couple with whom you are working, and are able and prepared to adjust thoughtfully to them. Similarly, a "flow" can be easily interrupted by an ill-fitting series of poses for the couple; one awkward building block on top of another does not a meaningful, intimate moment make.

This is why it's important to open your session with a warm-up set of poses that involves natural flow and movement. For example, ask a couple to hold hands and walk away from the camera. From there, ask them to look back at the camera. Then have them turn around and walk back toward the camera. Finally, ask them to jump, skip, run, dance, sing, or whatever feels right for these individuals and the moment at hand. The idea is to do something fresh and fun.

Remember, just because a jump or other movement looks great for one couple doesn't mean it will look great for your next couple. But if your rapport is in place and a request like this won't sideline the session, give it a try! Sometimes it's better to be a photographer willing to take risks with the right couple than one who always sticks to the safety shots.

behind the lens

The engagement session also offers a low-risk time to take chances, unlike the wedding day, which generally has a tight time schedule and compulsory shot list. It's a good time to try out new concepts, poses, or lighting scenarios, and figure out what works (and what doesn't) with your clients.

MAGGIE WINTERS PHOTOGRAPHY
Nikon D700, 24–70mm lens, ISO 640, $\frac{1}{640}$ sec. at f/2.8

ON THE BOARDWALK
a modern dip

Even the briefest glance at this delightful moment allows ample insight into this couple's individual personalities and the dynamics of their relationship. Though there are some consciously styled elements here—from the complementary white pants and shirt to the boardwalk lines and purposeful placement of the couple—the magic of this image is in the authentic joy captured between these two men. The photographer's style and familiarity with his subjects (and their comfort with him) is unmistakable.

Though the moment has been captured in a single frame, one can discern the fluid strength in the stance and arm support offered by the white-shirted gentleman. The flirtatious laugh and unrestrained enjoyment of his partner is infectious, and one can't help but wonder what was just said to inspire such a reaction.

We like to think of this pose as an example of a modern spin on the traditional dip. To try it, ask one partner to bend back (supported by his partner), lean his head back, and laugh out loud. If the couple isn't already looking for a moment to camp it up, preface the instruction by encouraging them to try, with the promise that they'll never have to see it if it looks ridiculous. Don't be afraid to reverse the order and have the other partner arch his back and laugh out loud. As a final touch, encourage both men to laugh at the same time (if they aren't already).

behind the lens

Have a great zoom lens? Zoom all the way in and move back for good framing. Using a long lens (with a zoom greater than 100mm) is not only more flattering, because it compresses features, but can also make the background appear closer and larger. This can be used to make more visually pleasing images as well as to enhance the image's narrative.

ARGUEDAS PHOTOGRAPHY
Nikon D700, 70–200mm lens, ISO 200, $\frac{1}{2500}$ sec. at f/2.8

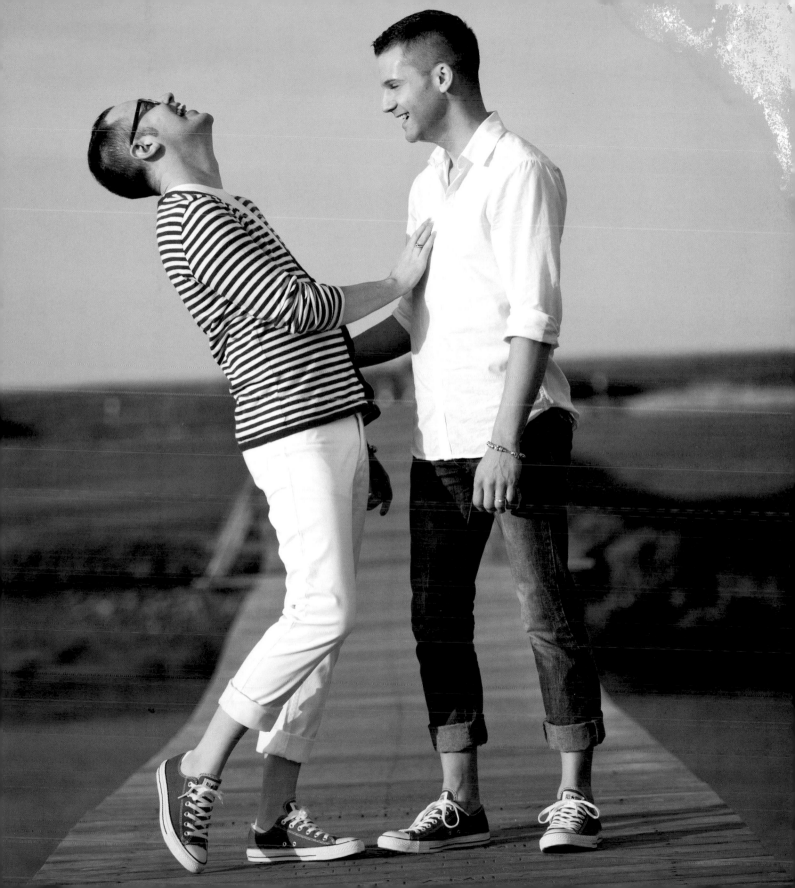

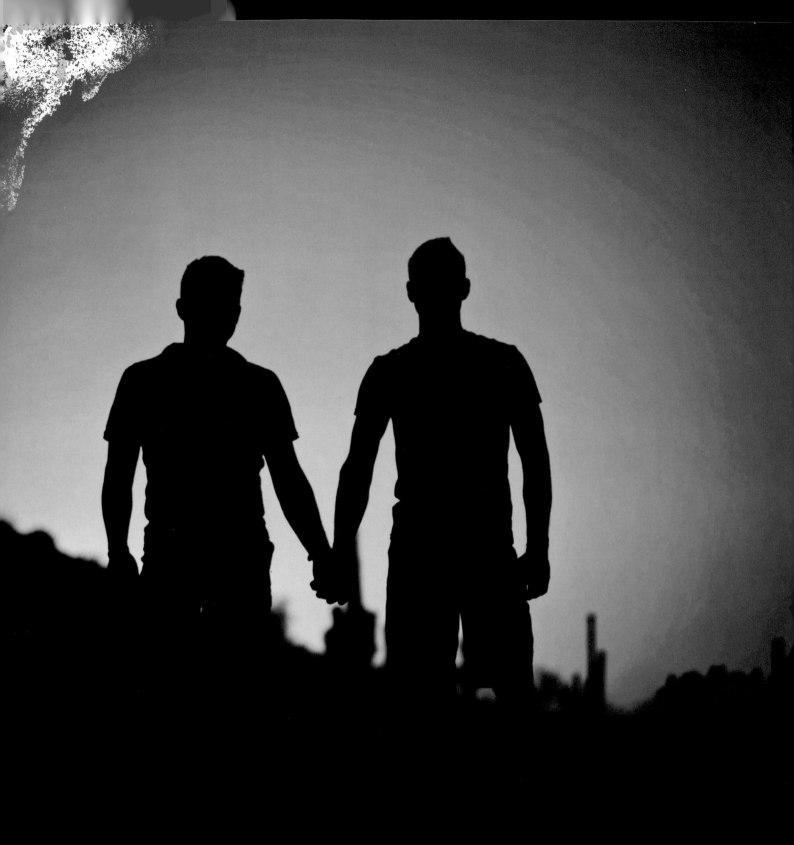

HAPPILY EVER AFTER
repurposing notions of romance

To communicate closeness, one might tend to rely on posing a couple physically close. But this pose offers an inspired exception to the rule. By having a couple stand side by side—so far apart they have to reach a bit to clasp hands—you can create a perfect separation between bodies without forfeiting the notion of romantic connection.

If both subjects are physically strong men, the image should represent them as such. Strength and individuality are communicated by a subject standing strong on his or her own two feet, not leaning against someone or something. These are clearly two strong individuals who are connected at the hands in a truly intimate and yet powerful fashion. Additionally, the contrast of the dark landscape and dramatic sunset, with the low camera angled up toward the elevated subjects, completes this image, capturing more context—a clear sense of rugged location, their masculine physiques and muscle tone—than is commonly found in a silhouette.

The end result? We are invited to share in this breathtaking sunset and the sense that this couple is taking in the moment: everything the end of a long day together should be.

behind the lens

By underexposing the subject and exposing for a bright background, the camera loses the detail in the subjects and turns their bodies into a silhouette. It can be a wonderful effect, but as with most "effects," an overreliance on the effect in a photograph can result in a neglect of the message. Not so here. Taken in the San Tan Valley desert in Arizona, this image is striking in its composition and clear message of strength and intimacy.

TAMMY WATSON PHOTOGRAPHY
Canon EOS 5D Mark II, 100mm lens, ISO 320, $1/2000$ sec. at f/3.2

TIMELESS LOVE
snuggle with a twist

Props in an engagement session, not unlike bouquets on a wedding day, can sometimes be a challenge to work into a portrait. They can be bulky and awkward and get in the way of spontaneity or posing a couple physically close. Conversely, a prop can also express a detail about a couple's favorite things to do together. This might include favorite books, favorite time periods, favorite hobbies . . . even pets! Either way, a prop can add style or personalize an image, making it more special and unique to the couple.

In the case of this lesbian couple, placement of the suitcase between the two women could have made them look disconnected. Photographer Maggie Winters's keen eye for detail, however, transformed this obstacle into an asset. Because the couple pointed their knees away from each other, they created a complementary angle with their legs, requiring them to twist their upper bodies toward each other as they nuzzled. This is a complicated bit of posing that can look believably natural.

behind the lens

Find out during your engagement session or presession interview if a lesbian couple is going to have two bouquets at their wedding. If so, learn more about the size of the bouquets and whether they'll be complementary or matching. Then, consider using a prop or pair of props—such as two hats, two handbags, or two sandwiches!—during the engagement session to consider solutions for the double bouquet challenge.

MAGGIE WINTERS PHOTOGRAPHY
Nikon D700, 24–70mm lens, ISO 200, $\frac{1}{500}$ sec. at f/3.5

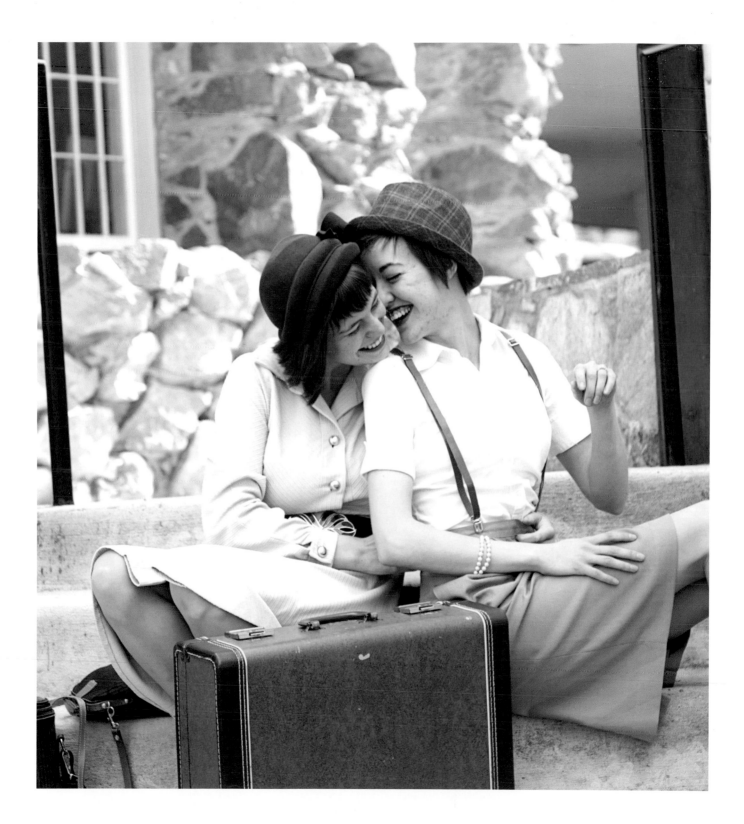

EMBRACING THE MOMENT
do a little dance

It doesn't matter how many times you consult the *Farmers' Almanac*, the weather just might not cooperate with your best-laid plans. And neither might the couple. But that doesn't mean you can't be prepared for a session regardless of what surprises (and inclement weather!) might be in store.

After being asked to dance together, this couple embraced the spontaneity of the moment, responding to the rain in a theatrical and joyful fashion. Moments like this can also provide helpful information for the wedding day. Watch to see who leads, who runs for cover, who grabs the umbrella, and who opens it for their partner, and file away that valuable insight into the couple's personal dynamic.

behind the lens

Find out how your clients feel about dancing and whether they'll be doing a dance at their wedding reception. If they confess to taking dance lessons to prepare for the reception, don't miss the opportunity to ask for a sneak peek of the sensational dance they're planning!

AUTHENTIC EYE PHOTOGRAPHY
Canon EOS 5D Mark II, 70–200mm lens, ISO 1250, 1/500 sec. at f/4.0

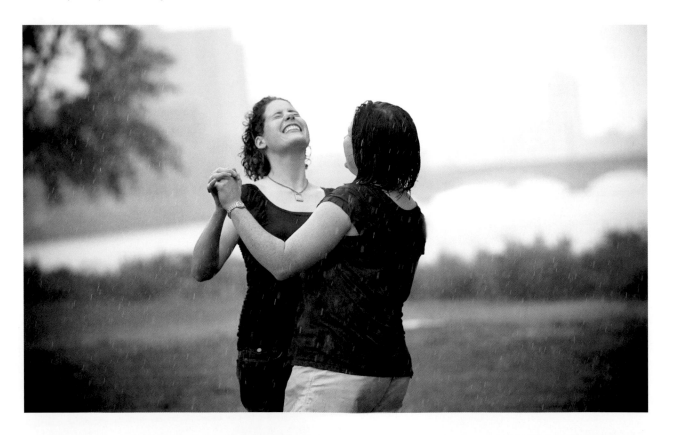

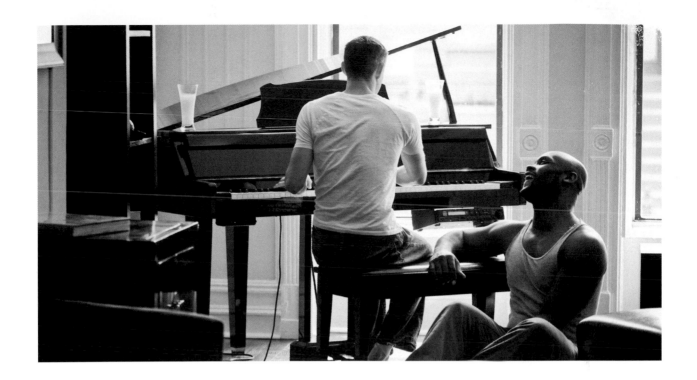

IT TAKES TWO
improvisation

It can be difficult in an engagement session to capture the "everyday" moments a couple shares; those quiet moments when a couple is connected and engaged, not appearing posed and not preoccupied with the camera. Lifestyle photography is a popular approach to document real-life events or situations in an artful way. It allows a couple, like the one featured here, to strike a pose true to their lives and for the photographer to primarily focus on documenting the real moment, rather than forcing a couple to fit a pose the photographer fancies.

By observing the couple interact with each other in real time, you can consider which poses will work best for them, rather than relying on the poses better suited for the "average" heterosexual couple.

behind the lens

Doing a session in the couple's home may offer an intimate look at some of their routines, hobbies, and habits. It might also increase their comfort with the session, lend inspiration to capture the couple responding to each other, and give a bit more insight into the fabric of their lives to help capture the most authentic portrait possible.

UNUSUALLY FINE
Nikon D300, 70–200mm lens, ISO 250,
$\frac{1}{60}$ sec. at f/2.8

FIRE ESCAPE
in her arms

There was once a time when creating a professional portrait meant that the subject would be posed, looking directly at the camera. But times have changed. The lesbian couple featured here may not be making eye contact with the viewer, but the essence of their love is explicitly represented. We are witnessing an authentic moment, an intimate exchange that is beautifully framed, rather than restrained, by the lines of the railing that surrounds them.

Though this pose looks effortless, there is a very clear attention to detail with hand placement. This is an important touch, because hand placement impacts upper body posture. Because the woman in front has placed one hand flat one on top of the other, her upper body is poised at ease and her hands are not a distraction to the foreground. This also allows her partner to tuck in around her, using her waist and the railing to frame a natural embrace. The resulting balance suggests a mutuality and equality in the relationship, rather than a reliance on the outdated notion that a couple should be posed where one person's position (traditionally speaking, the male's) would be dominant to the other (the female).

behind the lens

Always be prepared with a wooden crate or "apple box" in your kit, or keep an eye out during your session for the nearest set of stairs. Using one of these tools can make a huge difference when you need to manufacture a bit of a height difference to improve a pose. You can either "frame out" the crate, work it in creatively, or adjust your crop accordingly when you're editing the album.

MAGGIE WINTERS PHOTOGRAPHY
Nikon D700, 24–70mm lens, ISO 640, $\frac{1}{250}$ sec. at f/2.8

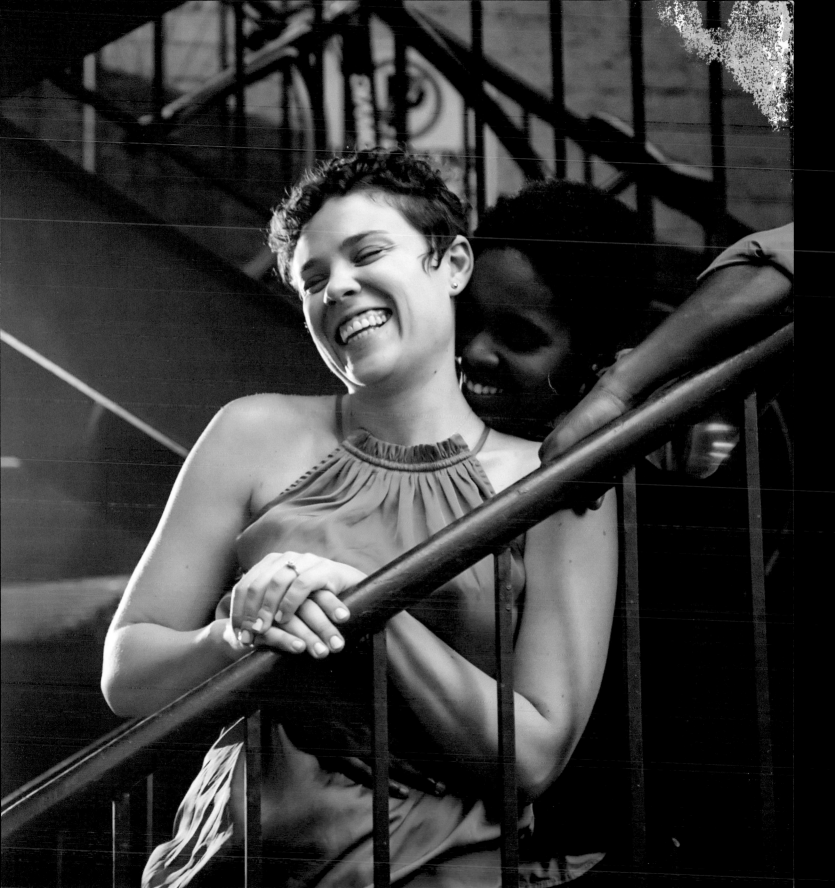

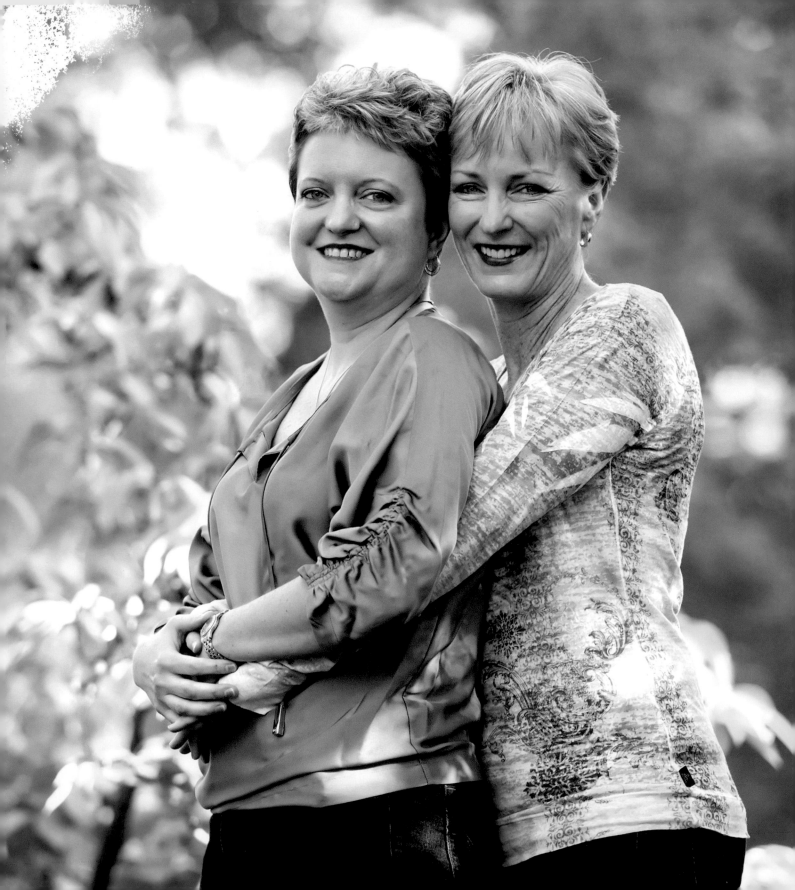

AUTHENTIC COMFORT
know your audience

behind the lens

Kristi and Lisa chose the Fort Worth Japanese Gardens as a backdrop to commemorate their legal elopement to Vermont. At the time, they also had plans under way to host a "big wedding" with their friends and family back home in Texas, even though the second wedding would not be legally recognized. From a photographer's perspective, this engagement process offered three occasions to document their celebration (an engagement session, a legal elopement, and a wedding); this will remain a common pattern for same-sex couples until marriage equality is recognized nationwide.

LYNCCA HARVEY PHOTOGRAPHY
Nikon D700, 70–200mm lens, ISO 640, $\frac{1}{250}$ sec. at f/4.0

Engagement sessions have traditionally been for young lovers. Not anymore. In the new frontier of same-sex engagement portraiture, you might easily find yourself working with a couple who has been in a committed relationship longer than you have been in the profession. As such, remember that the message communicated in an image should reflect the stage and age of a relationship. A mature couple, for example, might be better captured in a pose that shows the ease of their comfort and familiarity with each other, rather than one imbued with the feel of the giddy, early days of love.

What might be referred to as the classic "prom pose" is reinvented here for this lesbian couple. It's an easy favorite with many photographers, but to avoid an awkward result, you must tread with care when using it. The pose works best when one person is taller than the other and has arms long enough to comfortably reach around his or her partner without strain. You can instruct the partner in back to pull the partner in front in as close as possible, while holding shoulders up and back, and finding a relaxed position for the hands. Whether the hands end up on the partner's stomach or hips can be determined based on the best physical match for the couple.

SEATED EMBRACE
layering with organic inspiration

The key to photographing a seated couple is using an intuitive layering of bodies. This creates a physical closeness that communicates emotional intimacy without making the couple look like they've been awkwardly or rigidly stacked according to a one-size-fits-all formula.

The obvious place to begin is by asking the person who is physically larger than the other to serve as the foundation. In engagement and wedding portraiture with opposite-sex couples, the woman always sits on the man's lap; to do otherwise is to suggest a punch line. Thankfully, with same-sex couples, photographers aren't backed into this stereotypical pose; rather, one can pose by body type or personality instead of plumbing.

With subjects who are the same or a similar size, it can be challenging to layer them without hiding one behind the other. Sidney Morgan solves this by asking each woman to sit close, facing each other and turned slightly toward the camera. This creates a comfortable embrace for the couple; neither is hidden, and the seated pose removes height from the equation.

behind the lens

When layering bodies, don't be fooled by attire choice. Just because one partner is in a dress, her (or his!) body type isn't always best placed as the outermost layer. With same-sex couples, there is no one-size-fits-all solution. It's up to the photographer to observe the couple, better understand their relationship, and perhaps even think outside the box to find the pose most fitting for the couple.

SIDNEY MORGAN PHOTOGRAPHY
Canon EOS 5D Mark II, 50mm lens, ISO 320, $\frac{1}{500}$ sec. at f/1.8

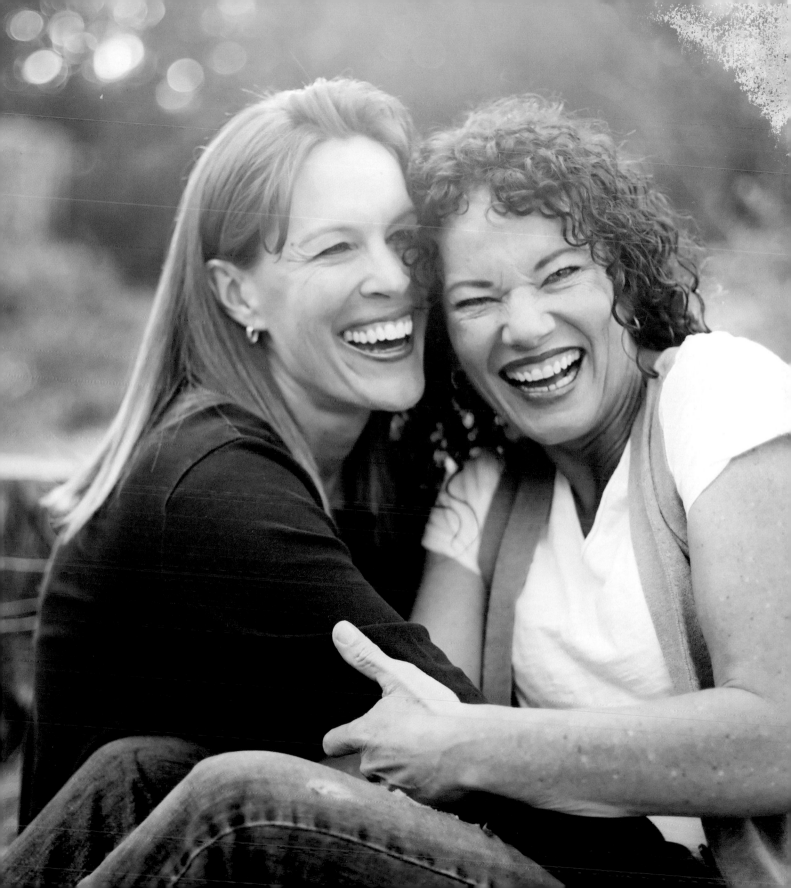

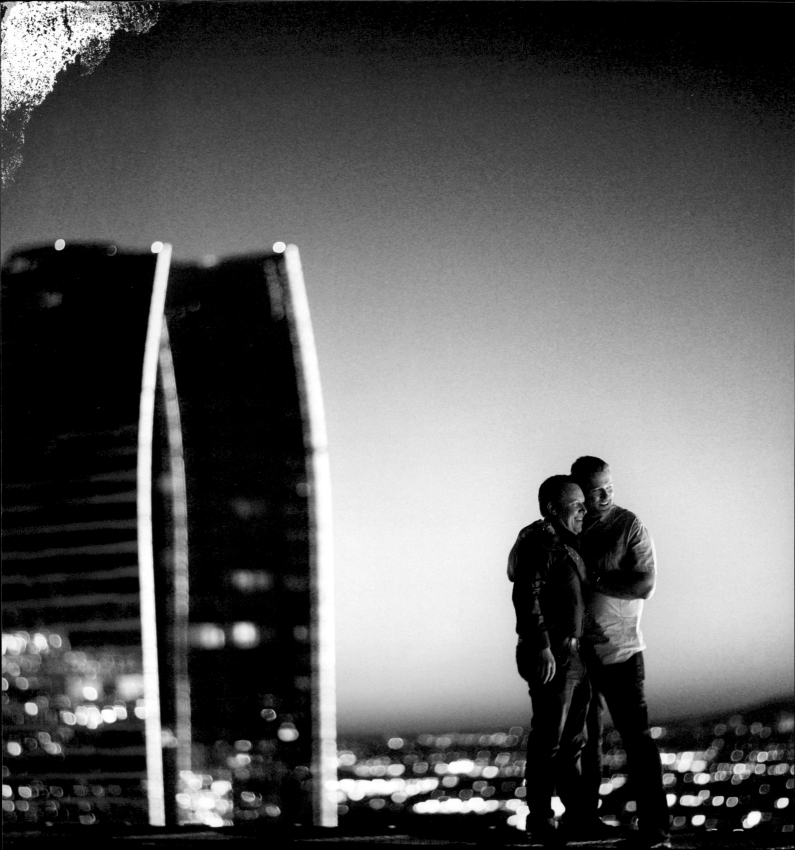

BRIGHT LIGHTS, BIG HORIZON
rooftop with a view

behind the lens

A photograph at sunset is dramatic, because the light is soft and the sky is beautiful. But sunsets present challenging lighting scenarios, because one must balance artificial light (to light the subject) with the bright natural light of the background. Be careful not to overexpose the skyline and lose the details of the subject and colors of the sky. Instead, create a "modeling light" by keeping the artificial light off-camera, allowing for gentle shadows and more natural-looking light.

CEAN ONE STUDIOS
Canon EOS 1Ds Mark III, 85mm lens, ISO 1000, $\frac{1}{30}$ sec. at f/1.2

In art school, students are taught to deconstruct images, turn them upside down to look at the composition without being distracted by the message. Doing so should reveal perfect lighting, exposure, composition, craft, and positioning. A photograph needs to be both visually pleasing and emotionally powerful.

This moment, as captured, tells us that the men are looking out toward a new horizon together, but the modern touch of the glass building with neon outline also suggests something of a new frontier for all of us.

Photographer Jeremy Fraser also does a nice job of finishing the shot by asking the taller of the two men to place his hand on his fiancé's heart. In so doing, he adds a nice connection between the men and demonstrates a mindfulness of hand placement.

SHOULDER SEASON
personal moments, public spaces

To get a couple to relax, start by helping them get physically comfortable, and then get out of the way. Asking a same-sex couple to sit next to each other and chat as you step back for a long shot is a good idea. Give them the opportunity to forget that you are even there. The only instruction should be to not look at the camera.

This is an especially good strategy for couples who are less comfortable with PDA, even if it's as simple as a touch or sidelong glance when they think that no one is looking. In addition to providing yet another occasion to observe how a couple interacts (such as who sits where, who crosses his legs, who laughs nervously), you'll provide more room for the authenticity of the relationship to appear and, if you are in a public space, draw less attention to your session.

behind the lens

Photographer David Wooddell suggested this invaluable exercise for straight photographers: Go to a very public place, and get on the other side of the lens. Find a colleague to photograph you and another friend (of your same gender), modeling as a same-sex couple. How does it feel? Do people look at or respond to you differently? Smile or scowl? Avert their eyes? We can never know fully what it feels like to be someone we are not, but we can learn a lot by walking in their shoes for an hour or two.

RETROSPECT IMAGES
Canon EOS Rebel T2i, 50mm lens, ISO 800, $\frac{1}{1600}$ sec. at f/3.5

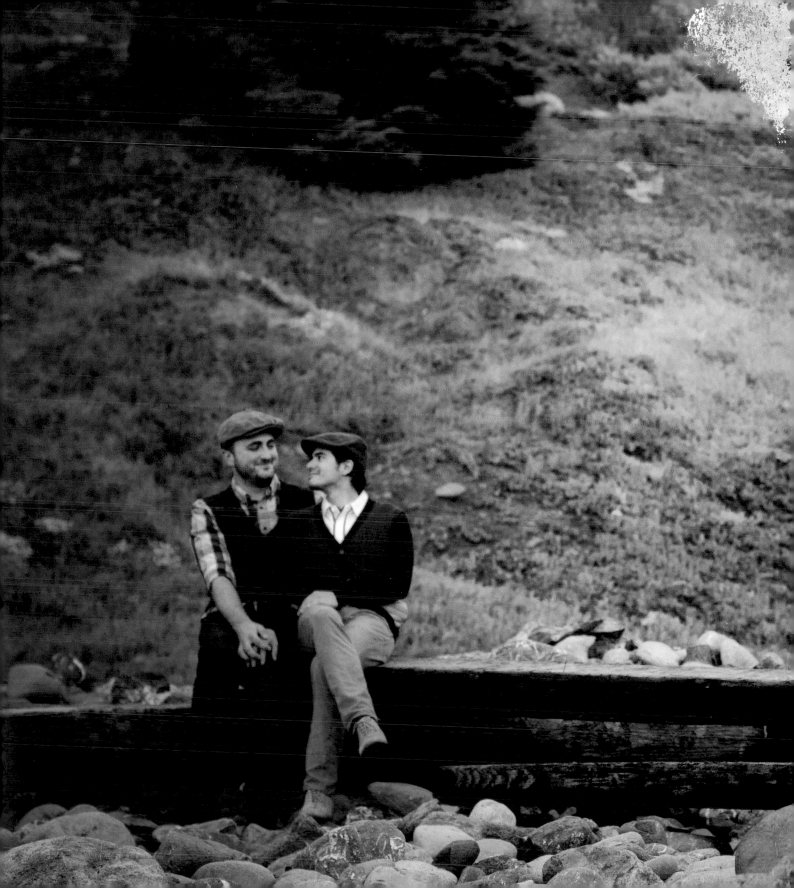

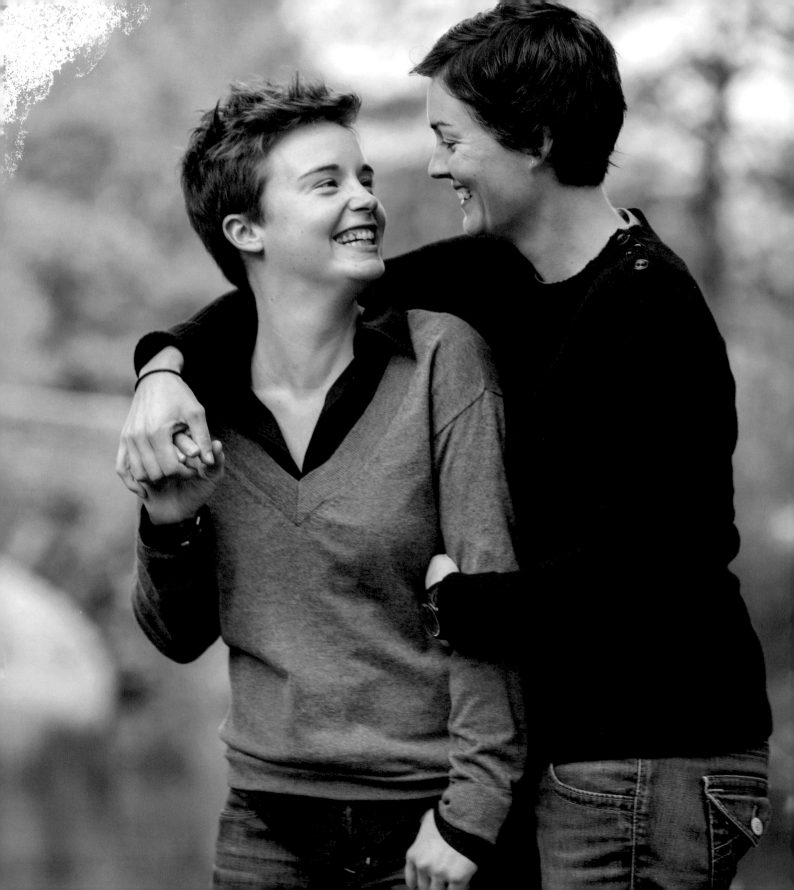

STANDING EMBRACE
casual moments of joy

During most sessions, photographers strive to arrange couples efficiently but with meticulous attention to detail, and, within those constraints, inspire genuine moments of emotion. The true challenge is to do this not just once, but to repeat this minor miracle over and over with different couples, who have different relationships and different inhibitions. You are likely to do your best work if you have a vision of a pose in mind before instructing the couple and if you've asked yourself how that pose will apply to the couple with whom you're working.

It's easy enough to have a couple arrange themselves front to back and a little off-center so that they're layered in a natural-looking way. But getting people to put their hands on each other in a tidy fashion is often more challenging. Couples often wrap their arms too tightly around each other or, worse yet, wrap their arms around each other in ways that can distract from the essential focus and purpose of the portrait. The best way to get a couple into position is to model or mirror what you want them to do and then help them relax into it.

Remember that couples often interpret the photographer's instructions differently than intended. And that's okay. Don't be overly strict in enforcing a pose. Sometimes, you might just find that the couple will come up naturally with a better solution as they relax, because they know how their bodies fit together.

behind the lens

Allana Taranto of Ars Magna Studio in Boston says that she instructs couples by saying, "I want one of you there and one of you here." She doesn't presume which one will choose the dominant position. She lets them show her the dynamic of their relationship and follows their lead.

ARS MAGNA STUDIO
Canon EOS 5D Mark II, 135mm lens, ISO 200, $\frac{1}{200}$ sec. at f/3.2

AFFECTIONATELY YOURS
serenity

There's no magic trick to getting a couple to show themselves as intimate or emotionally vulnerable in front of a camera. A one-to-two-hour public engagement session doesn't make this any easier. So how do we get our couples, like the one featured here, to look great (which is what posing does) while also preserving their natural affection for each other? Give them permission to be affectionate.

Before you begin photographing, have a quick conversation with the couple to let them know what they can expect. For example: "I've got four basic poses I'm going to ask of you, front to back, front to front, side to side, and back to back." Show them what you mean. Then add, "When you are in each of these poses, I am going try different angles and camera settings. You can try stuff, too. If you feel like kissing, then give each other a kiss!" It's amazing how much faster you can tap into a couple's natural affection when you give them permission to be affectionate.

Remember: The couple is looking to you to lead. They've (likely) never done this before and will benefit from your reminders that they can be themselves. Sometimes couples remain stiffer out of fear of "ruining" the pictures. If all goes well, there's often a time that happens well into a portrait session when the couple will begin to improvise within a pose. It is this improvisation that tends to lead to the most genuine moments.

behind the lens

It's always a good idea to take time before the session to talk with a couple, without a camera in hand. It can be helpful in setting the tone, and photographers are in the position to set the ground rules. Let your clients know that they can say no to any instruction. Encourage and empower them to follow directions in a session, even if the pose request seems unusual, while also allowing them the freedom to express themselves.

AUTHENTIC EYE PHOTOGRAPHY
Canon EOS 5D Mark II, 70–200mm lens, ISO 200, $1/125$ sec. at f/5.0

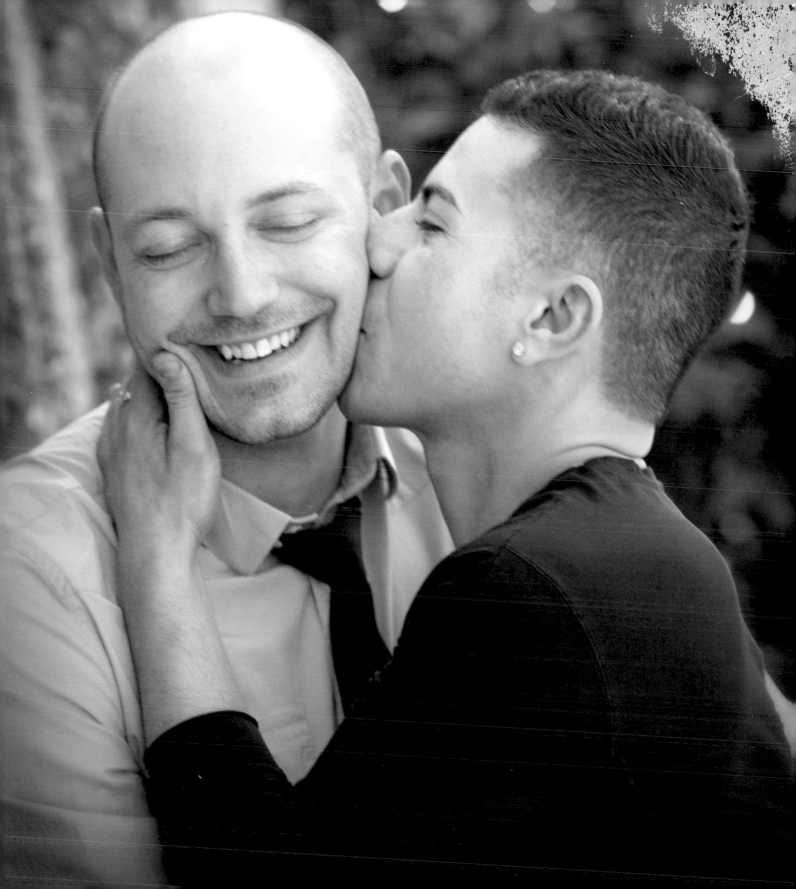

INSPIRATION GALLERY
additional engagement poses and ideas

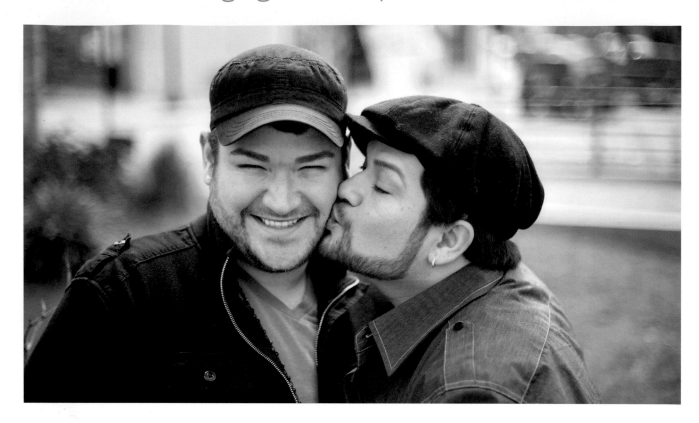

The endearing kiss. [ABOVE] This kiss is on our list because kisses capture love. Make it a kiss on the lips, a cheek, or a shoulder. Know your couple, and encourage them to keep it playful and spontaneous to show the authentic side of how they relate. This endearing kiss shares a little something about the personal side of each man without making the viewer feel like an intruder.

KATIE JANE PHOTOGRAPHY
Nikon D700, 50mm lens, ISO 250, $\frac{1}{6400}$ sec. at f/1.4

The crowd pleaser. [OPPOSITE] A common challenge for photographers who shoot engagements and weddings is meeting the expectations of both the client and the extended family. We advise a balance of style and simplicity to create a diverse offering to please everyone who reviews the album. Here, having the men facing forward with heads touching conveys a gentle yet simple connection, and the sunset provides a stylistic backdrop without upstaging the couple.

ARGUEDAS PHOTOGRAPHY
Nikon D700, 35mm lens, ISO 200, $\frac{1}{250}$ sec. at f/5.0

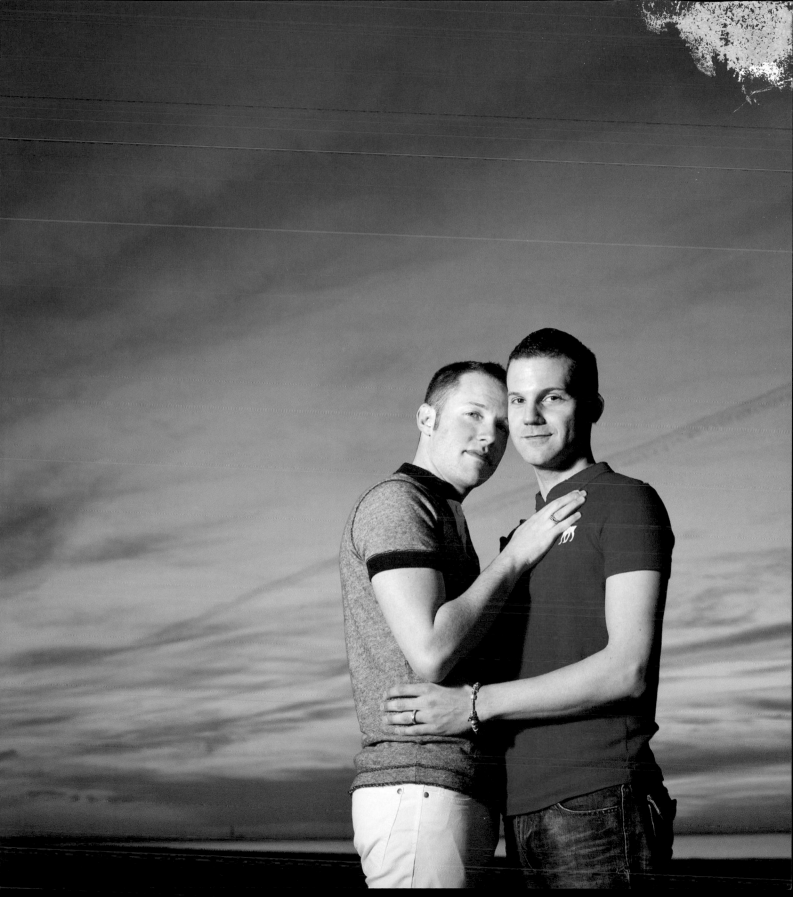

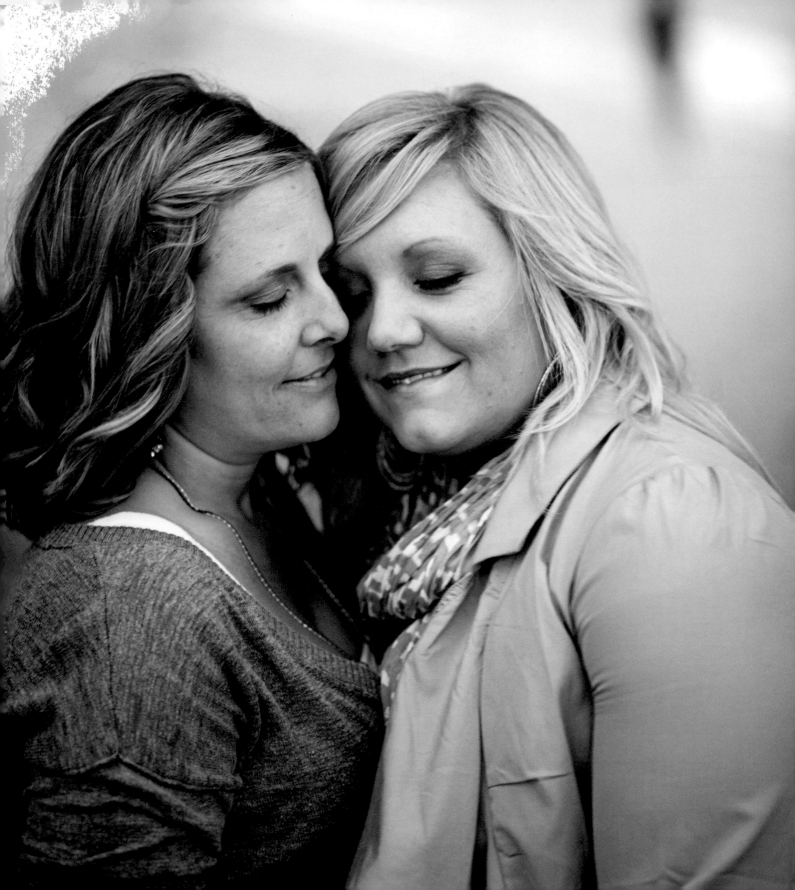

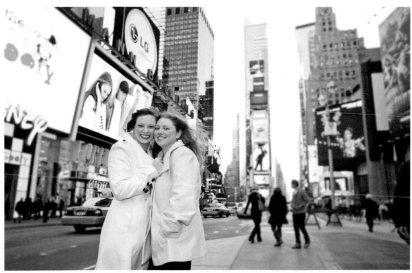

Cheek to cheek. [TOP] Use the details of the surroundings to your advantage. Even a chill in the air can be impactful and necessitate an embrace, introducing a feeling of rightness to posing cheek to cheek.

SEAN KIM PHOTOGRAPHY
Canon EOS 5D Mark II, 28mm lens, ISO 250, ¹⁄₂₀₀ sec. at f/4.0

Casual connection. [BOTTOM] Seasoned photographers will recognize this pose from the traditional wedding playbook for grooms and their best men. This casual yet connected pose generally conveys a feeling of friendship and support. When applying this to a couple, however, a direct and meaningful gaze shared by the two men is necessary to indicate a much closer, more intimate relationship.

MEREDITH HANAFI PHOTOGRAPHY
Canon EOS 5D, 50mm lens, ISO 160, ¹⁄₁₆₀ sec. at f/2.0

Nuzzle. [OPPOSITE] Nothing says love like a nuzzle. The challenge with people of the same height (common for same-sex couples) is getting them close without covering up too much of their faces. Layering their bodies is key to solving this challenge. Guidance with phrases, like "Put your shoulder into your partner's armpit," can reduce confusion so that the couple can stay in the moment and focus on their nuzzling.

CHARD PHOTOGRAPHER
Canon EOS 5D Mark II, 85mm lens, ISO 800, ¹⁄₉₀ sec. at f/1.8

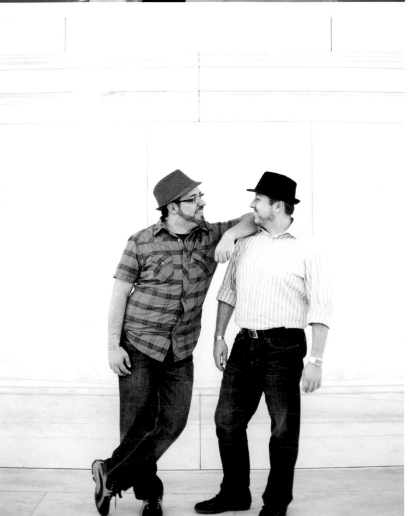

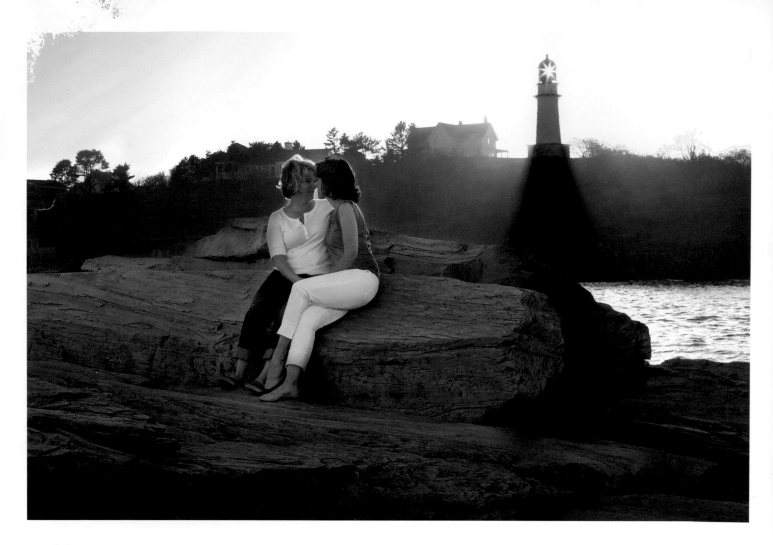

Symbolic locations. [ABOVE] Engagement sessions may take place in a location symbolic to the couple. Getting a better understanding of the reason for the choice can offer an inroad into the couple's story. Though some sessions may be timed to occur during the best light of the day, the consideration of location might also be useful in helping a couple feel more comfortable about requests for poses that involve displays of affection.

AUTHENTIC EYE PHOTOGRAPHY
Canon EOS 5D, 24–70mm lens, ISO 400, 1/250 sec. at f/13

Creative couples. [OPPOSITE] Some couples will suggest a theme to the engagement session, like a prop-filled picnic, a meaningful location, or stylized outfits. These occasions provide a wonderful opportunity for the photographer, because working with creative couples often leads to inspired images. To the extent possible, brainstorm with the couple in advance, and be prepared to introduce some ideas of your own to help them connect more authentically with the session.

AUTHENTIC EYE PHOTOGRAPHY
Canon EOS 5D, 15mm lens, ISO 200, 1/400 sec. at f/5.0

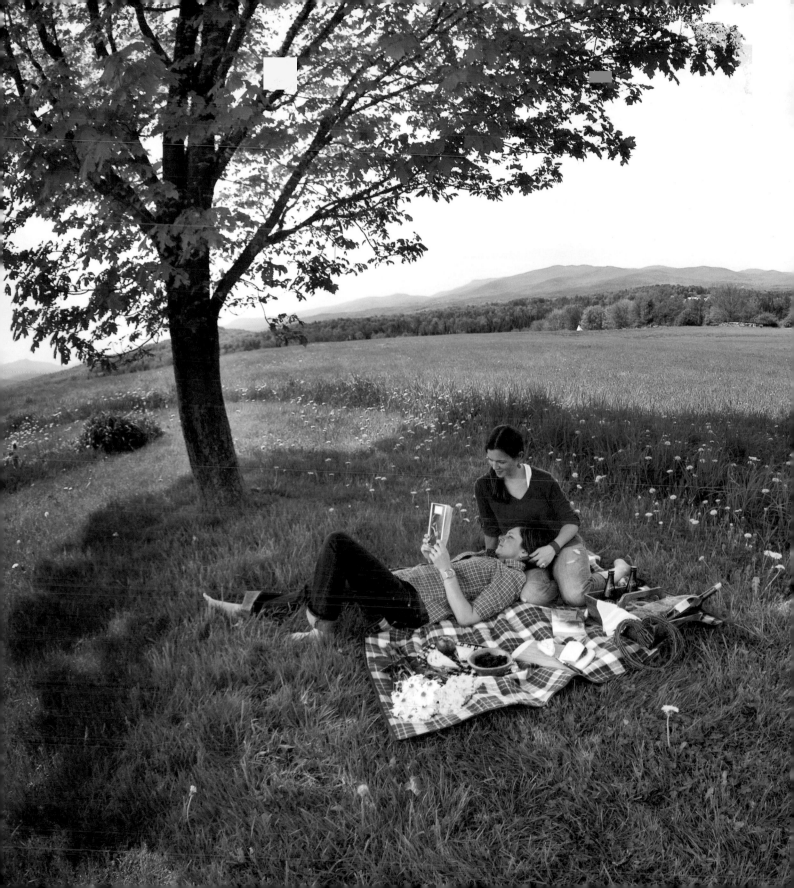

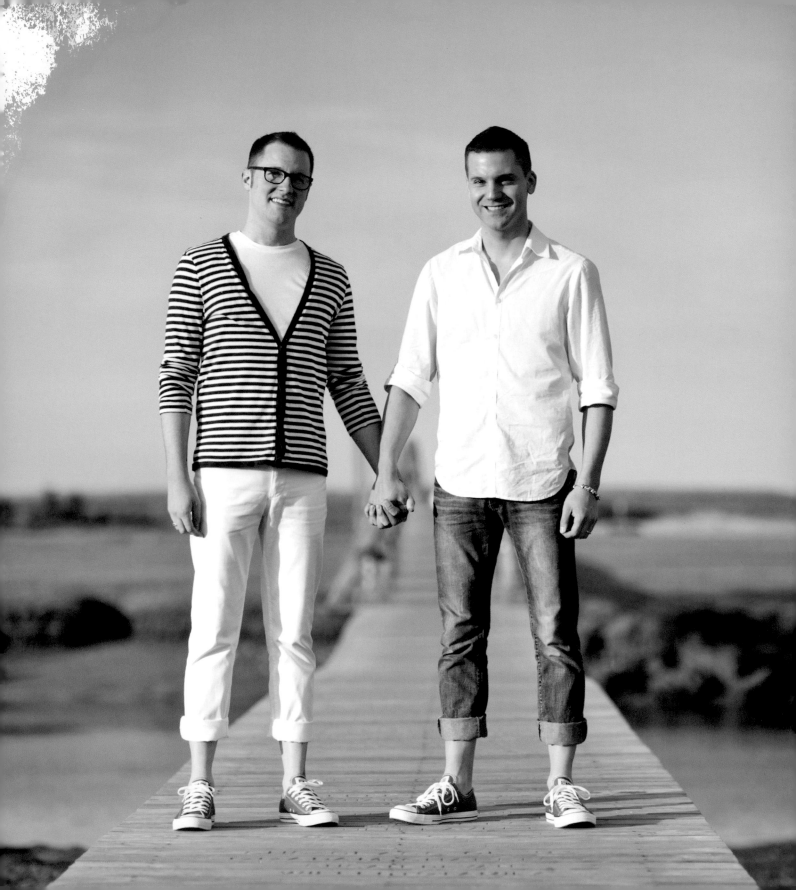

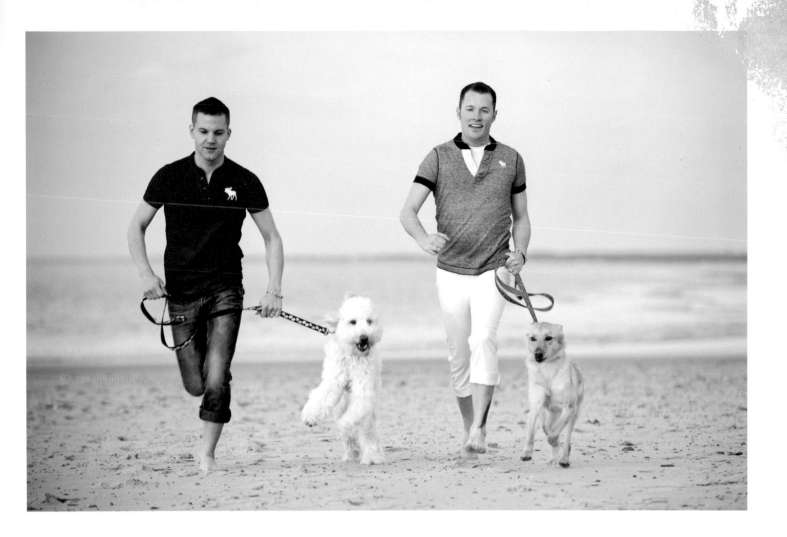

Express yourself. [OPPOSITE] Engagement sessions are likely to feature subjects who are more casually dressed. Some may have style ideas of their own, but an attire consultation for the session can be helpful. It's possible that the casual attire might help some couples to feel more comfortable than they might in outfits designed to be worn only for a special occasion (like a wedding)—and will likely offer you more clues about how those couples express themselves.

ARGUEDAS PHOTOGRAPHY
Nikon D700, 85mm lens, ISO 200, $^1/_{8000}$ sec. at f/2.0

Man's best friend. [ABOVE] Because so many same-sex couples have lived together in committed relationships before tying the knot, they might have a special four-legged friend (or two). In these cases, it's not uncommon for a favorite pet to be included in an engagement session, so consider your couple, their pet(s), and how you might include the entire "family" in the session.

ARGUEDAS PHOTOGRAPHY
Nikon D700, 70–200mm lens, ISO 200, $^1/_{200}$ sec. at f/4.0

Have pun with it! [ABOVE] It's okay to have a punch line; you just need the right punch line for the right couple. Some same-sex couples are traditional; some are not. Some will enjoy the irony of a same-sex couple repurposing traditional marriage symbols and roles; and some will not. Your job is to know where that line is for each client. Above all, remember that just because you think it's funny doesn't mean it is.

CARLY FULLER PHOTOGRAPHY
Canon EOS 5D Mark II, 70–200mm lens, ISO 200, $\frac{1}{400}$ sec. at f/2.8

A shoe-in. [OPPOSITE] Photographing a couple's hands and feet has become commonplace, but photographers often miss the opportunity to pose feet just as they would pose bodies. Great shoes alone don't make a great photo. There has to be some attitude, something unique about the way the shoes, feet, or hands are held to make the image as good as it can be.

KANDISE BROWN PHOTOGRAPHY
Canon EOS 5D, 50mm lens, ISO 160, $\frac{1}{800}$ sec. at f/2.5

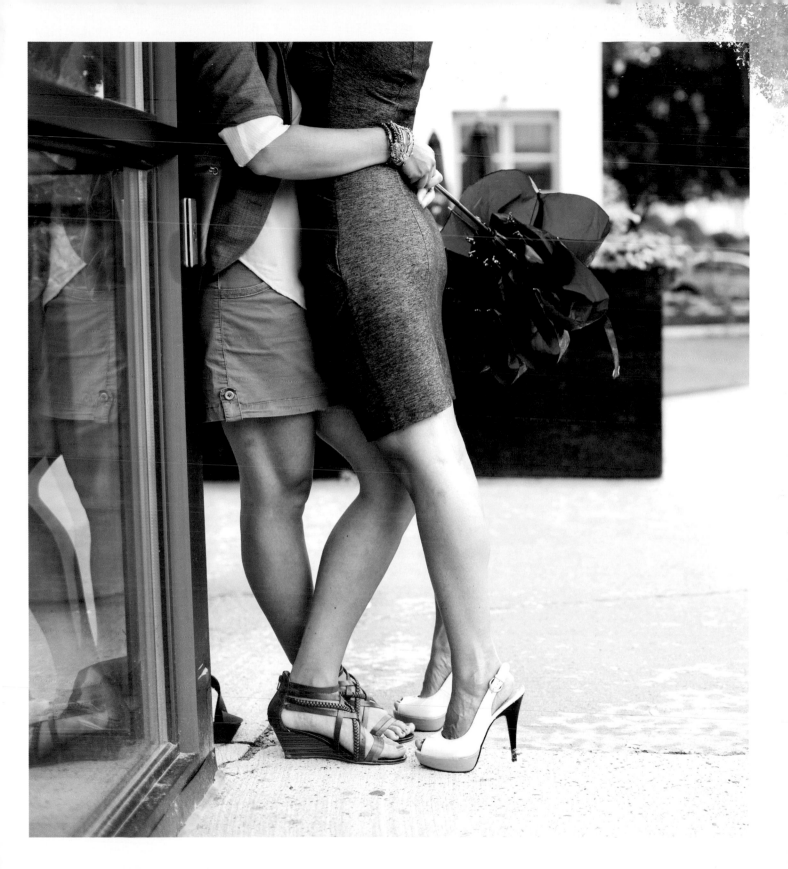

—4—
TWO
GROOMS

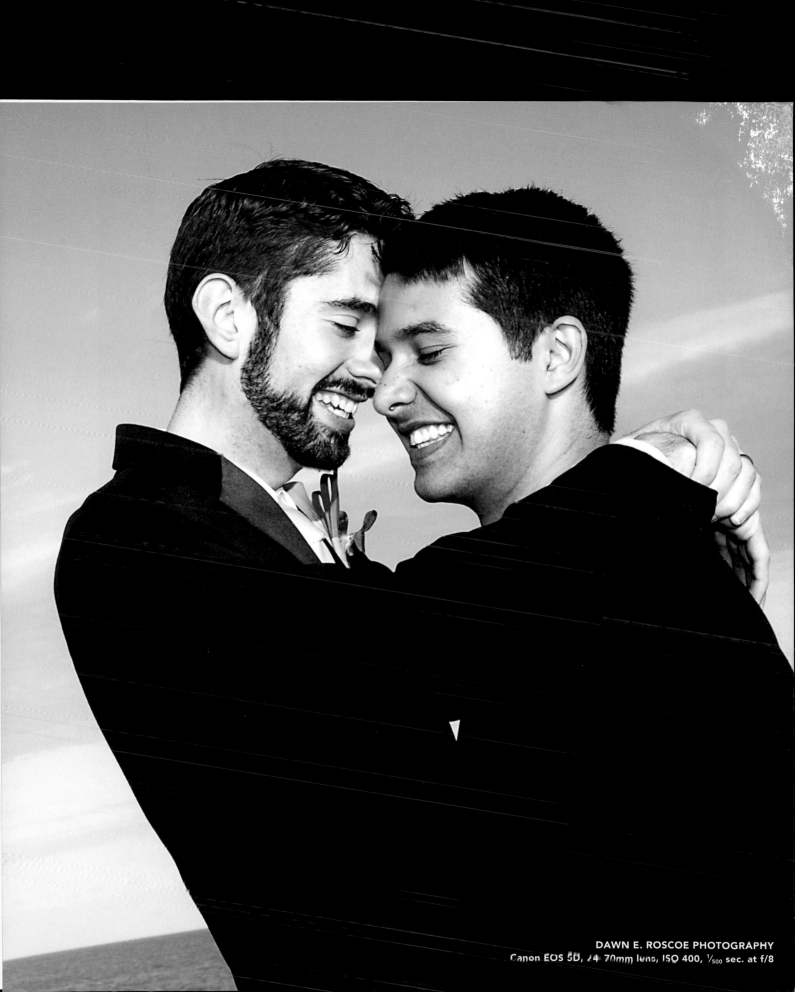

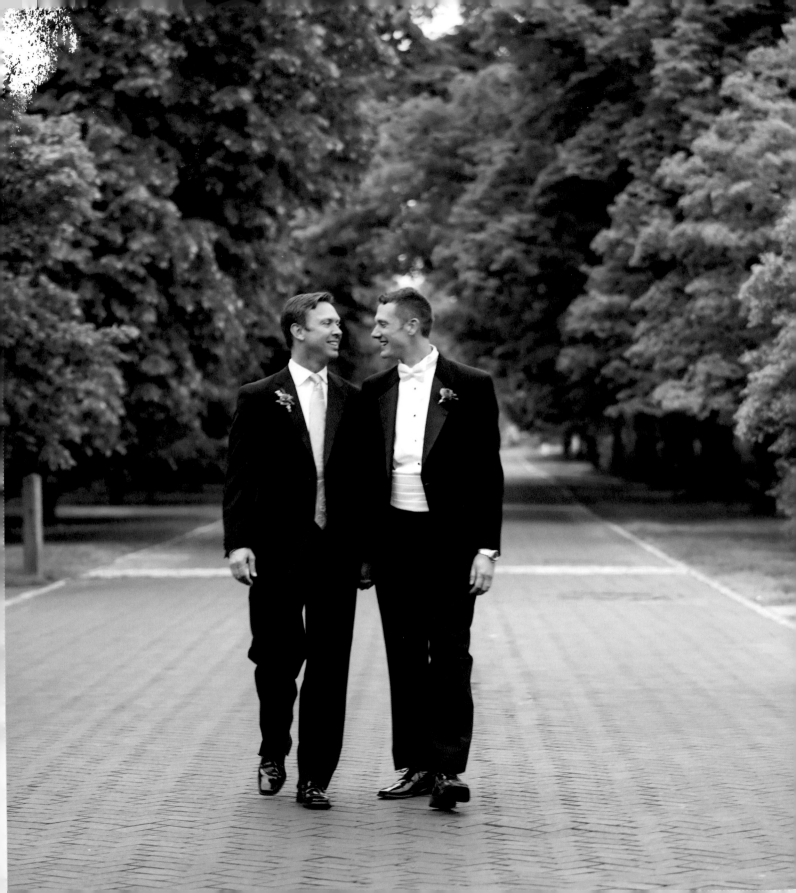

WALK WITH ME
taking a session in stride

One of the best places to start when opening a wedding portrait session with a gay couple is to ask them to hold hands and walk. The motion-oriented pose (see also "The Umbrella Connection" on page 34) is a wonderful way to help a couple relax, and the very nature of the pose communicates equality and connection.

A walking pose, generally resulting in side-by-side body positioning, can be done in many variations, including moving toward the camera, moving away from the camera, looking back over the shoulders at the camera, looking directly at the camera, and looking at each other. You can also move your own position relative to the subjects to capture the motion from a different angle. Regardless, each way the pose is adjusted communicates a different message. For instance, an image of a couple walking away from the camera often implies that something is being left behind, along with a sense of moving forward. These images can feel bittersweet in a way that is entirely appropriate for the emotional and legal transformation that takes place on a wedding day.

Oftentimes, it's hard to know what is going to work best for a couple until you try it. So encourage your clients to experiment, have fun, and take some risks. You can always edit out from the final collection of images a photograph that didn't work, but you can't edit in a photograph that was never taken.

behind the lens

By asking your grooms to "talk amongst yourselves" as they walk, you will cause their gaze—and in turn, that of the viewer—to shift inward, making the center of focus the interaction between the men. To show two men in close, direct conversation offers that extra hint that this is an intimate, loving relationship; these men are not just friends or siblings.

AUTHENTIC EYE PHOTOGRAPHY
Canon EOS 5D Mark II, 70–200mm lens, ISO 1600, $\frac{1}{100}$ sec. at f/2.8

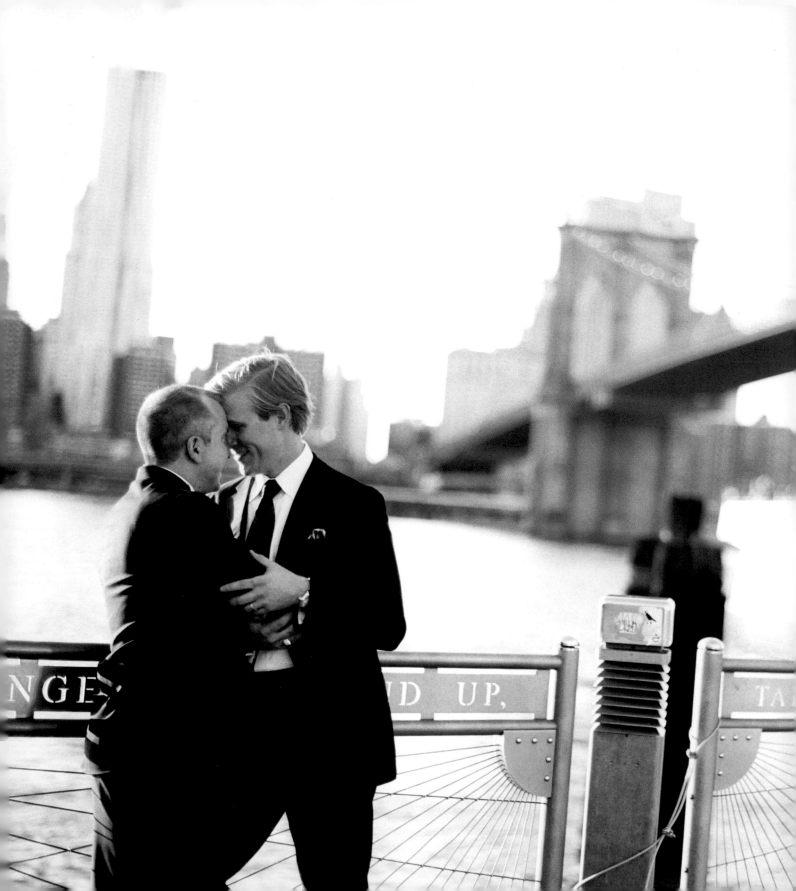

LOCATION, LOCATION, LOCATION
marriage in manhattan

behind the lens

The element of noncontrasting, dark attire necessitates special lighting or unique posing. Backlight or a rim light are excellent lighting techniques to highlight the individuals' separate bodies. But changing the couple's angle to the sun sometimes means losing the desired backdrop. Finding ways to connect the couple—with a thoughtful placement of hands, legs, or arms, while also leaving space between them—is an example of how thoughtful posing can help to communicate intimacy while avoiding ending up with overlapping bodies with no contrast to define where one person ends and the other begins.

JEN LYNNE PHOTOGRAPHY
Canon EOS-1v 35mm, 24–70mm lens,
Kodak Portra 800, $^1/_{125}$ sec. at f/2

During the planning session, talk with the couple about the personal (and perhaps even political) significance of special locations and other symbols they've chosen for the wedding and/or reception. Consider the organic ways in which these backdrops or symbols might be incorporated into photographing the event, the wedding party, or the couple.

In addition to hitting many of the marks of strong image composition—most notably with a confident use of lines directing the attention inward to the subjects—photographer Jen Badalamenti brings an added significance to this session. The grooms share a public embrace and commemorate their legal wedding day at the Brooklyn Bridge, a location that not only highlights the city in which this couple has chosen to marry legally but also echoes the historical significance and tradition of marriage in New York City.

A WHITE WEDDING
there's nothing like a
man in uniform

In this chapter, we've talked a lot about the problem of the lack of contrast resulting from two dark suits or tuxes. Not surprisingly, this same challenge occurs when both partners are wearing their dress whites. Thankfully, some of the small detailing—the buttons, the awards and decorations, the flowers—helps to anchor the eye and keep it from being lost in so much white. And the external color details provided by the porch railing and American flag help frame the couple.

Most civilian photographers would need to do a bit of extra preparation to ensure that they are ready to photograph a traditional military wedding; and this is all the more true if you are photographing a military wedding with a same-sex couple. Military tradition is deeply steeped in conventional gender roles and customs, so it is incredibly important in these cases to work with the couple before the Big Day to understand more about the military rituals and dress they'll incorporate.

behind the lens

Feeling like your photographs of two men depict the couple more like friends or siblings? Make sure that you blend in plenty of front-to-front embraces, and if you pose them side to side, make sure that you capture a series in which they layer their bodies and gaze directly into each other's eyes. Most straight men will speak to one another while standing shoulder to shoulder, looking ahead, making very little sustained eye contact. Use a more direct exchange of gazes to help make your point that this is a couple in love.

RED STONE PHOTOGRAPHY
Canon EOS 5D Mark II, 85mm lens, ISO 400, $1/1600$ sec. at f/3.2

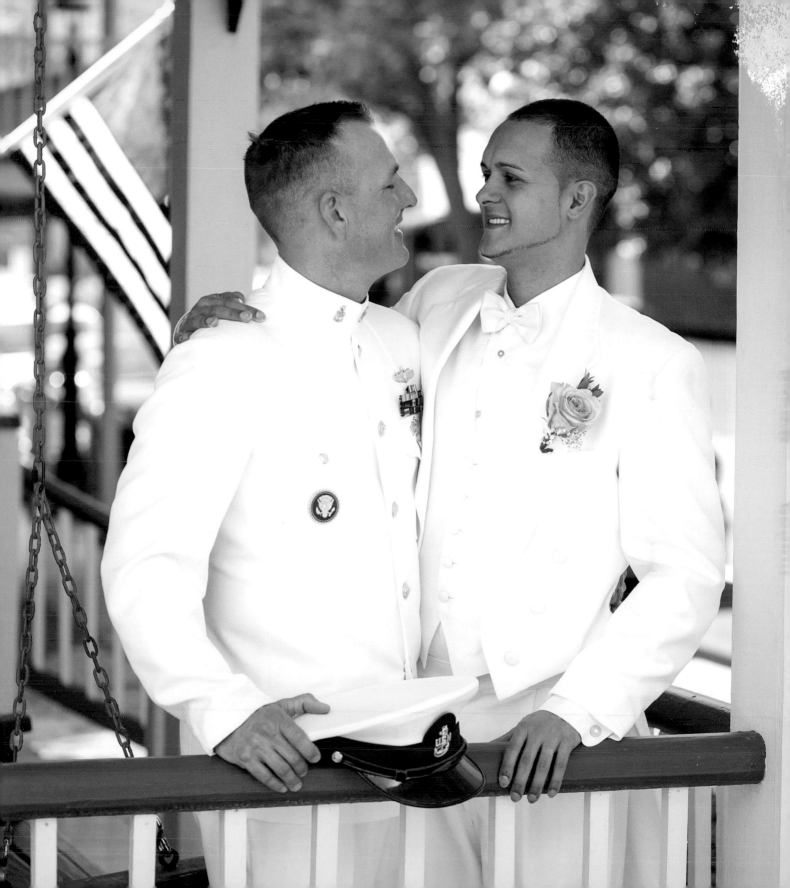

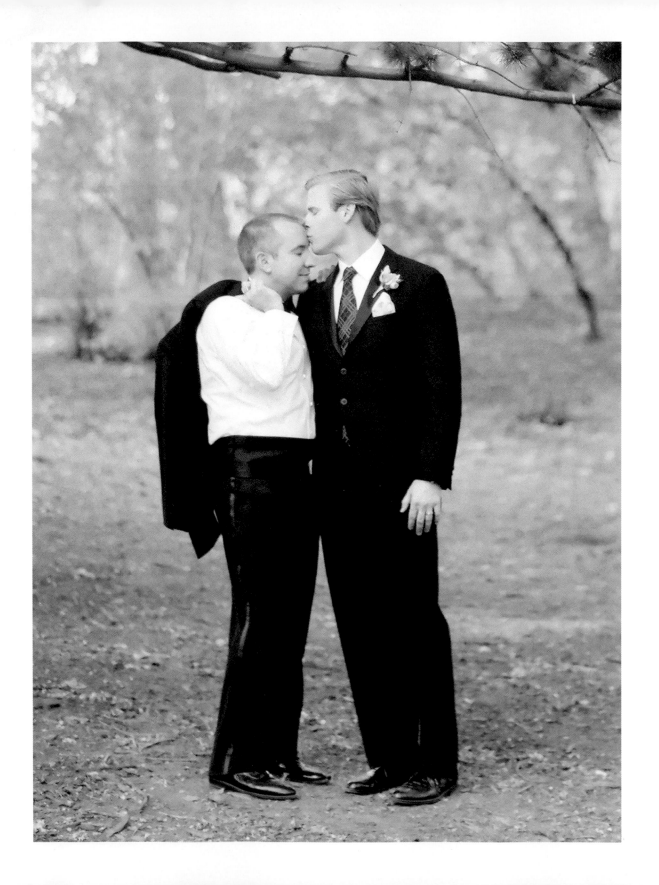

CONTRAST AND APPEAL
distinctively intertwined

When photographing two grooms in matching black attire, take extra care to ensure that they don't begin to look like a dark mass with two heads. Your goal is to photograph the male couple intimately intertwined, while maintaining a sense of individualism in the figures.

Here, the simple request to have one groom hold his jacket over his shoulder creates a nice contrast between the men, and it allows plenty of room to play up the traditional wedding colors: black and white.

If your grooms are wearing their jackets, however, try to position their bodies in a way that allows each white shirt to show underneath the black jacket. You might also consider asking one of the grooms to button his jacket and the other to leave his unbuttoned. Remember also to consider hand and feet placement, which are essential to body separation. If the feet, arms, and hands are placed a little apart, allowing light to shine through the space, this will help to accentuate the individuals' bodies.

behind the lens

Despite the fact that the majority of wedding photographers shoot digital, some, like Jennifer Badalamenti, have come back around to analog film. In this image, she exposes for the shadows, overexposing the highlights, which results in beautiful colors and skin tones. This technique does not work nearly as well in digital, because once the detail is lost in the highlights of a digital image, it's gone for good. Film is known to have greater latitude within the highlights.

JEN LYNNE PHOTOGRAPHY
Canon EOS-1v 35mm, 85mm lens, Rollei ASA 400 B&W film, $\frac{1}{60}$ sec. at f/2

IN CONFIDENCE
reflective distinction

Layering a couple with the taller of the two in the back is a long-standing and effective technique from the traditional wedding playbook. When you're posing heterosexual couples, this pose works more often than not because of the frequent height difference between men and women. Thus, for this pose to translate seamlessly to a same-sex couple, it helps to have a visible difference in height and shoulder width so that the different body types will layer naturally in this traditional pose. When these physical differences are present, there's no need to reinvent this pose.

But don't stop there! Just because a traditional pose works for a same-sex couple doesn't mean it communicates the authenticity of the relationship. Transform this pose from one that's borrowed from the heterosexual playbook into one that truly "sees" the subjects as they are—of the same gender and in love. To do so, position the couple in a visually pleasing way, and then create a "private" space and nurture a sweet moment into being for them in order to capture how the couple relates to each other.

behind the lens

Good portraiture begins in an authentic place. For a portrait to convey warmth, warmth must be present. For a portrait to convey love, a space must be created in which the love can be present. Some photographers think they can distract the viewer from a lack of authenticity by using filters or other gimmicks. To the extent possible, avoid this! An image should be wholly compelling on its own, and then enhanced by the photographer's ability to manipulate perception through a skillful use of the camera.

JIMMY HO PHOTOGRAPHY
Canon EOS 5D Mark II, 135mm lens, ISO 2500, 1/200 sec. at f/3.2

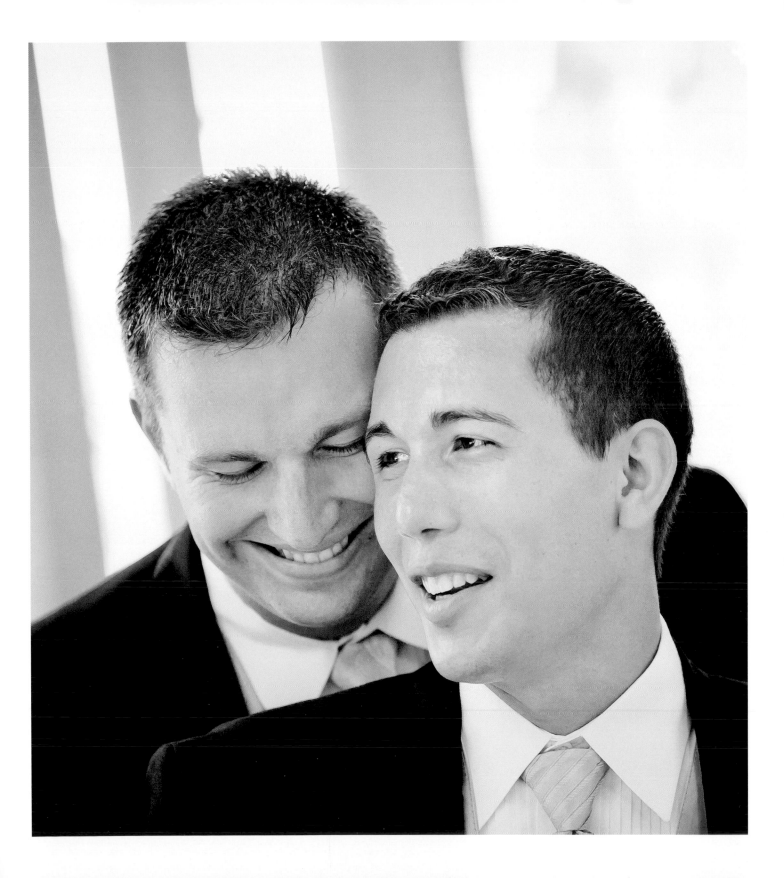

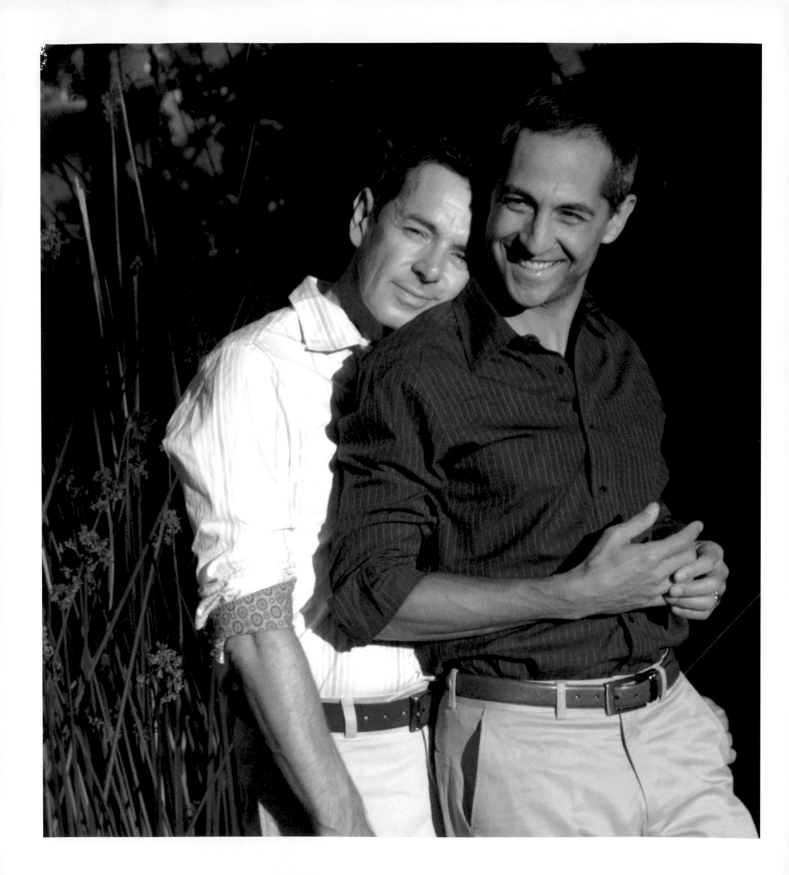

CONTENTMENT
that peaceful, easy feeling

behind the lens

Photographer Jody Webster Holman likes to photograph couples in an editorial style, using natural light whenever possible and, to the extent possible, avoiding posed situations. She loves this image because of how organic the moment was. The couple spent the day in Sonoma, venturing from one winery to another, tasting, touring, chatting, enjoying the day, and then meeting up with a friend who performed a short ceremony for them at one of the wineries. She recalls this moment of the two grooms enjoying each other near the end of the day as truly heartwarming.

HOLMAN PHOTOGRAPHY
Nikon D100, 72mm lens, ISO 100,
$\frac{1}{350}$ sec. at f/8.0

This casual pose of contentment offers us a new example of connection and "couple ness" without relying on the traditional playbook. In fact, this pose is one that would likely work well for most same-sex couples and some opposite-sex couples.

Photographing couples who are the same or similar height and body type can, at times, be challenging. This unique pose allows for two men (or two women) of the same height to layer their bodies without blocking each other. Further, the act of leaning upon each other adds a nice touch of interdependence.

Consider also the finish. The focal point (or points) where the individuals' eyes are looking and what expressions they reveal will define the message of the final image for the viewer. If the couple is looking at something outside the frame, for example, a new message or an element of mystery or action is introduced. Further, if they're looking at the same thing, an element of mutuality is introduced. In the case of the latter, direct them to a specific object that they can both focus on, because a slight variance in the focal point can be distracting.

THE KISS
standing toe to tippy-toe

Photographers look for a moment that tells a story greater than what we see in the frame, a narrative that plays off of the visual cues in the photograph. Photographer Jeremy Fraser captures the feet of these grooms in a way that communicates as much or more about the individuality of each man than a full-body portrait might. Taken from this captivating perspective, Fraser directs the viewer to recognize that, from the variation in their polka-dotted socks to the color of their trousers and the size of their shoes, these two men have a different, yet complementary, means of expression.

The pose offers an added measure of delight because of its ironic twist on the foundations of wedding photography, where the smaller woman must reach up on tiptoe to lock lips with her beloved. Thanks to our understanding of the whole of this classic pose, we are able, from only the parts given to us here, to surmise that these two men are very much connected—and romantically so.

behind the lens

Creating a shallow depth of field is often desirable, because it holds attention to the focus point. In this pose, a shallow depth of field works—and works beautifully—because the men's feet are on the same horizontal plane. But note that when there is more than one subject in the photo, a small aperture may leave one of them unintentionally and undesirably out of focus.

CEAN ONE STUDIOS
Canon EOS 1Ds Mark III, 50mm lens, ISO 250, $\frac{1}{5000}$ sec. at f/1.2

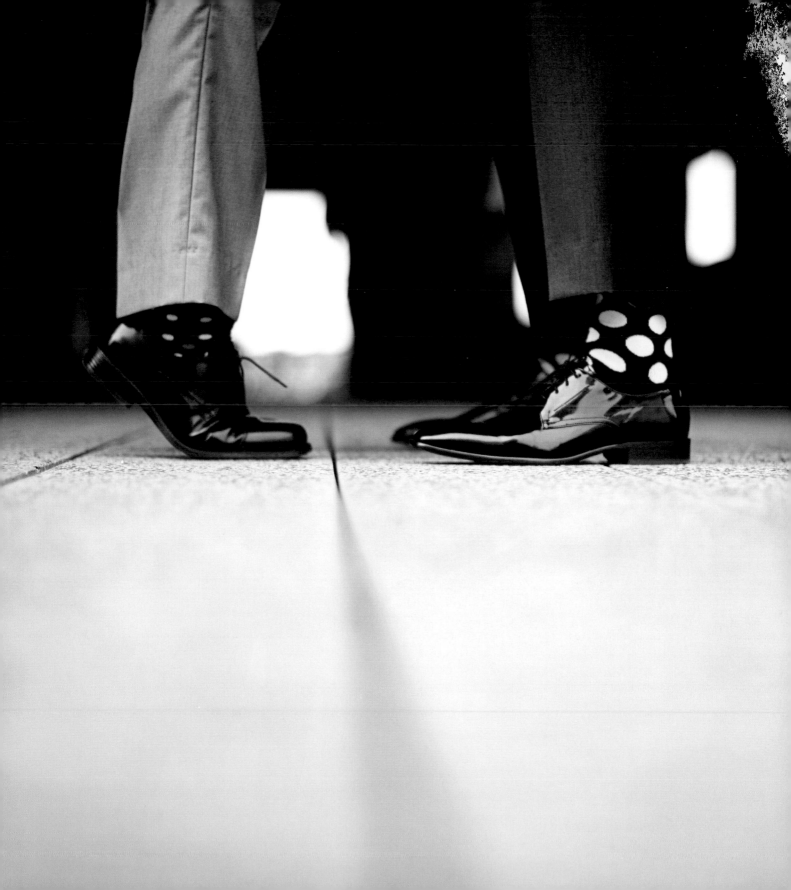

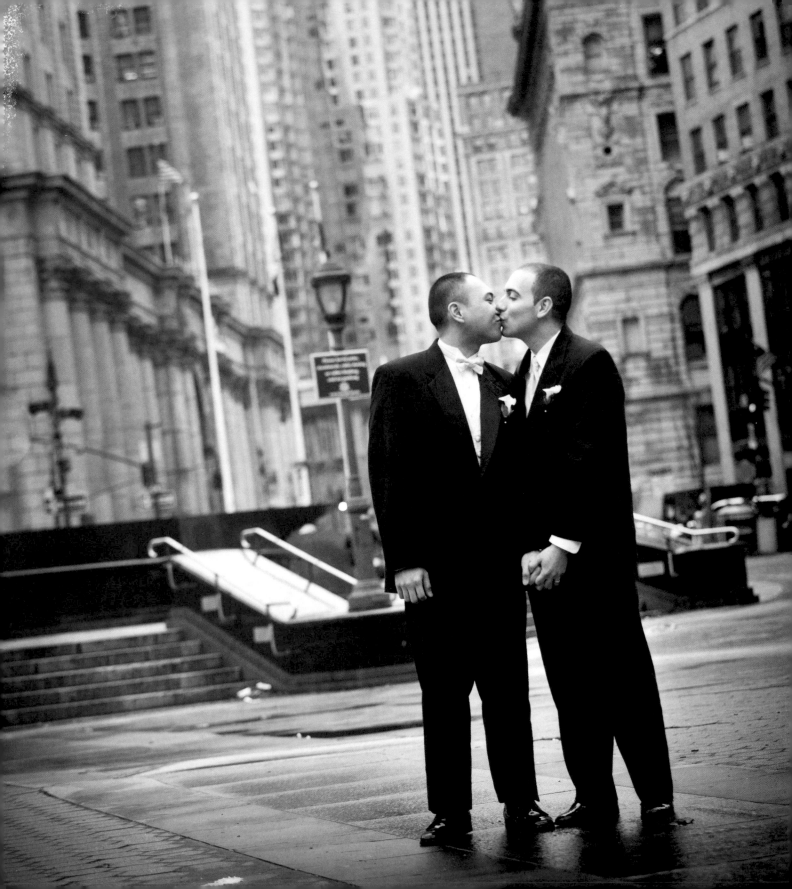

PUBLIC DISPLAYS OF AFFECTION
making a statement

Wedding couples are often photographed kissing in public. And when wedding photographers ask opposite-sex couples to kiss each other, they don't think twice about it. They have no reason to; most straight couples hold hands or kiss each other in public spontaneously, comfortably, and without self-consciousness. For same-sex couples, however, one must not overlook the cultural experience of identifying with an often invisible and marginalized group or the experiences associated with coming out. Consider the situation and the couple thoughtfully before asking a couple to embrace in public.

For many, this is an issue not just of comfort but also of safety. This is especially true for couples who came out a time when identifying as gay or lesbian was less accepted. And this is even truer for gay men, who often encounter more overt homophobia than lesbian women. Finally, this need for increased sensitivity remains true for any LGBTQ individual who was raised in a culture where identifying as something other than heterosexual or heteronormative remains a disenfranchising experience.

That said, and presuming that the stage is set correctly, even those couples normally averse to public displays of affection may be game for this pose on their wedding days. It will likely convey the love and connection it intends to symbolize, but with two grooms—or two brides for that matter—this pose takes on a whole new dimension. A same-sex kiss shared in a public space remains inherently powerful and meaningful.

behind the lens

Our first priority with same-sex couples must be to ensure comfort and safety. Even couples who may be comfortable kissing in public may find themselves uncomfortable doing so in front of the camera. The camera (and a photographer shouting out instructions) can draw unanticipated attention to a couple. For any couple new to this experience, it is the photographer's responsibility to be prepared to switch locations and adjust the session as needed.

LESLIE BARBARO PHOTOGRAPHY
Canon EOS 5D Mark II, 70–200mm lens, ISO 800, $\frac{1}{800}$ sec. at f/3.2

AN INTIMATE MOMENT
creating space

Do you have a couple that is concerned about displaying affection in public? Look for a small area of seclusion, and carve out a quiet space in the bustle of a busy wedding day. It might not be the go-to location most commonly used by photographers at that venue. Perhaps it is off the beaten path. Or perhaps it takes place while the couple is getting ready together (if they are getting ready together).

If this private moment is deliberately posed, the traditional front-to-back layered pose, coupled with a nuzzle, works very well with most couples. We advise posing based on body type and not on gender expression or attire; thus, it's often the person who is taller or broader (rather than being defined as the one who is wearing the pants) serving as the foundation of the pose to offer balance.

When working with a couple in suits, you'll have the advantage of a wider variety of pose options, because you won't have to restrict your pose requests to protect a fluffy white gown (or two!) that you dare not wrinkle or get dirty. Thus, couples dressed in suits or pants are often amenable to sitting or squatting to gain a more flattering angle or background.

behind the lens

When striving to take your photographs to the next level, be your best critic in real time. If you are using a digital camera, take a few stills, and then ask the couple not to move or to talk amongst themselves while you look at the image on the LCD on the back of the camera. Consider all that is right in the image, but then look more deeply at the pose for what is wrong and offer additional incremental instructions to the couple from there to take the image to the next level.

AUTHENTIC EYE PHOTOGRAPHY
Canon EOS 5D Mark II, 70–200mm lens, ISO 800, $1/800$ sec. at f/3.2

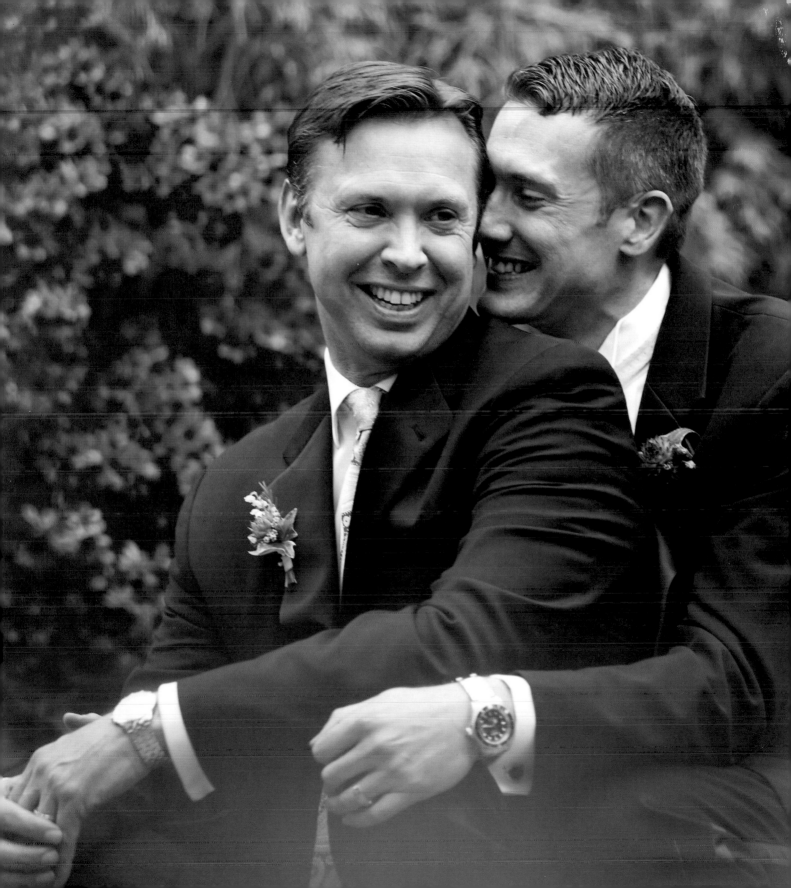

INSPIRATION GALLERY
additional poses and ideas for two grooms

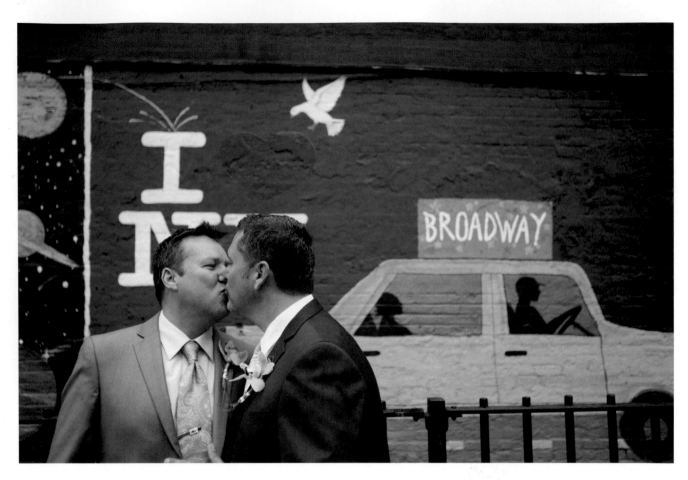

Pucker up. [ABOVE] An image of a couple kissing may be a requisite album image in the world of wedding photography, but it's important to know your clients' comfort level with public and private displays of affection before you start photographing. And this is especially true for two men. Ask; never assume.

CEAN ONE STUDIOS
Canon EOS 1Ds Mark III, 35mm lens, ISO 100, 1/250 sec. at f/2.8

Tender embrace. [OPPOSITE] A thoughtfully posed embrace with balance and contrast provides the perfect setup for a gentle kiss to create a truly tender moment.

HUDSON RIVER PHOTOGRAPHER
Canon EOS 5D Mark III, 85mm lens, ISO 800, 1/640 sec. at f/3.2

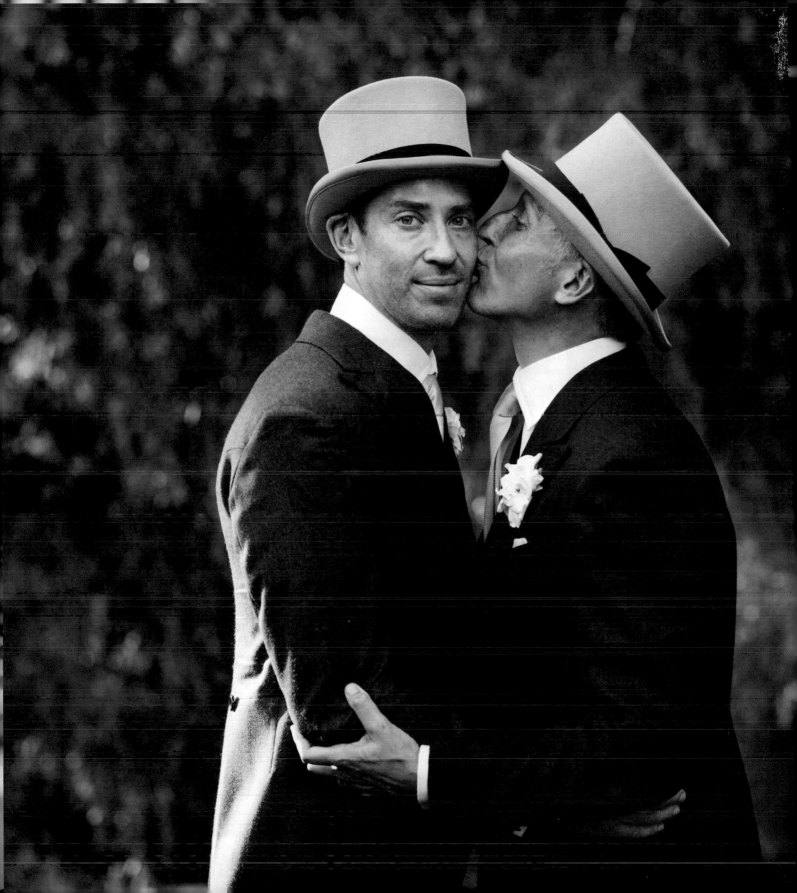

Get the details. In an opposite-sex wedding, the groom's attire generally takes the backseat. In a wedding with two grooms, opportunities to showcase the details of the men's attire abound. Give it the royal treatment, but make sure you showcase the attire details in a way that references both grooms. An isolated cufflink, ring, or pair of men's shoes could be at any wedding; these images shine because it's clear that those items belong to *two* grooms.

[ABOVE] ARIELLE DONESON PHOTOGRAPHY
Canon EOS 5D Mark II, 24–70mm lens, ISO 1000, 1/250 sec. at f/2.8

[LEFT] CHRIS LEARY PHOTOGRAPHY
Canon EOS 5D Mark III, 24–70mm lens, ISO 640, 1/250 sec. at f/9.0

[OPPOSITE] LESLIE BARBARO PHOTOGRAPHY
Canon EOS 5D Mark II, 70–200mm lens, ISO 400, 1/100 sec. at f/4.0

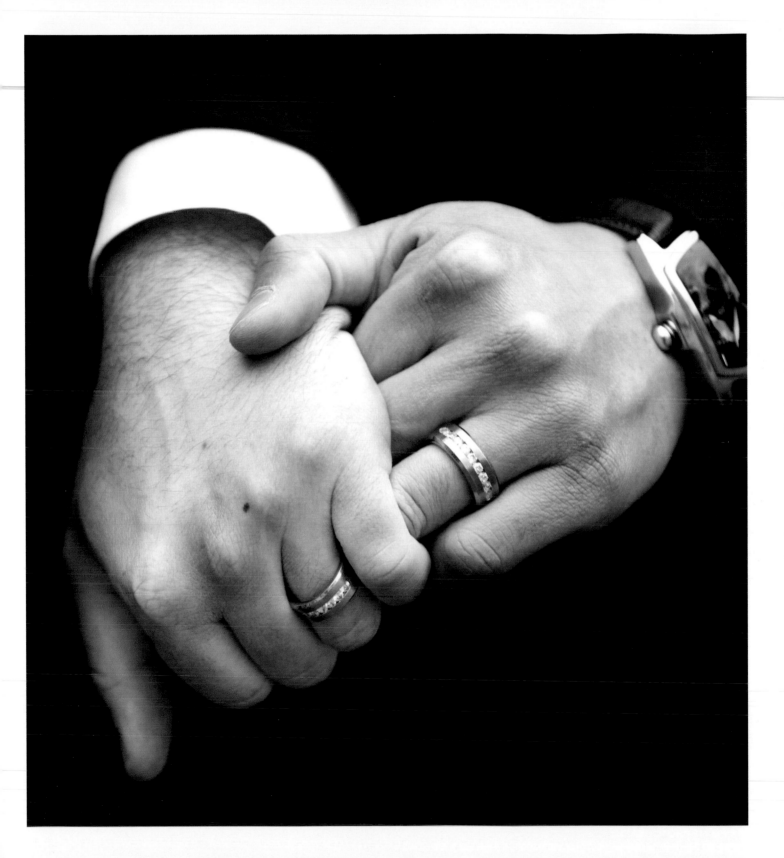

5

TWO BRIDES

I N AN INDUSTRY LONG DOMINATED BY
All Things Bride, one might think that the
details surrounding a lesbian wedding would
be, well, a piece of cake. Just double everything
and call it a day, right? Wrong. Two brides in two
gowns who embrace the traditional rituals might
give you a long list of standard wedding images
and opportunities for iconic moments, but they'll
also give you some challenges, like addressing
color contrast, posing, and logistics, among other
potential cultural differences.

The real shift in thinking about photographing
two brides is in understanding that not all couples
want a traditional wedding, and even if they
do, seemingly limitless wedding attire choices
for women add a level of nuance and decision
making not generally needed when working
with two grooms. Lesbian weddings might
feature two brides in gowns, one bride in a dress
and one in pants, or two brides in pants. And
though following the traditional rules of "who
wears the pants in the family" might seem to
make posing two women based on what they're
wearing a simple proposition, it's actually a bit
more complicated. Poses that work for a straight
couple (pants and dress) or male couple (pants
and pants) may not translate to a female couple
because of physical attributes, gender expression,
and/or identity.

For those brides who do like to go the
traditional route and want a wedding day replete
with the traditional bridal trimmings, including
two wedding gowns (especially those with trains
and full skirts), you'll have some interesting

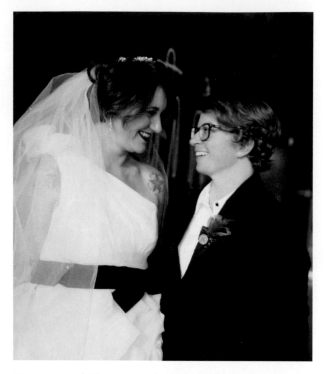

Karyne and Shvonne's height difference and
attire choices need to be considered when
posing them in ways that reflect authentically
how they identify and relate to each other.

WEDDINGS TO THE PEOPLE
Canon EOS 5D Mark II, 24–70mm lens,
ISO 2000, $\frac{1}{40}$ sec. at f/2.8

decisions to make about how to pose the two
women in closer proximity than all of that fabric
might allow. The choice to follow a traditional
path (as we discuss at greater length in chapter 7)
also leads to potential wedding-day challenges in
which a photographer might find herself needing
to be in two different places at the same time
in order to capture the spotlight moments of a

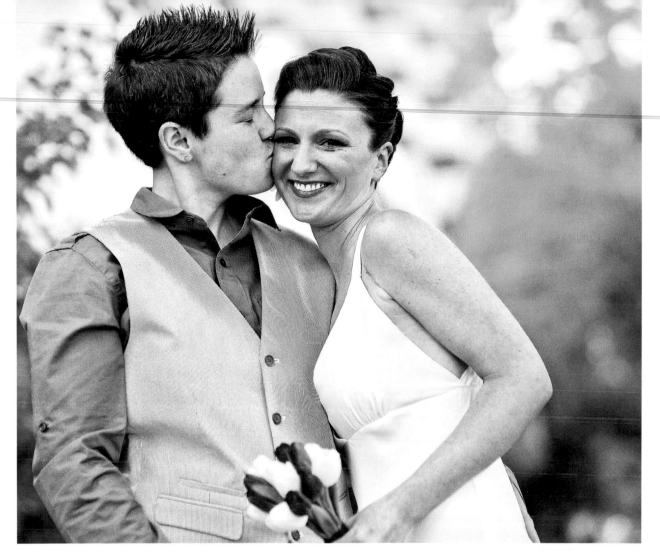

Becca and Laura share a sweet smooch in front of the Warwick Hotel in
Denver, Colorado, on their wedding day.

ANDREA FLANAGAN PHOTOGRAPHY
Nikon D700, 70–200mm lens, ISO 800, 1/250 sec. at f/2.8

wedding day for each bride (should they both desire them).

Some lesbian couples might choose an attire combination featuring a dress and pants. Some of these couples might identify in a traditional butch-femme or other genderqueer relationship, and some just might be wearing whatever outfits feel right at the time. Because the ways in which women express their feminine (and, yes, masculine) traits can be more complex than meets the eye, you must tread very carefully and avoid making assumptions about what a bride's

attire says about her gender expression. Resist the urge to automatically apply the male-female poses from the traditional wedding photography playbook to these couples. Sometimes it works; sometimes it doesn't. Get to know the couple. Be thoughtful. Then pose them.

Regardless of what the couple is wearing, it will be important to think about how you pose two women when directing hand placement and when posing them front to front. A man's chest is considered a neutral space for the woman's hand when posing a bride and groom front to front; but a more suggestive, unintended message might result if you are asking one bride to place her hand on her bride's chest. But, again, this will depend on the couple, the positioning, and the presentation of the pair. Similarly, posing two women front to front in a tight embrace might need some additional finesse for the most comfortable and visually appealing fit.

Finally, just as with two grooms, it's important to pay attention to a few other differences when photographing two women. Physically speaking, two dark suits or two white dresses can pose a challenge with contrast; and similar height, shoulder width, and physical shape can mean layering challenges when it comes to posing. Additionally, avoid making assumptions about family participation and the couple's comfort with PDA, while also considering the ages of the couple and the length of time they've been together.

After decades of the wedding industry claiming that the only client who matters is the bride, a photographer might feel like a kid in a candy store with two brides and one wedding. At a wedding with two brides, the bridal bias is not bias at all. But it does bring with it as many challenges as it does opportunities. Know your brides, and their place in the bridal spectrum, and your rapport will serve you well!

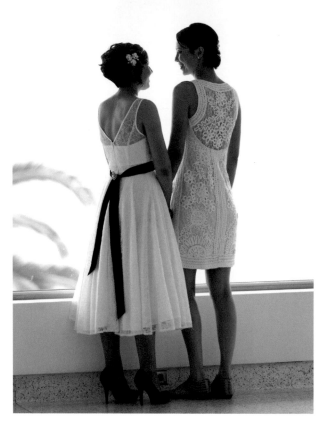

The framing of this image allows us to peek in on a private moment between the brides, while also allowing us to get a longer look at the details of their dresses.

ARS MAGNA STUDIO
Canon EOS 7D, 135mm lens, ISO 1600, $\frac{1}{1600}$ sec. at f/2.0

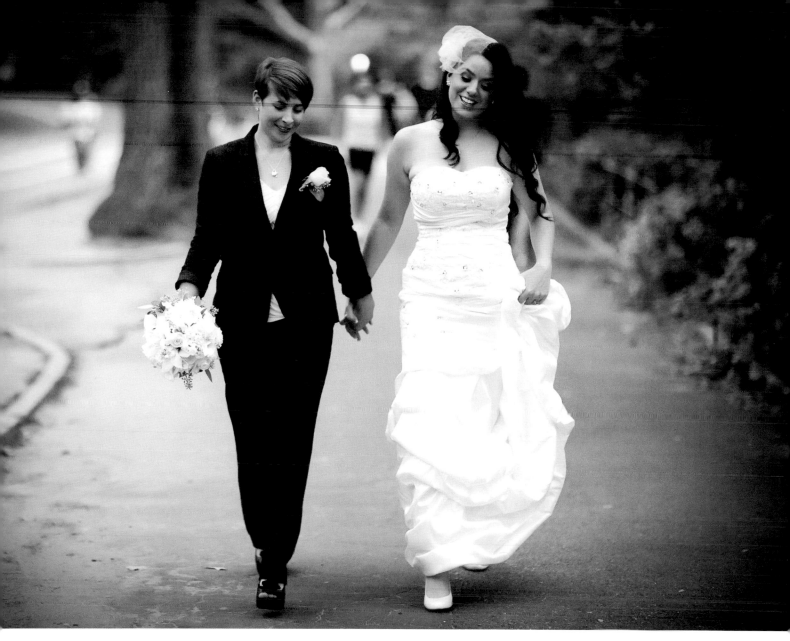

Kim and Anne of Sacramento, California, eloped to New York City and elected to have a simple session of portraits in Central Park. This action pose helps to draw out their personalities and enjoyment of the day, and the extra detail of having the bride in pants carry the bouquet offers a touch of playfulness and gallantry.

SARAH TEW PHOTOGRAPHY
Canon EOS 5D Mark II, 85mm lens, ISO 2500, $\frac{1}{6400}$ sec. at f/1.6

CONTRAST AND APPEAL, TAKE TWO
a canopy of color

If you have a lesbian wedding for which both partners want to wear white dresses, show them this photo. There's no better example than this to explain the benefit of choosing complementary attire that offers subtle, yet important, contrast. To ask for contrast doesn't mean that a couple needs to re-create the traditional black-and-white color scheme. A female couple can express their femininity and individuality in a wide range of colors, whether with the attire foundation or the details.

When photographing two brides in white in an outdoor, direct-sun situation, your best choice is to find open shade for your portraits. White reflects light so well that there will be a large spectrum between the correct exposure for the white versus the darker exposure for skin tones and background. In the end, white is very likely to be overexposed. Open shade, like that cast by the thick crowns of blooming trees, is brighter than shade cast by buildings, so it narrows that difference between light and dark.

behind the lens

To get the motion desired in this walking shot, as well as the right lighting scenario, may take a couple of tries. Start with the couple a few steps back from the ideal lighting location, and have them walk forward. Encourage them to look at each other (without being afraid to keep one eye on what's in front of them!), but do tell them that, as soon as they get into a shaded area, you want them to make eye contact or be otherwise expressive.

ANDI GRANT PHOTOGRAPHY
Canon EOS 5D Mark II, 70–200mm lens, ISO 125, $\frac{1}{320}$ sec. at f/3.5

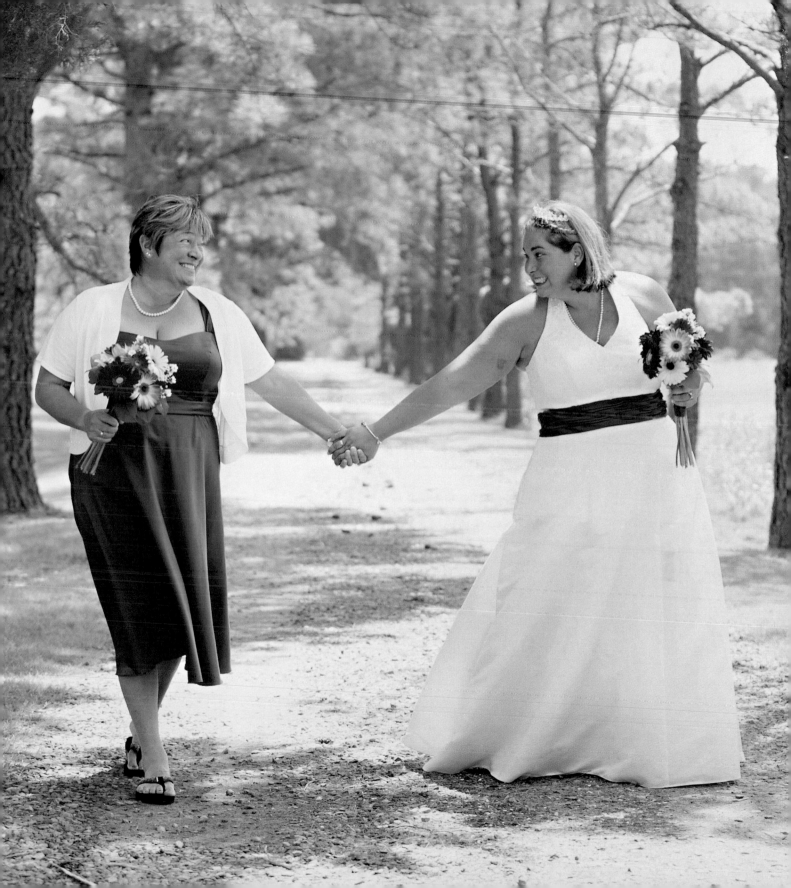

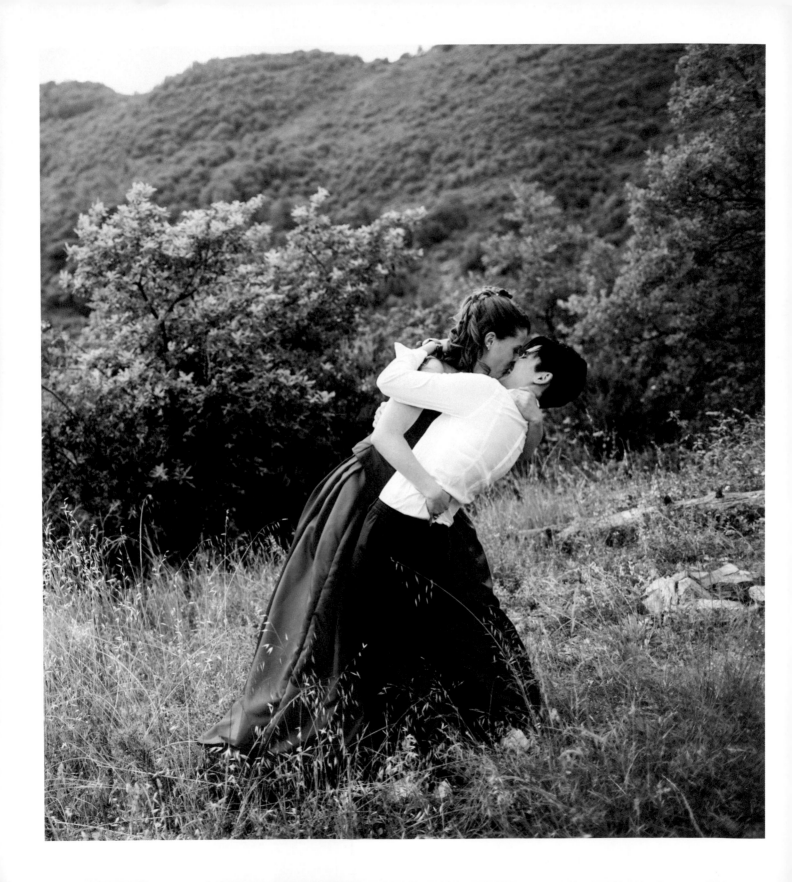

GENDER BENDER
a little dip'll do ya

There is so much play on tradition in this image, from a red wedding dress that one might expect to be white, to a second bride in black pants and white shirt, to a formally outfitted couple in a natural landscape where a woman in a dress is dipping a woman in pants. The photo has much to say about this couple: their taste, their playfulness, and their strength as a couple.

Generally speaking, dipping shots should be attempted with care, especially if neither partner has a clear strength advantage relative to the other. No one wants to be the reason a dip collapses! This photo, however, contains a beautifully designed trick to prevent a dip disaster. Look closely at the wide stance taken by the woman in the red dress for balance and leverage. It's a pose that works because of the delight we experience in seeing a bride in a gown dip a bride in pants, but also because the gown hides an otherwise wide awkward stance essential to making this pose work.

behind the lens

There are many things a woman can mean by the simple act of wearing pants. Avoid jumping to quick conclusions, and don't assume anything about the attire a couple wears and what it says about each person's gender identity or sexual orientation. Get to know the couple first, and then begin to apply a few pose adjustments to bring a representation to those traits you have come to know.

JULIAN KANZ PHOTOGRAPHY
Canon EOS 5D Mark II, 35mm lens, ISO 100,
$1/2000$ **sec. at f/2.0**

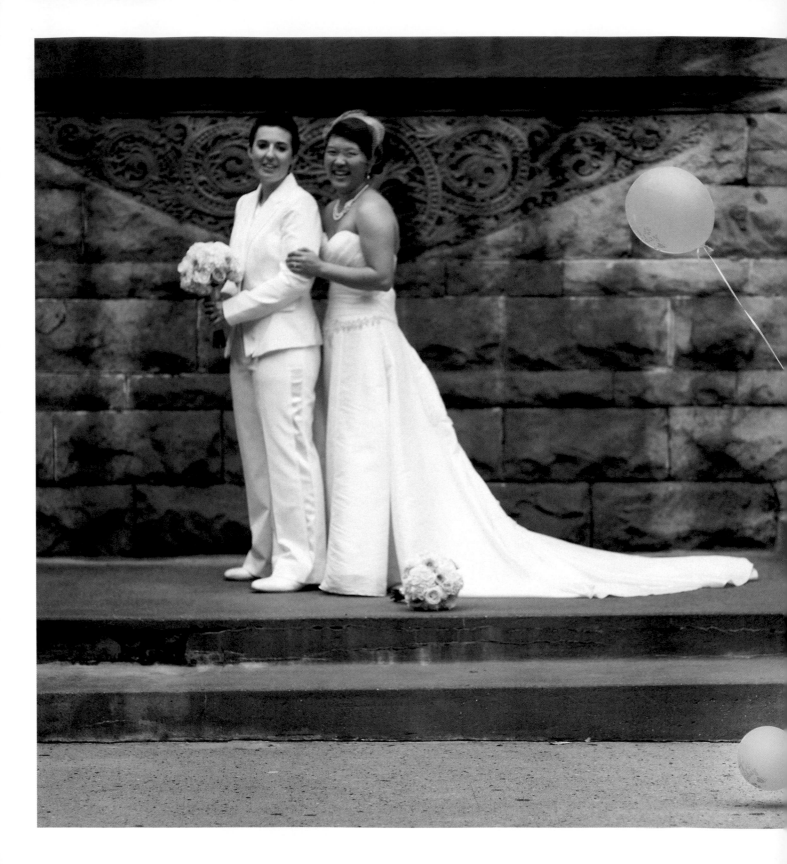

WITNESS
in the eyes of a child

Because the sight of two women in wedding attire is still a relatively new thing, onlookers may do a double take when they encounter a wedding session with two brides. These double takes can be out of surprise, confusion, support, and, in some cases, disapproval. A photographer working with same-sex couples should be prepared for this at all times and ready to react to shield the couple if needed or to capture the evolving wedding story as unexpected witnesses pay respects.

There's no posing tip, style, or camera setting that can explain how to capture a moment like the one featured here. To do this, you'll need to rely on your intuitive skills to sense what is going on around the camera—and then react, frame, and focus on the moment in a fraction of a second. This is wedding photojournalism at its finest. Here, the subject is no longer the thoughtfully and creatively posed brides or the creative solution to the conundrum of what to do with two bouquets. It is the moment of one young girl discovering and regarding an unexpected twist—two brides in a wedding portrait in the making.

behind the lens

Some wedding photographers are true journalists, capturing the wedding as an unfolding story. Others influence the couple and some of the rituals with poses, verbal requests, and their outgoing personalities. In choosing a style, a couple needs to understand the end result and the process required. For those couples who prefer a photojournalistic style but would also like to have more posed portraits, "day after" sessions are a perfect way to focus on styled portraits without interfering with a busy wedding-day schedule.

HUDSON RIVER PHOTOGRAPHER
Canon EOS 5D Mark II, 135mm lens, ISO 250, $\frac{1}{640}$ sec. at f/2.0

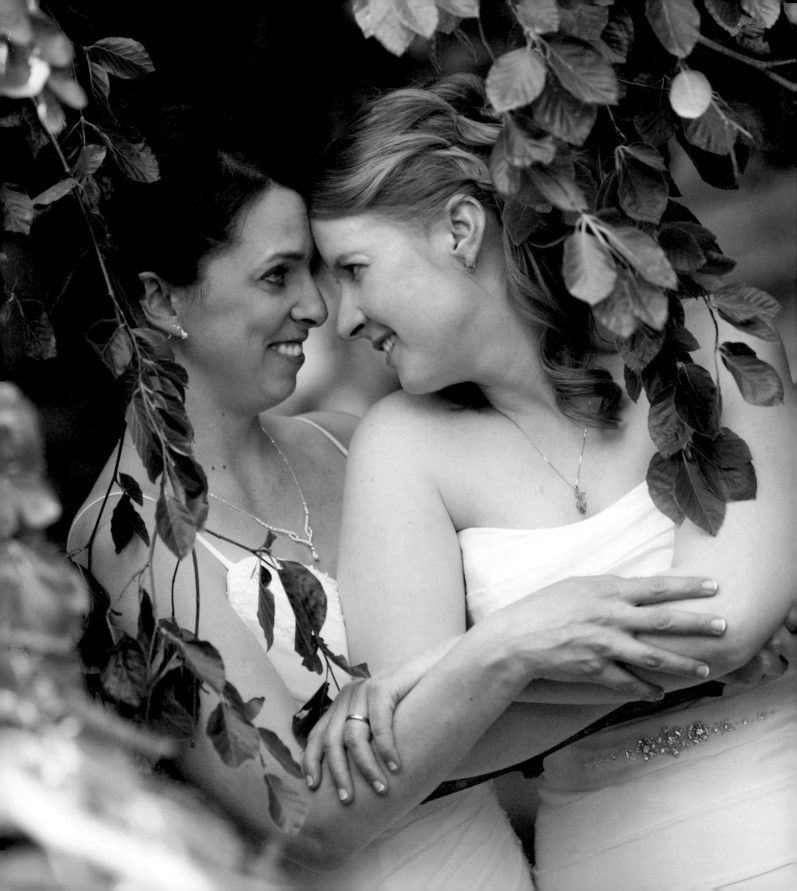

ENTWINED
naturally bracing

These brides are of a similar height, in similar attire. The resulting challenge is to fit them together in an overlapping, connected fashion without concealing either bride behind the other. Photographer Allana Taranto makes this look easy here by posing one bride "square" to the camera and asking the other to turn toward her wife and tuck her shoulder behind her. The final touch of having them gently rest their foreheads together and intertwine their arms solidifies the message of connectedness.

Much of the strength of this image also comes from the photographer's choice of setting. By or under trees is an obvious place to pose a couple, because trees offer flattering and even light, and green leaves introduce colorful contrast and symmetrical framing. But what about those pesky leafless branches? Leafless branches and, worse yet, tree trunks can sometimes be so solid, straight, and bulky that they distract from the portrait. That is, unless you can work a little magic to turn a branch into a visual element rather than an obstacle. Here, Taranto accomplishes this by having the couple lean on the branch as if it were a railing, which accomplishes two things: it covers the bare branch, and it provides a beautiful framing element for the pose.

behind the lens

Photographer Allana Taranto explained that, during this ceremony in Boston's Public Garden, people gathered around to watch the brides exchange their vows as the officiant began to speak. When the officiant asked the congregants (the family gathered in the small circle around the brides) to offer their love and support by answering "we do," the resounding chorus of "we do" came from everyone who had gathered, not just the family. Her brides, Tracy and Sara, were amazed that they received all positive attention from the public (the tourists on the duck tours, passersby, and so on), which, they explained, validated their choice to come to Boston to get married.

ARS MAGNA STUDIO
Canon EOS 5D Mark II, 135mm lens, ISO 100, $\frac{1}{160}$ sec. at f/3.2

GENDER BENDER, TAKE TWO
reaction

If the primary aspect of creating an amazing portrait is posing a couple thoughtfully, then documenting the couple's reaction completes it. Sometimes to get the right reaction, you need to add some action. Photographer Julian Kanz gets an excellent reaction out of this couple by adding a little twist to a common pose.

Instruct one partner to walk up behind the other, wrap her arms (or even legs) around the other, and kiss her wife's cheek. The result is a fresh and fun still image that speaks of motion, life, and love. And bonus!: What's not to love about the touch of the woman in pants holding the bouquet? Yes, even with one bouquet, you can pass it around. Just make sure that your couple is on board with getting creative with a prop that is traditionally paired with a wedding gown.

behind the lens

To get a couple to behave "naturally" in front of the camera, have fun with them. A natural exchange between two people, captured in the moment it matters, can overcome almost any awkward pose, background imperfection, or other conceptual flaw.

JULIAN KANZ PHOTOGRAPHY
Canon EOS 5D Mark II, 35mm lens, ISO 160, $\frac{1}{1600}$ sec. at f/2.0

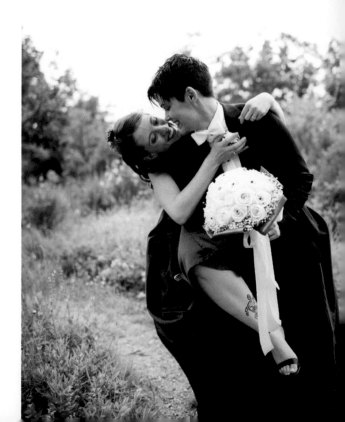

TRADITION
modern vows, rustic sensibilities

behind the lens

The brides, Kristen and Emily, explained that two of their good friends, who had been partners for many years and grew up in a time when coming out and celebrating one's love amongst friends and family was not as openly accepted, may have had the best time at their wedding. On multiple occasions that night, they shared their feelings with the brides about how important the day was to them. Emily said that knowing her friends were deeply impacted by the incredible feeling of comfort and acceptance that everyone there had—not only for their relationship but also for all of their gay and lesbian friends who were in attendance—was one of the best parts of their wedding day.

AUTHENTIC EYE PHOTOGRAPHY
Canon EOS 5D Mark II, 70–200mm lens,
ISO 400, $\frac{1}{1000}$ sec. at f/2.8

As we've discussed, applying a traditional pose to a same-sex couple is not always advised. When used thoughtfully, however, a traditional pose can work beautifully and can highlight the authenticity of the moment and the relationship of the couple.

These two brides planned a traditional, white wedding with all of the trimmings at the Webster Barn in Vermont. In keeping with their rustic theme, they rented an antique truck to serve as a lemonade stand for refreshments. Applying this traditional pose—with one partner sitting on the lap of the other—works for this couple because of their body types, personalities, and comfort with public affection.

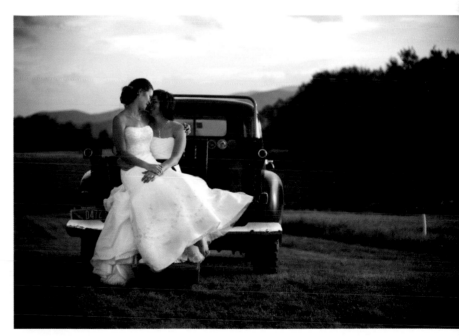

A WOMAN IN UNIFORM
sign of the times

There will be a day when military weddings for same-sex couples will be routine rather than novel. But we're not there yet. It has, after all, only been a short amount of time since "Don't ask, don't tell" was repealed. That's part of what makes same-sex military weddings just that much more special and spectacular; it represents a double dose of equality.

Photographing a couple from above does a couple of things: first it creates a slimming effect, and second it adds a unique perspective. In many instances, this is a technique you can use to frame out something undesired in the location or make a plain location look more interesting.

In a perfect world, strive to avoid straight arms, and leave objects, like bouquets, in their full and complete form. Alas, weddings do not often allow for the "perfect" conditions that can be manufactured on a commercial set with professional models. Photographers and couples are charged with a tight time schedule, external pressures, and familial responsibilities. In short, concessions are sometimes made. Your priority is expression and intimacy over perfect posing.

behind the lens

Hands and feet commonly express stress during a session. If your clients are nervous and are gripping hands, ask them to lay their hands flat because it will help them to relax their arms and shoulders.

EMILY G PHOTOGRAPHY
Canon EOS 5D Mark III, 35mm lens, ISO 400, $\frac{1}{1600}$ sec. at f/2.5

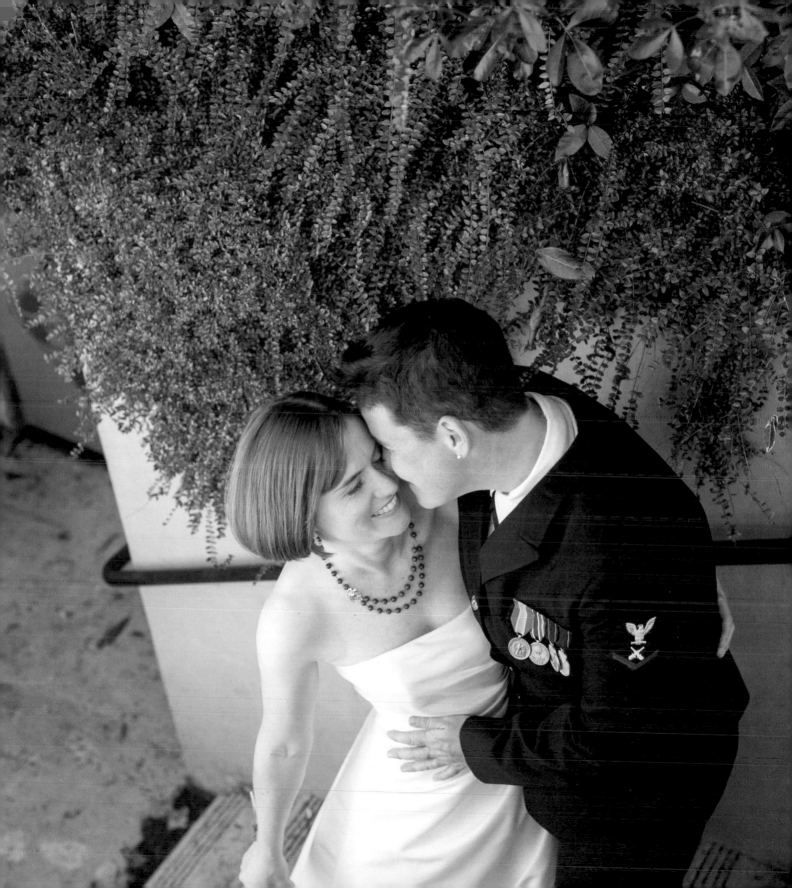

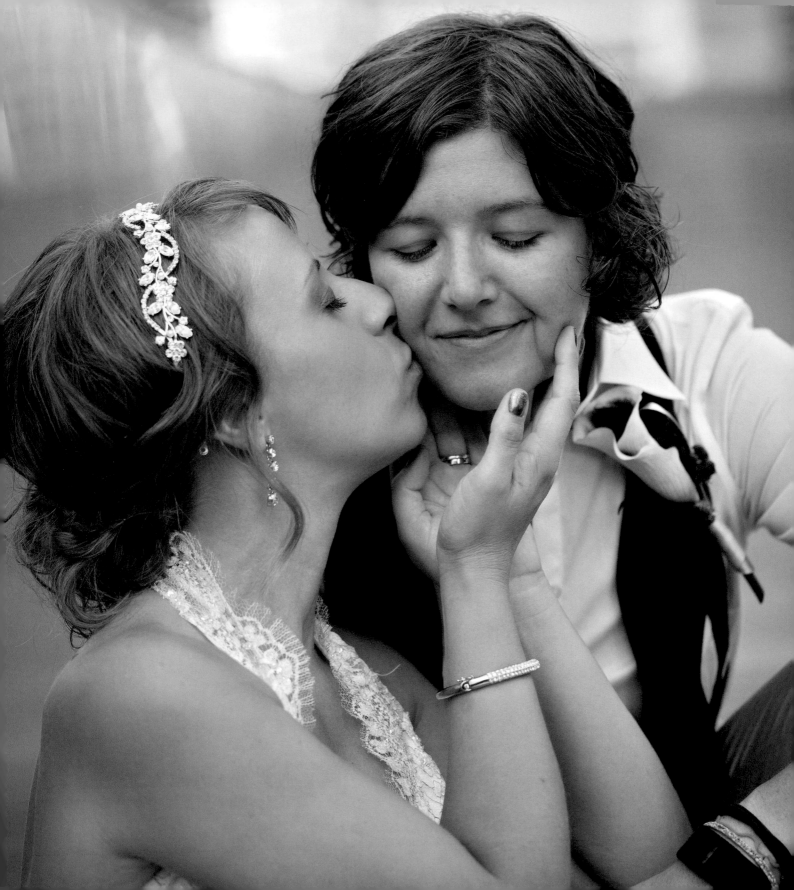

TOUCH
in this moment, forever

behind the lens

Dawn and Mandy met when out with a group of friends, and they sat at the bar and talked all night. When Dawn left, Mandy hinted at getting Dawn's number, but Dawn's phone was dead and she was too tired to realize Mandy's intentions and didn't give it to her (though Dawn did really want to see Mandy again). Even without Dawn's contact information in hand, Mandy told her friend after Dawn's departure that she was going to "marry that girl." Fortunately, they ran into each other again two weeks later, and the prophecy came true when they married fourteen months later.

IT'S BLISS PHOTOGRAPHY
Canon EOS 5D Mark II, 100mm lens, ISO 200, $\frac{1}{640}$ sec. at f/3.2

This pose offers another excellent solution for working with a couple of similar height. With one bride sitting sideways and the other crouching behind her, square to the camera, the couple's bodies are naturally layered, and the slight height difference sets the frame for the finish. The contentment and intimacy between these brides in this moment is as palpable and powerful as it is gentle and sweet.

It can be incredibly difficult, if not impossible, to get your clients to demonstrate the posing skills worthy of a professional model in the short few hours in which you have to work with them. A few simple, specific, and well-timed instructions can help the couple look more natural in what can be a self-conscious moment for some. In this case, photographer Ann Walker took a beautiful moment and transcended it with purposeful hand placement by asking the seated bride to place her hands ever so gently on her wife's chin.

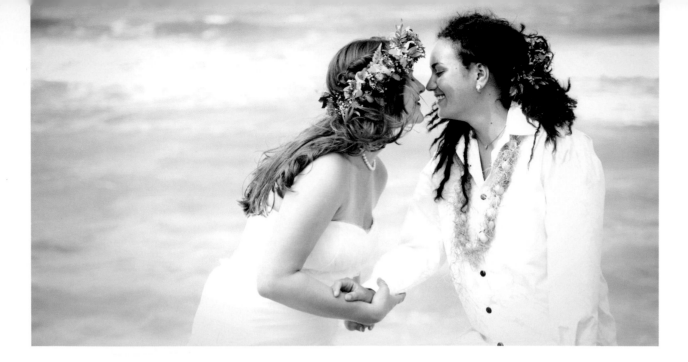

LOVE AND LIGHT
timing (and exposure) is everything

It's easy to appreciate this supersweet, supercute, and intensely personal moment of love just as it is. But it's also worth noting that the moment that Torie McMillan has captured shines against many odds. Photographing two brides dressed in white, embracing in the bright sun with the ocean—surely the biggest reflector on the planet—as the background, is a really tough scenario. But here, McMillan turned that brightness into an asset rather than a deficit, capturing an exchange between her couple in a way that seems bright, cheery, and hopeful—exactly as any start to a lifelong commitment should be.

Beyond managing the challenges to a seaside setting, this image benefits from impeccable timing. Rather than showcasing the standard newlywed kiss, McMillan reveals a new dimension of intimacy between these women, showing us just how much sweeter the moment before a kiss, with its sweet nothings quietly exchanged, can be.

behind the lens

Because white reflects light so well, photographers often are forced to overexpose it, which means details in the clothing may be lost. Add to your preportrait consultation a brief discussion about clothing color choice. Solid colors are best; avoid stripes and logos. White is okay, but other colors are better. So if a couple is interested in breaking the wedding mold, wearing something other than white in a case like this might be practical and inspired!

TORIE MCMILLAN PHOTOGRAPHY
Canon EOS 5D Mark II, 24–105mm lens, ISO 200, $\frac{1}{640}$ sec. at f/4.0

TAKING A STANCE
what the sole has to say

When the upper body is cropped out of a shot, one is left to wonder about the parts left out of the frame. Thus, the feet must speak for themselves to make an image of the lower body work. In this example, the simple act of having the bride on the left cross her legs feminizes what might otherwise have been an androgynous stance. Nothing wrong with either, of course; the question is which stance best reflects the couple's personality. And if the photographer hits this subtle mark, he or she will provide a compelling image that unveils details unique to each subject's personality, all without relying on a facial expression.

It's certainly true that this pose (or the concept of two expressive pairs of legs) can be applied to any couple, regardless of sexual orientation. It's a matter of finding a compelling backdrop, requesting two different actions for each pair of feet, and considering details like shoe styles and accent colors to pull the image together.

behind the lens

People express themselves in their attire, accessories, grooming, posture, and so on. The hands and the feet are not simply vehicles for accessories; they are also vehicles for expression. When photographing a couple's feet, ask them to do something interesting with their toes and show a little personality in the pose.

EMILY G PHOTOGRAPHY
Nikon D300, 50mm lens, ISO 200,
$\frac{1}{1250}$ sec. at f/1.4

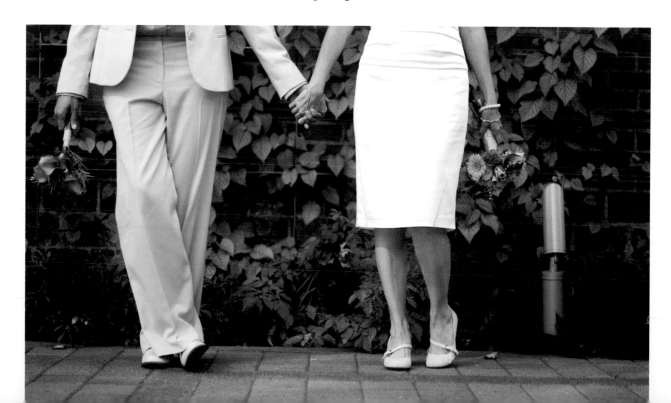

TWO BOUQUETS
double trouble

The only thing harder than photographing one bouquet is photographing two of them. Photographing one bouquet is hard, because bouquets aren't generally something one is accustomed to holding, and they can often be bulky and delicate. If you photograph two brides with two bouquets just as you would one bouquet, you may find yourself longing for the simplicity of a single bouquet or encouraging the brides to toss them (as far as they can throw them!) well before the reception.

With two brides, you might have two bouquets for one couple. The bouquets might be identical or complementary. They might be small; they might be large. But it's likely that the couple (and perhaps the planner, florist, or parent who advised them) doesn't realize that, from a photographer's perspective, even a single, large bouquet can be an obstacle when creating physical closeness in a pose.

It's important, then, to consider two bouquets as a challenge and as an opportunity for new pose solutions, color coordination, and other symbols of personal expression. The brides, for example, can personalize their bouquets by flower and color choice, but also by ribbon color and texture.

In posing, the best solution often comes when at least one (if not both) of the bouquets are put aside. This allows for the complementary colors and wedding details to be included, but without interfering in the closeness of the pose and intimacy of the moment.

behind the lens

Don't be afraid to share with your clients or their florist a few ideas that might be incorporated in the creation of two bouquets. In addition to providing personalized and knowledgeable service to your clients, you'll also have a head start on thinking about the kind of poses that will work with the couple and their floral "props."

KAT FORDER PHOTOGRAPHY
Nikon D800, 24–70mm lens, ISO 400, $\frac{1}{1600}$ sec. at f/3.2

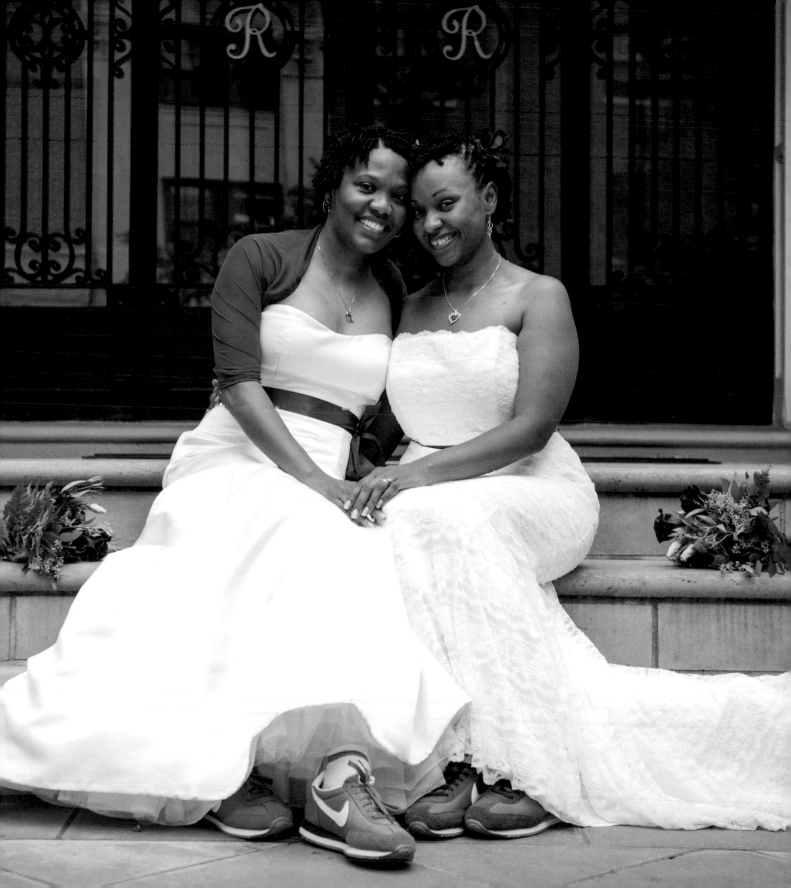

INSPIRATION GALLERY
additional poses and ideas for two brides

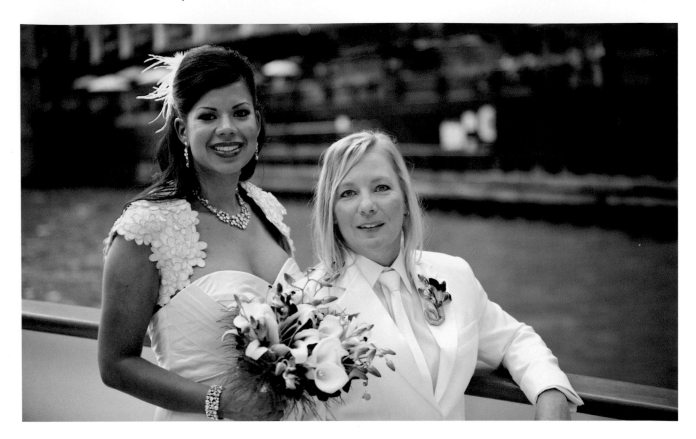

Consider the couple. [ABOVE] Just because one bride wears pants and the other wears a dress doesn't mean that the bride in pants should be posed as a heterosexual man would be. Consider thoughtfully the couple in front of you, their physical expressions, and their traits—and then apply those things to a pose suited for them, not someone else.

MAGGIE RIFE PHOTOGRAPHY
Canon EOS 5D Mark II, 70–200mm lens, ISO 400, $\frac{1}{125}$ sec. at f/2.8

The classic look. [OPPOSITE] Sometimes a traditional wedding pose like the one shown here will work for a same-sex couple. Communication, patience, and rapport will help you work through the pose "flow" to capture an authentic and comfortable moment that works.

AUTHENTIC EYE PHOTOGRAPHY
Canon EOS 5D Mark II, 70–200mm lens, ISO 400, $\frac{1}{1000}$ sec. at f/3.5

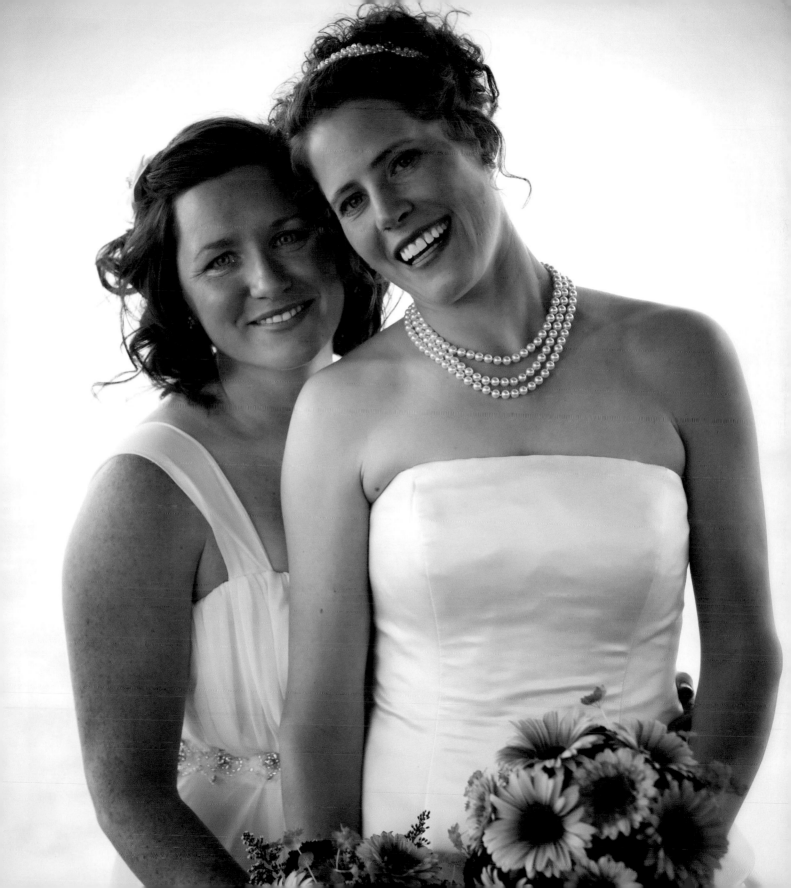

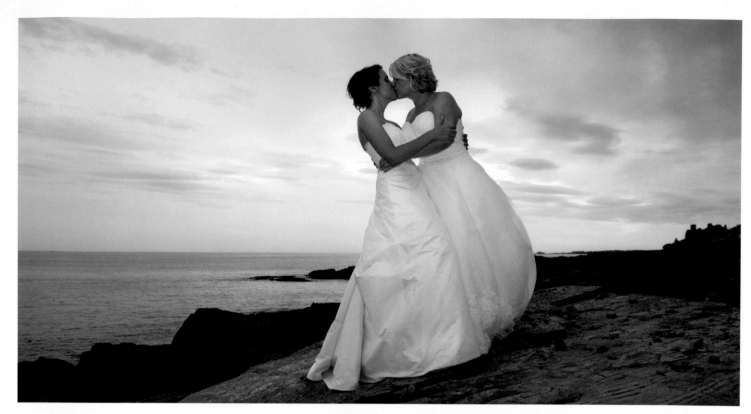

Avoid a dip disaster. [ABOVE] A dip pose, commonly used to great and dramatic effect for opposite-sex couples, has the potential to be a disaster for two women or two men. Beyond the physical challenges that can present a problem for a same-sex couple, you need to know your clients' comfort in assuming or playing with traditional masculine or feminine roles. It's a pose used best when the couple embraces the gender roles or physical traits associated with a strong dipper and a smaller "dipee," but it can also be used for a couple who wishes to be playful and ironic. Just remember to move this pose from your standard session list to the list of poses you employ on occasions when it's a great fit.

AUTHENTIC EYE PHOTOGRAPHY
Canon EOS 5D Mark III, 24–70, ISO 1600, $\frac{1}{60}$ sec. at f/4.5

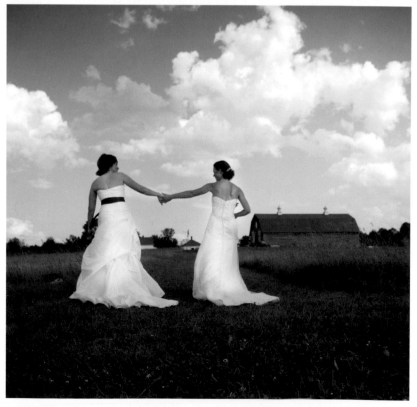

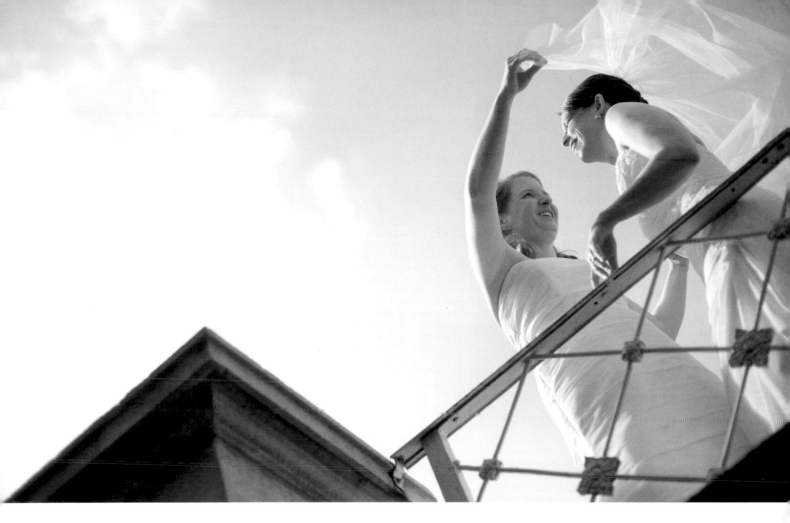

At the end of the day. [OPPOSITE, BOTTOM]
The best formal photos are sometimes not posed at all. Sometimes a couple will forget that the camera and photographer are present and will fall into their own rhythm. The photographer needs to be present enough in the moment to capture it.

AUTHENTIC EYE PHOTOGRAPHY
Canon EOS 5D Mark II, 24–70mm lens, ISO 400,
$^{1}/_{3200}$ sec. at f/4.5

Deliberate spontaneity. [ABOVE] Photographer Allana Taranto found a unique angle with which to compose this engaging moment, creating an absorbing work of art for this couple's wedding portrait. She hits just about every mark of the foundations of photography (as discussed in chapter 2), but she does so in a way that is modern and fresh. She utilizes a unique perspective (the "ant's-eye" view), her subjects' arms frame their faces (a frame within a frame), and she tilts the camera to accent the angle of the railing, creating visual tension. The result? A one-of-kind image reminding us that fundamentals, spontaneity, and timing can go hand in hand.

ARS MAGNA STUDIO
Canon EOS 5D Mark II, 50mm lens, ISO 250, $^{1}/_{8000}$ sec. at f/2.0

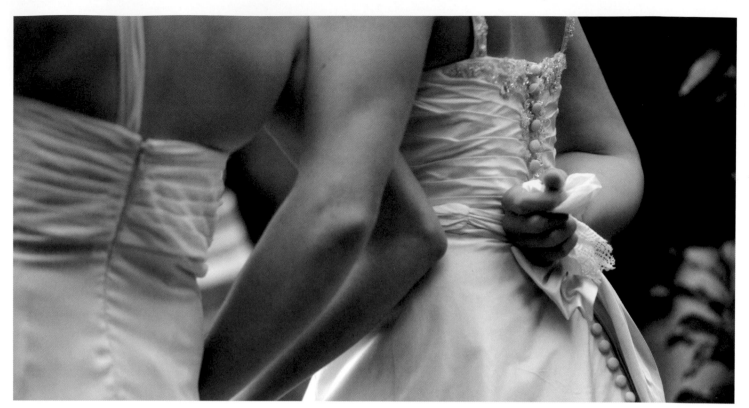

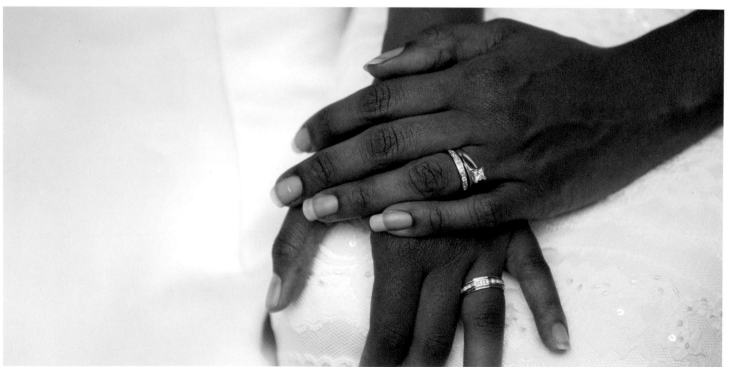

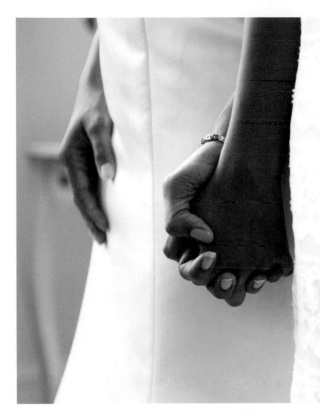

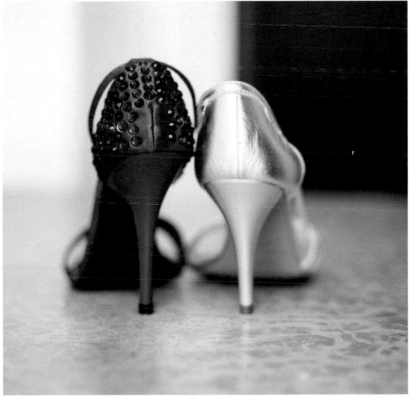

Get the details. At a wedding, no one is supposed to upstage the bride. Except, one might suppose, the other bride! Accessories, embellishments, and adornments abound for one traditional bride, so you can expect a visual feast when you have two of them. Perhaps the details for two brides will compete for center stage, perhaps they will complement with modest flair; or perhaps they will offer a perfect mirror. Either way, there's plenty of fun to be had with wedding details creatively and symbolically employed by two brides.

[OPPOSITE, TOP] WHITMEYER PHOTOGRAPHY
Canon EOS 5D Mark II, 70–200mm lens, ISO 1600,
$\frac{1}{800}$ sec. at f/2.8

[OPPOSITE, BOTTOM] KAT FORDER PHOTOGRAPHY
Nikon D800, 24–70mm lens, ISO 400, $\frac{1}{1250}$ sec. at f/3.2

[TOP] KAT FORDER PHOTOGRAPHY
Nikon D800, 24–70mm lens, ISO 2000, $\frac{1}{100}$ sec. at f/3.2

[BOTTOM] JULIAN KANZ PHOTOGRAPHY
Canon EOS 5D Mark II, 85mm lens, ISO 800, $\frac{1}{800}$ sec. at f/2.0

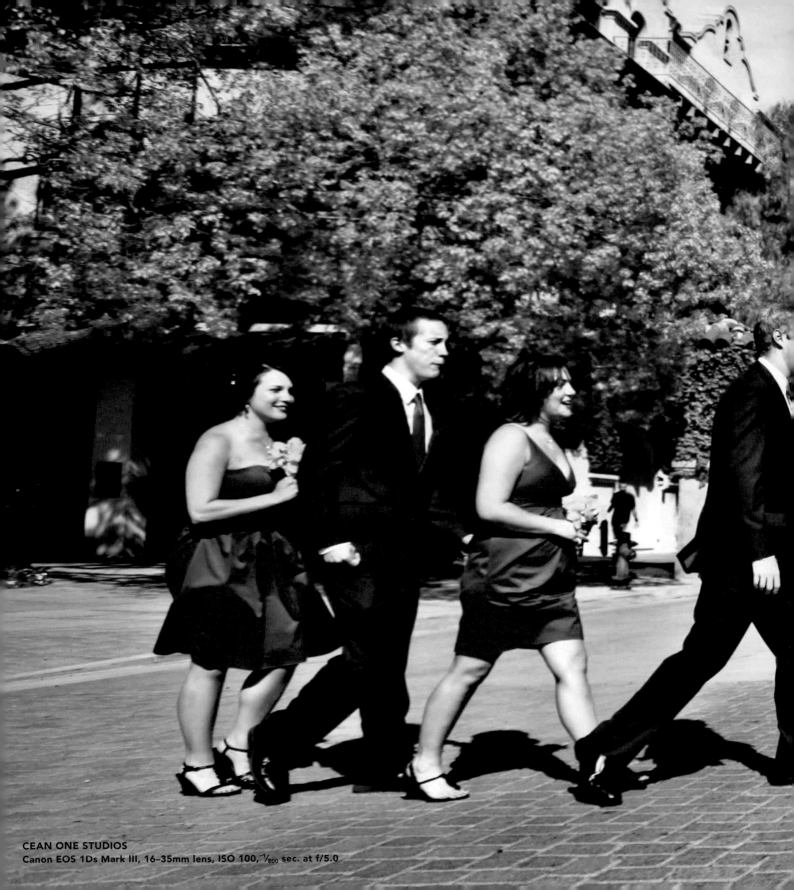

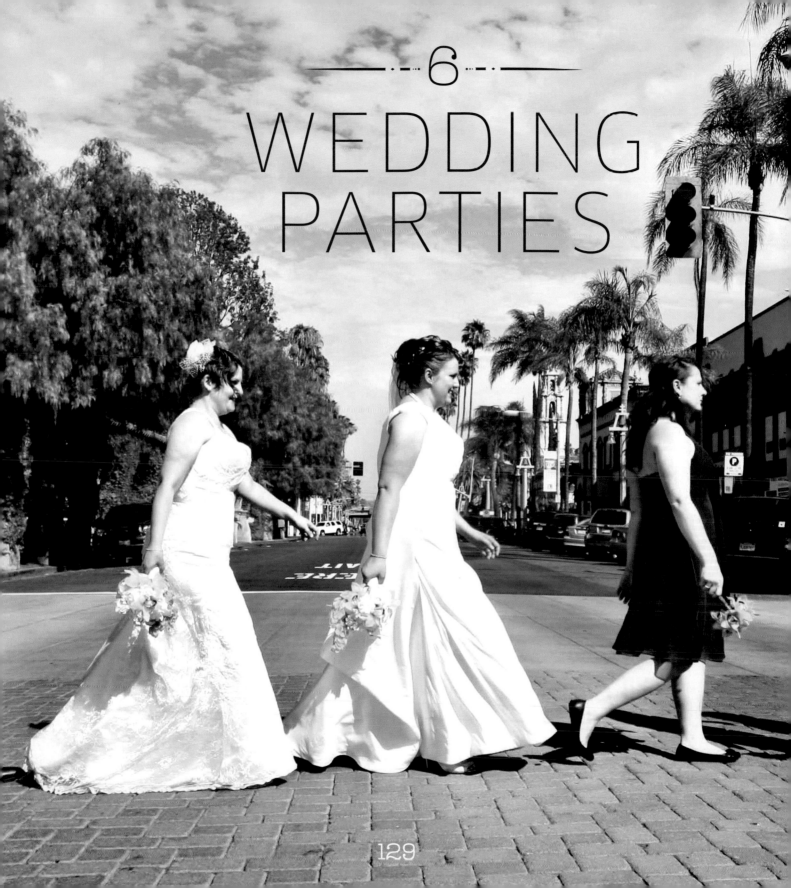

6

WEDDING PARTIES

PRIOR TO THE LEGALIZATION OF same-sex marriage, most weddings (or commitment ceremonies, as they were then called) were relatively modest in size and were highly personalized. But even when those ceremonies appropriated symbols of traditional wedding ritual, the wedding parties would generally consist of a Best Man or a Best Woman, and perhaps a handful of chosen attendants or readers, who may or may not have filled the traditional roles often seen in the wedding parties of heterosexual weddings. And that legacy is what can make photographing wedding parties at a same-sex wedding all the more challenging. It's hard to know what to expect from each couple, and relying on symmetry is no guarantee.

The witnesses and attendants from the earliest days of same-sex unions filled explicit roles to witness and support the couple. Because same-sex unions were rarely undertaken, not legal at the time, and marked a special occasion, the selection of attendants was devoid of most of the politics and drama about which friends or family get selected to wear matching dresses or suits, and about who will stand where in the long line of friends and siblings filling the wedding party.

As same-sex weddings have become more commonplace and more widely embraced in the mainstream wedding market, however, the traditional expectations and rituals of straight weddings are beginning to appear more frequently in same-sex weddings. Though same-sex couples remain likely to pick more freely who will serve in their wedding parties and what they might wear

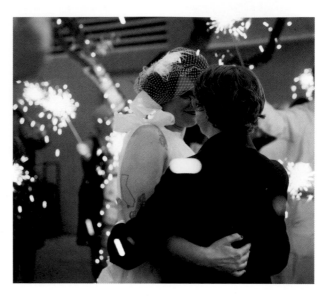

Karyne and Shvonne ask their friends and family to join in on the act by using sparklers to help them light up the dance floor in Las Vegas.

WEDDINGS TO THE PEOPLE
Canon EOS 5D Mark III, 24–70mm lens, ISO 640, ¹⁄₈₀ sec. at f/2.8

(including mixed-gender attendants, more attire options, gender-bending expression), more couples than ever are choosing to have wedding parties that are larger in size.

The good news is that, though same-sex couples may feel more comfortable embracing the wedding rituals once reserved exclusively for heterosexual couples, the reverse is also true. Many straight couples are now choosing mixed-gender wedding parties and are allowing for more creative expression within the group. So learning more about how same-sex couples approach the development of their wedding

parties will also benefit you as you prepare for wedding sessions with your opposite-sex clients.

IT'S OUR PARTY

Before you meet with your clients, familiarize yourself with the kinds of ceremonies that same-sex couples have (see chapter 7), think about the kind of photography services you can offer, and prepare yourself to capture the moments that really matter. In all cases, you should be mindful of how the involvement and emotions of the wedding party, family, and guests can be an integral part of the wedding story and provide a meaningful dimension to the wedding album.

The bottom line is that wedding parties will take shape around the kind of ceremony that's chosen. Here are some examples.

City Hall. As with most straight City Hall or courthouse marriages, the wedding party of a same-sex couple at City Hall is most likely to consist of a few witnesses. While it is true that the occasional stranger will be roped into serving as an official witness, more often than not, the couple will have a few close friends or family with them—even if they've chosen to travel for an out-of-state marriage license. In all cases, it's important for a photographer to be on hand to document not only the moment of the vow exchange but also the reactions of the people assembled to bear witness to the moment.

Group weddings. The other wedding party trend, one that coincides with same-sex marriage headlines and legal barriers having

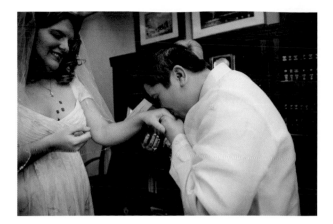

Isabel and Amanda of Florida eloped to Boston's City Hall for a legally recognized wedding on a chilly February afternoon in 2013. Their photographer, Kristin Chalmers, did double duty and served as an official witness to their marriage

KRISTIN CHALMERS PHOTOGRAPHY
Nikon D700, 24–70mm lens, ISO 400, $\frac{1}{100}$ sec. at f/3.5

been broken over the past few years, is gay weddings en masse. Organizers will plan a mass-scale wedding of multiple couples who wish to get legally married, either at the time of new legislation being passed or upon a related milestone anniversary event. In these cases, couples seem most driven to be acquiring the legal paperwork while also celebrating with lots of other couples in community fashion. Similar to the City Hall wedding, the community wedding for multiple couples provides ample opportunities for photographers to capture love in the public domain.

Small weddings. There are many couples who choose to have more modestly sized weddings and, as a result, might ask only two to four attendants to bear formal witness to their union. The readers, and perhaps even the officiant, are likely to have a relationship that is meaningful to the couple, so it will be important, especially in these cases, to ask the couple which group combinations they wish to have in their album. It may vary from the typical list a photographer might use and extend beyond the small wedding party of one or two witnesses. Then again, it might not!

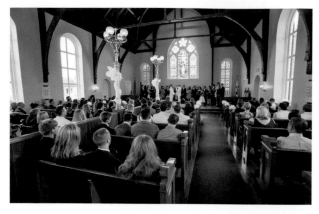

Dwayne and Jonathan's wedding party was so large it filled the entire front of the chapel at Old Christ Church in Pensacola, Florida.

RED STONE PHOTOGRAPHY
Canon EOS 5D, 17–40mm lens, ISO 1600, ¹/₁₆₀ sec. at f/5.0

Big weddings. Couples who produce an elaborate wedding ceremony and reception generally not only want to commemorate it but also have the budget to hire a photographer for a full day of services. These are also the couples who will have larger, more traditional-looking wedding parties and who have spent time researching weddings and reception planning on various blogs and wedding-planning sites. Thus, the majority of weddings of this size will tend to take on a more traditional shape, even if there's a range of diversity in the wedding party as it is presented. Here, a photographer will want to be prepared to pose and photograph the larger group of people but also be amenable to creative arrangements and mixed-gender representation in order to get the best portraits possible.

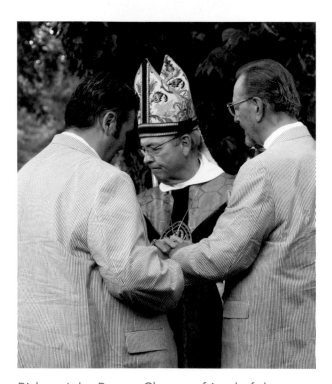

Bishop John Bryson Chane, a friend of the couple, marries Larry and Mark (who have been together for thirty years) in a private backyard ceremony in Washington, DC.

MEIN IMAGES
Nikon D90, 18–105mm lens, ISO 400, ¹/₁₀₀ sec. at f/5.6

FAMILY MATTERS

More parents than ever are excited about their gay son or lesbian daughter's wedding, but there are still many examples of parents who aren't supportive and either aren't invited to the wedding or have declined the invitation. Be sensitive about this reality, asking open-ended and respectful questions about what a couple envisions for the inclusion of biological and "chosen" family members, while also remembering that the family members—sisters, brothers, parents, grandparents, aunts, uncles, children, close friends—who do attend may very well provide some of the most moving and authentic moments of love to be captured at the ceremony and reception.

It is also the case that many couples who are getting married haven't just been together for many years; they have also started a family and will have children who will be involved in the ceremony. Or, the couple might have older children from previous relationships who will be participating. Make sure you understand who these family members are and why the couple has chosen a specific role for them. In these cases, the union might not just be about the couple but also about a proud and important milestone for the entire family.

In summary, be creative with group shots. Same-sex couples typically have some sort of a wedding party, but the attendants assembled can vary widely from tradition. There are mixed-gender wedding parties, no wedding parties,

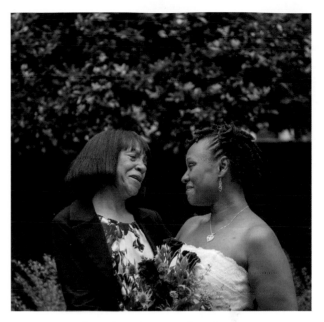

Donna and her daughter, Kelly, share a poignant moment on her wedding day.

KAT FORDER PHOTOGRAPHY
Nikon D800, 24–70mm lens, ISO 400, $\frac{1}{500}$ sec. at f/3.2

imbalanced wedding parties, costumed wedding parties, family as wedding party. You name it, same-sex couples have done it. And in the rest of this chapter, you'll find examples of grooms and their attendants, brides and their attendants, and family members as attendants and witnesses.

COLORFUL FORMALITIES
rows upon rows

These grooms offer us a traditional grouping for a nontraditional group. But the biggest challenge Dwayne and Jonathan's wedding party creates for a photographer is the large size of the group. We discuss the concept of layering quite a bit in the book, because it is an essential tool for making images that express connectivity. Layering in a group image like this, however, must be approached a bit differently. In the case of a large group photograph, it is the rows, not the attendants, that must be layered.

Ultimately, the goal for this full wedding-party image is a balanced portrait in which everyone's face is fully visible. To achieve this with a group this large and diverse in height, an elevated step for the back row is very helpful. Keep in mind that heads should not be stacked on top of one another; each person in the back should look over the shoulders of the people in the front row.

behind the lens

Though subjects can be organized by gender, wedding-party role, or color scheme, you don't need to limit yourself to the traditional patterns of wedding-party organization. In this instance, the position of the attendants (all representing one grouped wedding party rather than two distinct wedding parties) was dictated by a combination of the attire and the *order* of the color of the rainbow (ROY G. BIV, as the acronym goes).

RED STONE PHOTOGRAPHY
Canon EOS 5D Mark III, 24–70mm lens, ISO 250, $^1/_{2000}$ sec. at f/4.0

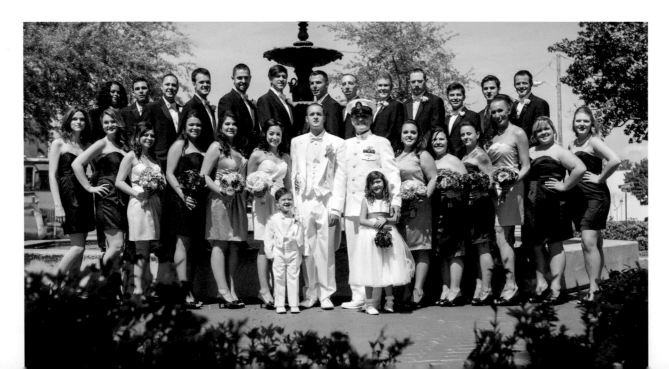

CHICAGO
style and substance

behind the lens

Photographer Arielle Doneson introduces a subtle but meaningful touch to this photograph by allowing the male attendants to the left of the grooms to hold hands. Typically, the only love connection pictured in a wedding-party portrait is the couple who is getting married. But, in this case, Doneson's choice to do so shows familiarity with and respect for the attending couple, while also introducing a sweet yet subtle texture of authenticity.

ARIELLE DONESON PHOTOGRAPHY
Canon EOS 5D Mark II, 24–70mm lens,
ISO 800, $1/60$ sec. at f/6.3

There are several dimensions to this image that make it an outstanding example of a modern and successful approach to photographing a wedding party. The attendants are dressed in complementary colors and styles, giving the wedding party as a whole a balanced and unified feel even with an allowance for individual expression and gender imbalance on either side of each groom. Many couples (or their planners) might be knowledgeable enough to plan for this, but it never hurts to discuss in advance with a couple how attire options and color palettes can impact the outcome of a session.

COMMUNITY SHELTER
interconnectedness

A more modern approach to wedding-party formals includes people being purposefully scattered, each posed in a slightly different manner. This can be a great way to add visual interest to an otherwise balanced group. And because you can't always count on symmetry, matching outfits, or gender groupings in a same-sex wedding party, it becomes a wonderful tool for finding new ways to present a unified wedding party or the grooms' (or brides') attending parties.

In this instance, the wedding party, even with its variety, remains connected by matching attire and props. And this element is the key to unifying the group even though they are positioned at some distance from one another. Without a prop or unifying element, scattering will look messy rather than purposeful.

behind the lens

Photographer Kristina Hill admits to getting choked up and teary eyed at nearly every wedding she has photographed. But she says that Tom and Brian's ceremony struck her much more profoundly. Regardless of how she has tried, she has struggled to articulate how much so but says that she hopes her photographs of Brian and Tom speak for themselves and that she is forever grateful for the experiences had and friends made in Puerto Vallarta at the wedding.

KRISTINA HILL PHOTOGRAPHY
Canon EOS 5D Mark II, 16–35mm lens, ISO 400, $\frac{1}{250}$ sec. at f/4.0

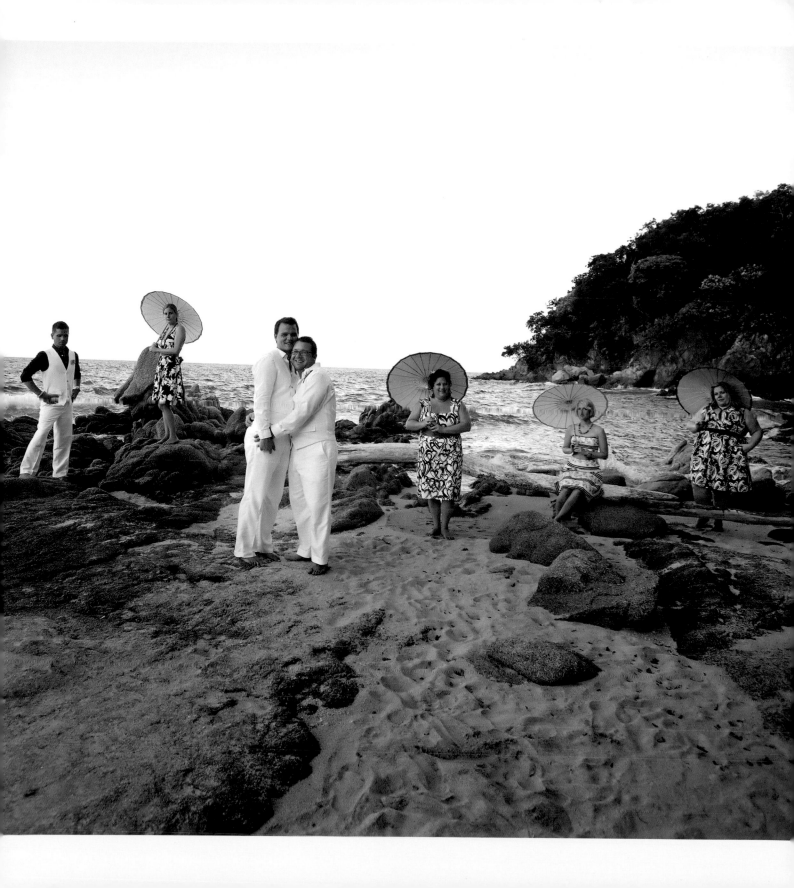

FASHION POLICE
flip-flop faux pas

With an image so full of commentary, it seems superfluous to say anything more. What person of taste wouldn't be mortified to see a member of the wedding party wearing flip-flops on the Big Day? This gag shot (pun intended) is a great example of how humor and playfulness in group dynamics result in fun and unique photos that add diversity and authenticity to the wedding album. More often than not, it is the photographer who needs to look for an inside joke within a group of friends and play it up. These photos, while appearing spontaneous, are influenced by the direction of the photographer to garner the most amusing effect.

Though this group showcases contagious fun and a lighthearted moment, one finds even more to love upon discovering the backstory. Steven, one of the grooms, who happens to be a tailor and made the dresses for the female attendants and the two tuxes for the wedding, explained that his friend, Becky, had just flown in from Virginia to be in the wedding and had gone to his house the morning of the wedding so that he could hem her dress. She left her shoes at the fitting but didn't realize it until the photographer started taking pictures. Fortunately for Becky and the grooms, someone was able to bring the shoes to the church so that she could swap out her footwear—but not before this expressive group could make a hilarious and memorable moment of the faux pas.

behind the lens

Laughter melts inhibition. Once you get a group laughing with you, it's easier to work with your subjects because they begin to identify you as one of them. A close-knit group of friends will likely be skeptical of a stranger coming in and telling them where to stand and how to look, but if you can fit right into the group, on its terms, your job will instantly become easier.

BRIAN PEPPER & ASSOCIATES
Canon EOS 5D Mark II, 24–70mm lens, ISO 400, $\frac{1}{400}$ sec. at f/6.3

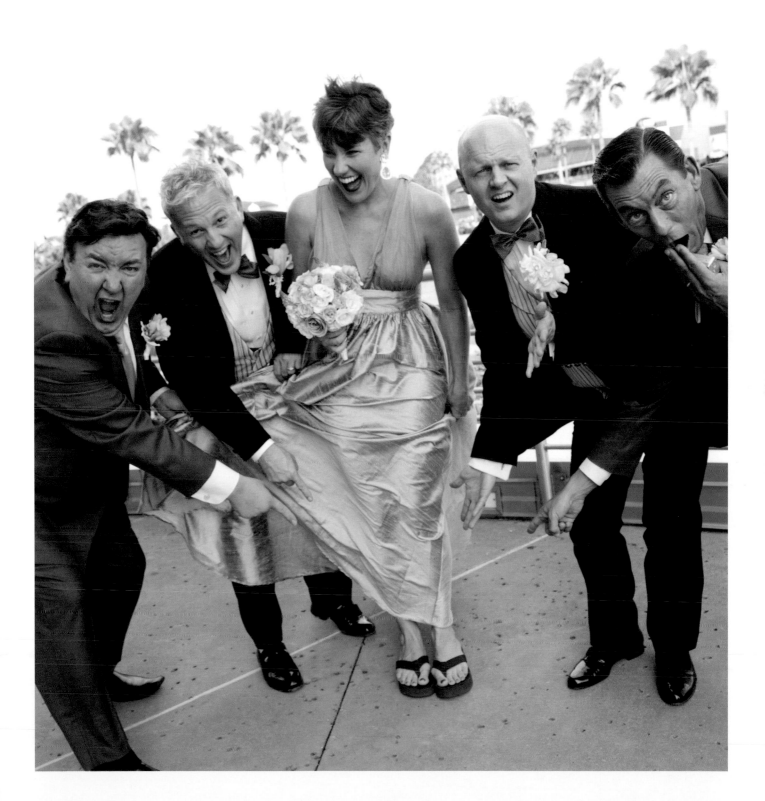

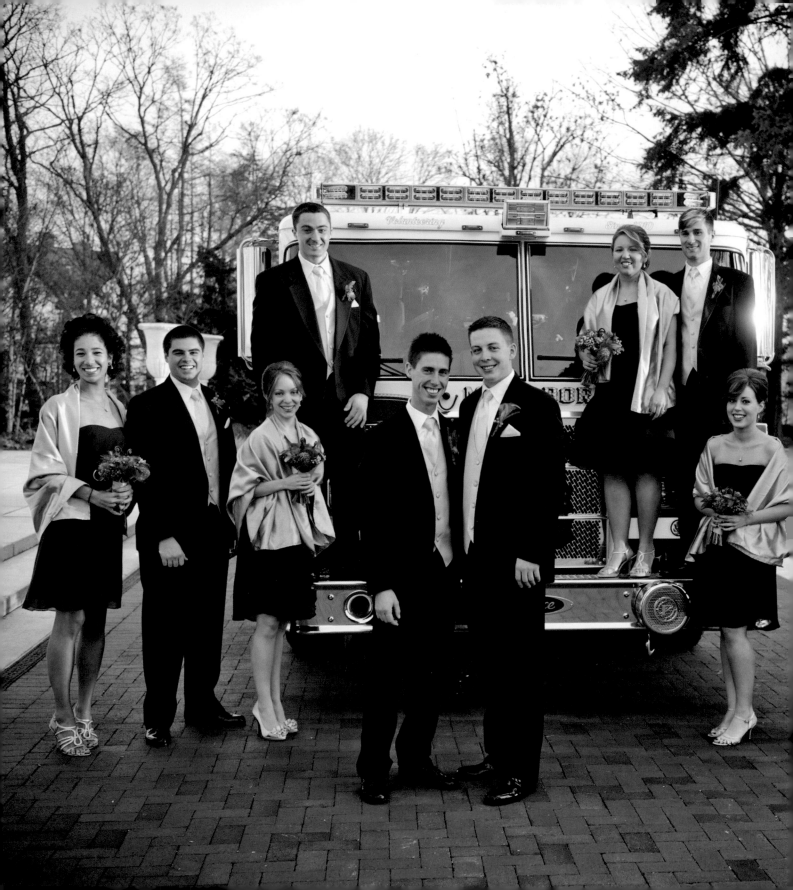

SYMBOLIC GROUP POSES
all-american boys

Balance and simplicity are still the cornerstones of a modern group photograph like the one pictured here. Most photographers will recognize this kind of arrangement as it is very common at straight weddings, too. Matching up attendants in opposite-gender couplings is pleasing to the eye, not only because of the visual balance it offers but because it is a combination to which we have become accustomed. But before matching up members of the wedding parties (in this case, "groomsmaids" and groomsmen!) in a pose like this, it's wise to ask if there are any couples in the group or any couplings to avoid. Explain your thinking to the group with a disclaimer: "I think this would look nice, but if it feels weird to anyone, we can do something different."

Remember, you are dealing with a clientele that comes up against heteronormative expectations on a daily basis. Don't force your gay wedding parties to look like a straight wedding party or to overplay a hand of presuming that everyone can be paired off. If the pose and grouping evolves naturally, all the better, but a measure of extra sensitivity is always well advised.

behind the lens

In addition to encountering posing challenges when photographing a same-sex couple and their wedding party (or parties), you might also find yourself struggling to find the right language. Best practice is to ask the couple what terms they are using, and begin in all of your practices to refer to same-sex wedding attendants as a wedding party, rather than as a bridal party.

OFFBEET PRODUCTIONS
Nikon D700, 24–70mm lens, ISO 200, $\frac{1}{125}$ sec. at f/2.8

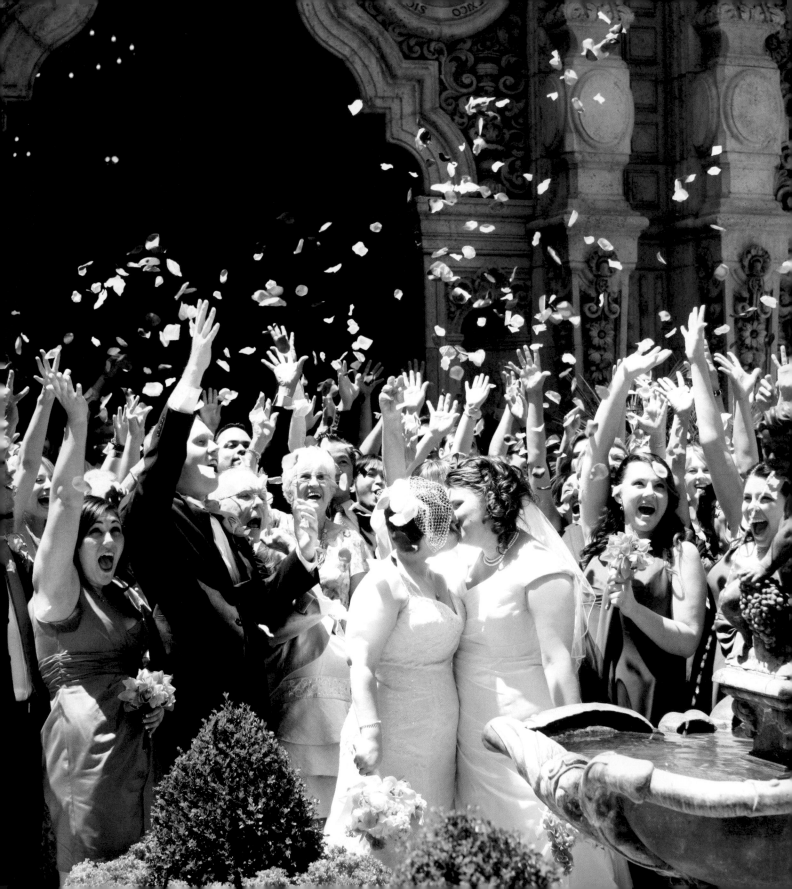

COLLECTIVE EMOTION
celebrate good times

"We want a photo of all of our guests" is a request that might sound like fingernails on a chalkboard. There is simply no harder group photo to take than a large group photo. For a same-sex wedding, however, a photograph that shows the support, enthusiasm, and celebration of a community is an absolute gift to the couple and a statement to anyone else who sees it.

Taking photographs of very large groups can be challenging, because organizing a group of this size is frustrating (people are talking and not listening), time-consuming (when time is already in short supply), confusing ("Hey, you, move a little to the right!"), and a recipe for a lost voice (unless you are bold enough to bring a megaphone). At a certain point, you can't worry about all the faces being seen; it's more the point to fill the frame with bodies than recognizable faces. It is, however, a good idea to organize the group by bringing immediate family and friends to the front, and suggesting that any of the shorter members of the group (including kids) come forward.

This image is actually a signature image at this venue for Cean One Studios and brings a special touch of celebration and commemoration to this wedding day. And introducing action into the pose presents the loosely and informally assembled group as unified, purposeful, and perfect, even though every face can't be seen.

behind the lens

Group shots at same-sex weddings have the potential to create a significant emotional impact; these are the images that show family and community support for the couples' unions. Often celebrating personal and political milestones, these photographs can capture viscerally the strong emotions present at same-sex weddings now that states have begun to legalize same-sex marriage.

CEAN ONE STUDIOS
Canon EOS 1Ds Mark III, 50mm lens, ISO 160, $\frac{1}{400}$ sec. at f/5.0

CONVEYOR
public spaces, delighted faces

Taken on a Metro escalator in Washington, DC, this image represents so much of what every photographer strives to create in his or her work: something meaningful, something fun, and something unique. The icing on this proverbial wedding cake, though, is that this photograph inspires a dialogue as it hints to a story outside the frame.

On initial glance, one feels the rush of joy captured on the faces of these two brides and their wedding party. With a longer look, however, one can't help but ask oneself what is going on off-camera. Something is clearly causing an animated reaction within the group. And this is the true art of "lifestyle" photography: creating opportunities where the subjects can be themselves and authentic moments can be captured, especially when something unexpected happens in the process. At a time when anyone can take a simple picture with a smartphone, professional photographers must focus on what separates a snapshot from a professional image. Dialogue, mystery, and message are just a few characteristics that take this photograph from a simple shot to a skillful image.

behind the lens

As you get to know your clients, you can tailor your creative ideas to best suit each couple based on their interests and hobbies. There are endless opportunities to make wedding portraits more creative and more personal. Resist the temptation, however, to let your creative urges run too wild. Otherwise, you might find that your desire to create art for your own portfolio will overshadow the authenticity of the couple and the moment; the needs and comfort of your clients are always your first responsibility.

MAGGIE WINTERS PHOTOGRAPHY
Nikon D700, 24–70mm lens, ISO 800, $\frac{1}{250}$ sec. at f/3.5

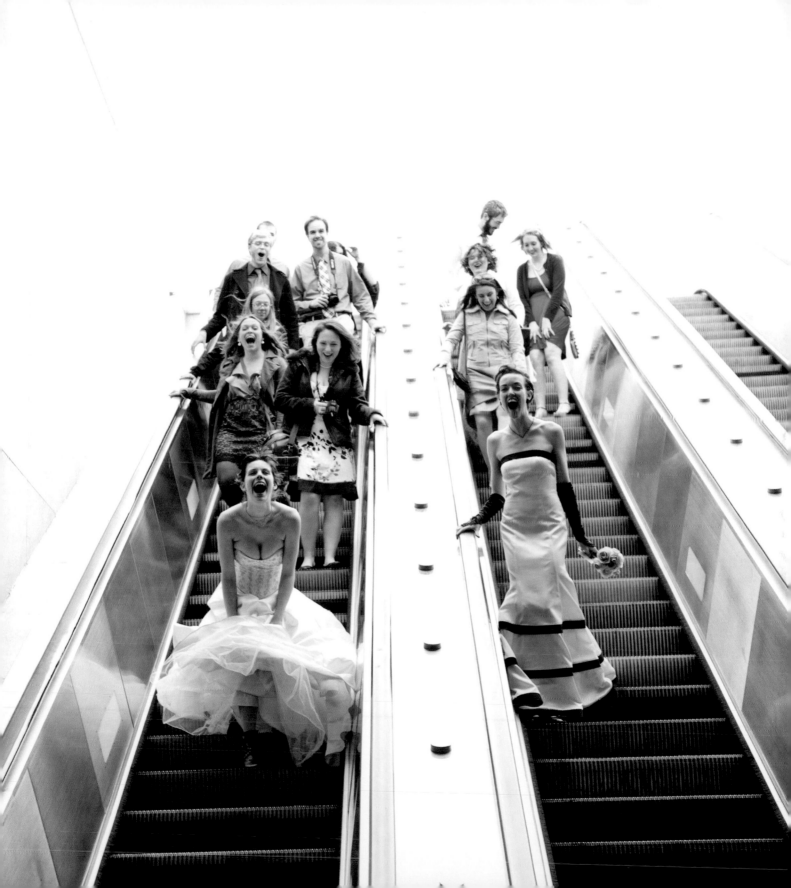

FLOWER BOYS
twist on tradition

Who can resist the image of a child in a wedding? Well, some can. But for those who can't, flower girls, and kids and pets as ring bearers, are a long-standing, whimsical wedding tradition to which many couples adhere. But who says an old tradition can't have a new twist? A girl can bear the rings or a boy can sprinkle the flower petals. Either way, the assembled guests are sure to respond with smiles as the kids do their thing—whether on- or off-script!

behind the lens

Anyone who chooses to have a junior attendant needs to be prepared for things to not go as planned. Children can be unpredictable, but then again, that's half the fun! For children, walking down an aisle or presenting in front of a large group of strangers can be extremely intimidating. Generally speaking, practice helps, and it's best to ask children older than three years old to play a formal role in a wedding.

AUTHENTIC EYE PHOTOGRAPHY
Canon EOS 5D Mark II, 70–200mm lens, ISO 100, $^1\!/_{320}$ sec. at f/5.0

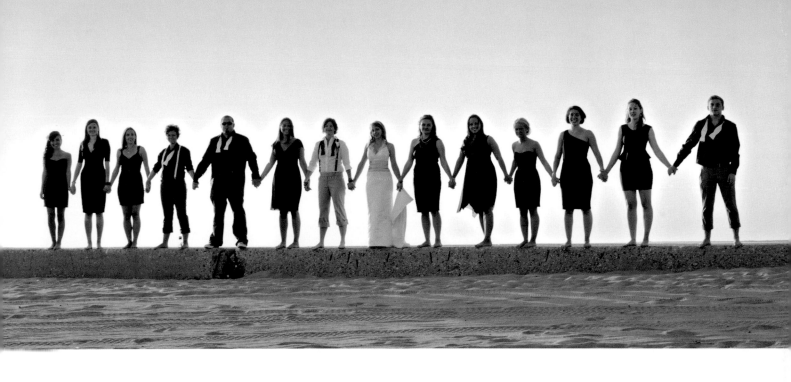

COMMUNION
hands clasped, outstretched

behind the lens

Generally speaking, the best way to win groups over so that they enthusiastically participate in the "formal" photos is to know what outcome you want, to be efficient with your posing requests, and to help your subjects understand what you're going for. There are times when a wedding party might feel confused, self-conscious, or awkward when asked to hold hands as a group. Using humor or sharing your intention to show connection and strength of community can help ease those inhibitions.

IT'S BLISS PHOTOGRAPHY
Canon EOS 5D Mark II, 50mm lens,
ISO 200, $\frac{1}{160}$ sec at f/11

In wedding photography, group shots are generally obligatory and often overly posed or dryly composed, but this doesn't have to be the case! This striking image by photographer Ann Walker offers the simplicity of a horizon and the steadfast strength of community. And this, we contend, is one of the true opportunities available when working with same-sex couples.

From a blending of attire styles—with a purple jewel tone being the primary requirement for the wedding party—to the flexibility for each person to choose the outfit style he or she deemed most comfortable, this mixed-gender wedding party shows unwavering unity even amidst its clear embrace of individuality.

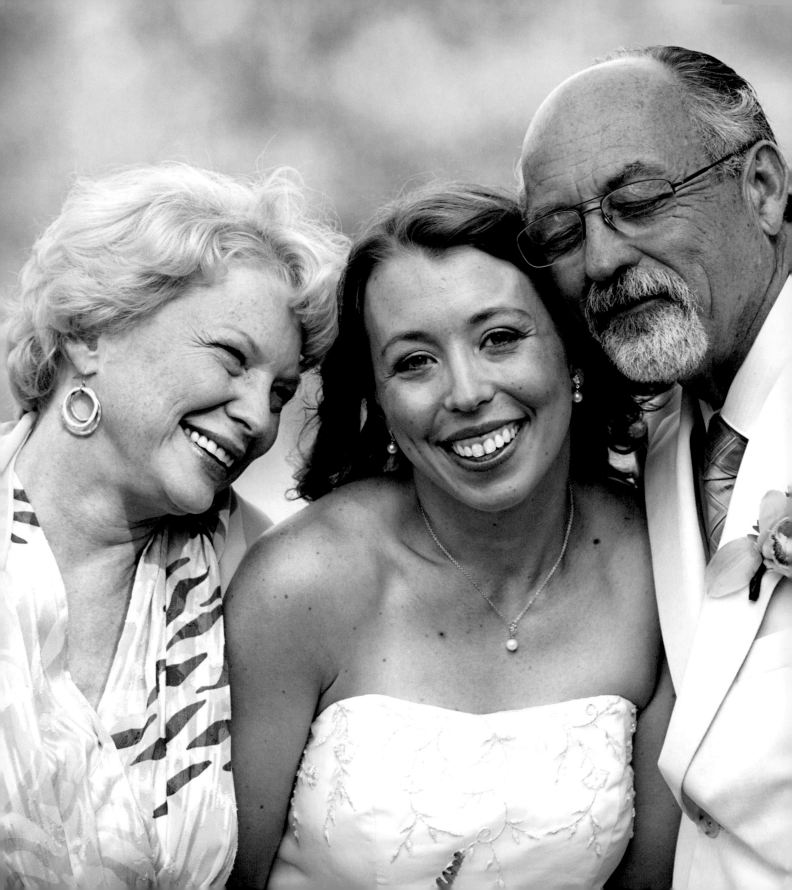

ALL IN THE FAMILY
emotional inspiration

A wedding is as much about celebrating friends and family as it is about a couple solemnizing a lifelong commitment. It's an emotional experience for any parent to see a son or daughter walk down the aisle, especially one with its own "coming out" backstory, and the emotional response can be even more pronounced for a parent who likely never thought his or her child would have access to legal marriage. Keep an eye trained on the peripheral moments as well; the reaction of a wedding guest—a grandparent or special friend, a mentor or cousin—can make for a memorable addition to the wedding album.

At same-sex weddings, emotional moments are particularly palpable during the ceremony and reception toasts. But as much as there will be many guests and attendants who are moved by the wedding, there may be some family members who are more guarded about their emotions as they continue to wrestle with their own acceptance of the couple's relationship. It is also important to watch for emotional moments that are a result of an important friend or family member choosing *not* to be at the wedding. Though this is happening less often with same-sex couples, it is still the case that some couples are confronted with the difficult circumstance in which they do not receive the support of their parents.

Beyond capturing the spontaneous moments during a wedding ceremony or reception, a photographer can also encourage an emotional response from biological and "chosen" family during the formal portrait session. Sometimes it's as easy as asking a bride or groom to look at his or her parent or asking a parent to look at his or her child.

behind the lens

Joanna wanted both of her parents to play at least one traditional role in the wedding. Her mom joined her and her bridesmaids when she went dress shopping. It was equally important to her that she and her dad enjoy a fun disco dance (inspired by a scene in the movie *Airplane!*) together at the reception. She feels incredibly fortunate to have such loving and accepting parents and says that it warms her heart every time she hears them call her wife, Nicole, their daughter-in-law.

AUTHENTIC EYE PHOTOGRAPHY
Canon EOS 5D Mark II, 70–200mm lens, ISO 400, 1/500 sec. at f/5.0

INSPIRATION GALLERY
additional poses and ideas
for wedding parties

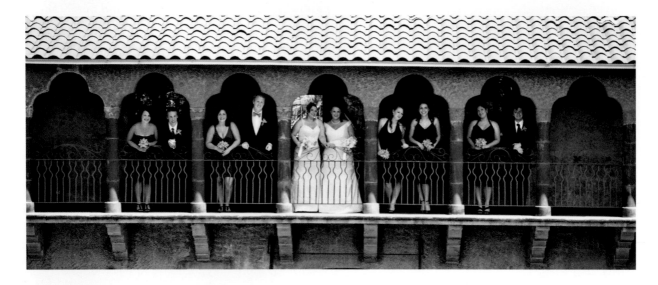

Know your venue. Take the time to think about the wedding or reception location and how you can find natural or constructed elements to help you organize the wedding party—especially if it has mixed-gender or -attire patterns, an unequal number of attendants, or a single wedding party rather than a division between grooms' or brides'"sides."

[ABOVE] CEAN ONE STUDIOS
Canon EOS 5D Mark III, 70–200mm lens, ISO 100,
$^1\!/_{400}$ sec. at f/2.8

[OPPOSITE, TOP] RED STONE PHOTOGRAPHY
Canon EOS 5D Mark III, 23–70mm lens, ISO 640,
$^1\!/_{640}$ sec. at f/3.2

Embrace dichotomies. [OPPOSITE, BOTTOM LEFT] Sometimes a traditional pose and/or location can be a great way to pay homage to a modern couple. Just because it's an antique fire truck doesn't mean it isn't well suited for two grooms and a mixed-gender wedding party.

RED STONE PHOTOGRAPHY
Canon EOS 5D Mark III, 24–70mm lens, ISO 250,
$^1\!/_{1600}$ sec. at f/4.0

Let it shine! [OPPOSITE, BOTTOM RIGHT] Some guests (like Jonathan and Dwayne's "Feather Girls") bring their own spontaneous energy and creativity to a wedding; others are in cahoots with the couple. Either way, look for group details and expressions outside of poses and smiles to tell the story of the day.

RED STONE PHOTOGRAPHY
Canon EOS 5D Mark III, 70–200mm lens, ISO 640,
$^1\!/_{640}$ sec. at f/3.5

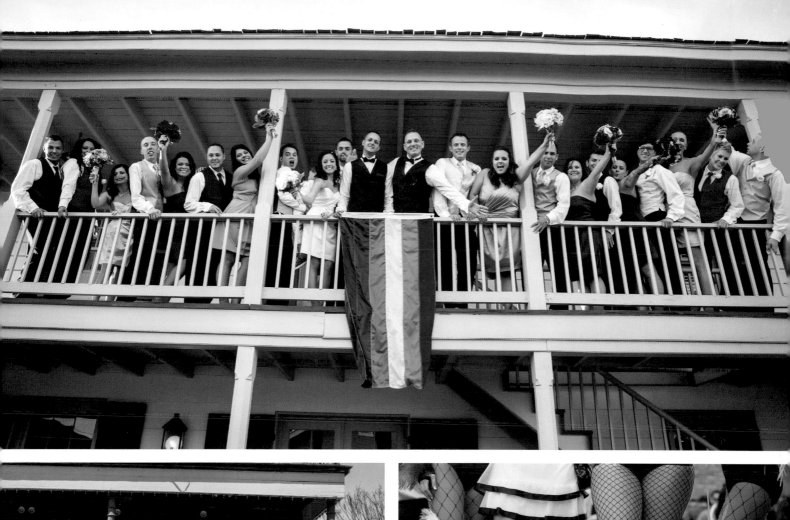

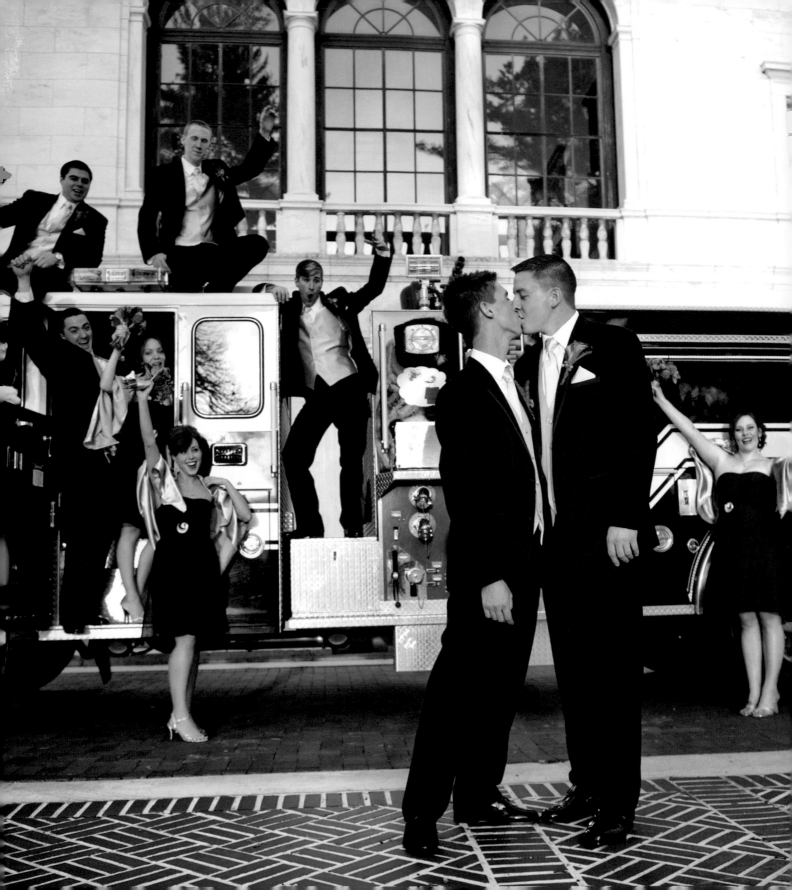

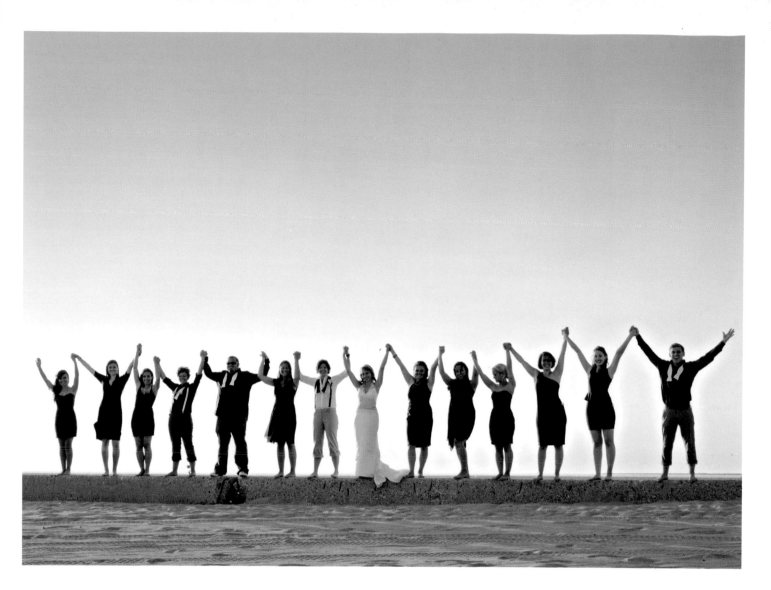

Another look. [OPPOSITE] Sometimes the same group and the same location prop (see page 140) can tell an entirely different story. Don't be afraid to consider all the angles!

OFFBEET PRODUCTIONS
Nikon D700, 24–70mm lens, ISO 100, 1/125 sec. at f/2.8

Show your support. [ABOVE] Beyond celebrating a relationship milestone for the couple, same-sex weddings also represent a marriage-equality milestone for all of us. All the more reason to ask the group to show their support with a unified cheer and hands raised in triumph.

IT'S BLISS PHOTOGRAPHY
Canon EOS 5D Mark II, ISO 200, 50mm lens, 1/160 sec. at f/11

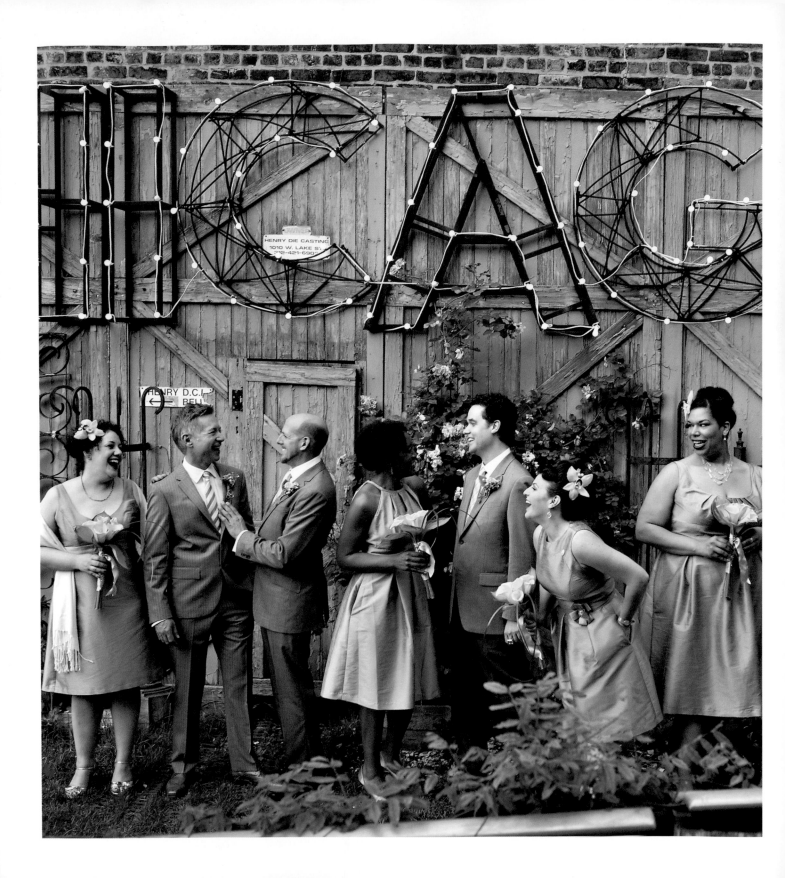

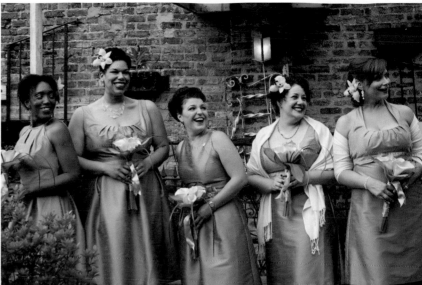

While the cats are away . . . [OPPOSITE]
Are you waiting on the couple to return
from a private moment or other wedding
responsibility? Consider spending some time
with the wedding party without the couple, and
photograph them interacting with one another,
especially if the group is already somewhat
tight-knit. Their rapport might inspire some fun
results or creative ideas for the group photo
once your grooms (or brides) arrive.

ARIELLE DONESON PHOTOGRAPHY
Canon EOS 5D Mark II, 24–70mm lens, ISO 800,
1/60 sec. at f/6.3

Mix it up. [TOP LEFT] If finding balance in the
wedding party means creative placement of the
attendants on either side, consider mixing it
up. In this case, the two "bridesmen" serve as
bookends for better visual balance even though
this representation did not reflect the brides'

wedding-party organization. Same sex couples
are already breaking new ground and are often
amenable to doing things differently; just make
sure you check in with the couple first.

AUTHENTIC EYE PHOTOGRAPHY
Canon EOS 5D Mark III, 24–70mm lens, ISO 200,
1/400 sec. at f/5.0

Your peripheral vision. [TOP RIGHT]
Sometimes, the guests' reactions behind or to
the side of the photographer make for a great
photograph and keepsake. Keep that camera
to your eye as much as possible so that you can
pivot quickly to get the spur-of-the-moment
image and the alternate take on the moment at
hand, especially when it comes to an animated
wedding party.

ARIELLE DONESON PHOTOGRAPHY
Canon EOS 5D Mark II, 24–70mm lens, ISO 800,
1/100 sec. at f/6.3

7

WEDDING
RITUALS

WHETHER WE'RE TALKING ABOUT commitment ceremonies, religious ceremonies, civil unions, or a legal marriage ceremony, there are two universal threads woven into today's same-sex weddings. First, same-sex couples may lean on relevant rituals to guide their ceremonies and receptions, but they often turn wedding traditions inside out to create personally meaningful celebrations for themselves. And second, because marriage is not available to all gay and lesbian couples (and has only recently become available to some), same-sex weddings are considered something special; the LGBTQ community does not take for granted the right to marry. These two coexisting threads

Parents-of-a-groom, Dara and Kolly, walk their son, Adi, down the aisle in Alice Millar Chapel at Northwestern University in Evanston, Illinois.

DAWN E. ROSCOE PHOTOGRAPHY
Canon EOS 5D, 85mm lens, ISO 1000, $\frac{1}{100}$ sec. at f/3.5

mean that same-sex weddings can be powerful and transformative for the guests in attendance, bringing a new understanding and appreciation of same-sex relationships.

The dynamism of emerging trends in same-sex weddings has had ripple effects for all involved, and a photographer needs to be aware of how prospective clients want to approach their weddings in order to be well prepared. Generally speaking, it's important that you approach a planning session with an open mind and follow the couple's lead, but be prepared to offer guidance.

Mother-of-a-bride, Nancy, watches her daughter, Kristen, exchange vows with her partner, Emily, at this Vermont wedding.

AUTHENTIC EYE PHOTOGRAPHY
Canon EOS 5D Mark II, 70–200mm lens, ISO 400, $\frac{1}{6400}$ sec. at f/4.0

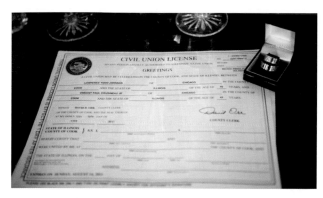

There are few straight couples who would request an image of their marriage license be included in their wedding album. For same-sex couples, the certificate serves as a powerful symbol of newfound legal status.

DENVER SMITH PHOTOGRAPHY
Canon EOS 5D Mark II, 24–70mm lens, ISO 1000, $\frac{1}{30}$ sec. at f/2.8

Plan ahead to consider how details like attire, color scheme, or flower combinations for two brides or two grooms might impact the photographs. Choices may range from the traditional to the unique or from everything in pairs to complementary options.

Be prepared to photograph all kinds of unions—from formal, traditional religious weddings to casual elopements at City Hall. And remember that some couples may have more than one ceremony. Don't be afraid to create packages that are designed specifically for couples who may seek services for legal elopements, City Hall weddings, or receptions at home following an out-of-state legal elopement.

Don't assume that parents of the couple are certain of their role in the wedding or that they will attend. For some, this can be a delicate topic, and the traditional wedding rituals may be adjusted to draw less attention to missing family members.

CEREMONIAL CONTEXT

As we've discussed, the types of ceremonies that LGBTQ couples choose for themselves include a lot of variety. And this variety not only will impact the photography options for the day of the wedding but should also influence the way in which you approach working with couples. That is, it is always a best practice—with all clients, regardless of sexual orientation—to avoid making assumptions about their plans and needs. Lead with your experience and expertise, but not at the expense of overlooking your clients' individual needs.

Similar to heterosexual couples, same-sex couples may be inclined to include their own family and/or religious wedding traditions in their ceremonies, but the additional choices that same-sex couples make might be influenced by the existence of marriage equality (or lack thereof) in their home states; the support (or lack thereof) from parents; the degree to which the couple is "out" as a couple in their lives; the number of years the couple has been

Jennifer and Mandy had a civil ceremony in New York City, a spiritual wedding on a dramatic cliff in Hawaii, and a party with family and friends in Memphis.

SEAN KIM PHOTOGRAPHY
Canon EOS 50D, 50mm lens, ISO 200, 1/100 sec. at f/2.2

together; the type (or number!) of weddings or commitment ceremonies the couple has previously had; and/or the age of the couple and the decade in which they "came out."

Increasingly, and for better or for worse, same-sex weddings are evolving to look more like straight weddings, and conversely, straight weddings are growing to look more like gay and lesbian weddings. As a result, there's some wonderful creativity and meaningful relationship ritual emerging for all couples in the market today. But keep in mind that a straight couple might choose a destination wedding in order to get married in a sentimental or fun location,

but a gay couple might choose a destination wedding to get married where it is legal because they don't have that same right at home. A straight couple might choose a backyard ceremony to save money on a reception rental, but a same-sex couple might do so because they are not able to marry in their church, leaving them fewer options.

Regardless of the type of LGBTQ ceremonies you might be photographing—nonlegal weddings, legal weddings, legal elopements (out-of-state marriages), and City Hall marriages—you will find that these weddings may be large in size or small in size, driven by tradition or the farthest thing from it. Parents might be involved in the planning, or they might not. Budgets might be small, medium, or large. It could be the couple's first wedding or its third (to each other!). The couple might have been together for three years or thirty.

Until marriage equality is recognized in every state, there will continue to be a variety of same-sex wedding combinations. Only after that point will most same-sex unions follow the more predictable "marriage tradition" of dating, getting engaged, and then getting (legally) married. Thus, being prepared to respond to the range of requests you might receive, while also being prepared to create thoughtful engagement and wedding packages for your LGBTQ clients, will be essential.

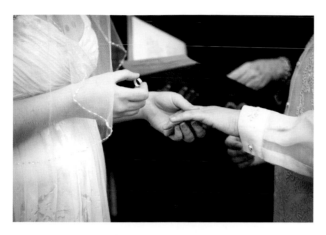

Amanda and Isabel exchange rings during their legal elopement ceremony at Boston's City Hall in 2013.

KRISTIN CHALMERS PHOTOGRAPHY
Nikon D700, 24–70mm lens, ISO 400, $1/_{100}$ sec. at f/3.5

RITUALS REVISED AND REPURPOSED

Wedding traditions have been designed for, and to date have evolved with, a male and female couple as central players. But just as same-sex couples have put their own touches on the old traditions and bride/groom roles, so, too, have many open-minded and forward-thinking wedding professionals brought tried-and-true traditions and their seasoned touches to same-sex weddings.

Though our advice about understanding and respecting the physical and cultural differences for LGBTQ couples remains in full force and effect, it's certainly acceptable to embrace and advise a couple to follow some of the mainstream "day of" rituals, particularly when it makes for a fun wedding album and a thoughtful visual wedding-day narrative; but it is essential that wedding professionals and photographers avoid the assumption that mainstream bride/groom traditions are best for all couples. To help you get started, we've highlighted a few inside looks at some of the most common wedding rituals, including getting ready and "reveals"; ceremonies and kissing; and showcasing attire, flowers, and rings.

Celebrant Jo Maden signs Emily and Alexandra's marriage license, formalizing their marriage paperwork in September 2013.

AUTHENTIC EYE PHOTOGRAPHY
Canon EOS 5D Mark III, 24–70mm lens, ISO 200, $1/_{250}$ sec. at f/4.0

CEREMONY RITUALS
new twists on old traditions

One by-product of the variety of commitment ceremonies selected by same-sex couples is that most couples will lean on whatever tradition or ritual suits them best and is most meaningful to the moment at hand. Examples include couples borrowing rituals from their own cultural history or from cultures other than those with which they identify because they relate to the symbolism. These rituals often include the breaking of the glass (from Jewish weddings), jumping the broom (from the custom of American slaves who used the symbol to recognize a ceremonial commitment in the absence of access to legal marriage), or handfasting (an ancient ritual of joining hands by clasping or wrapping cord to symbolize a couple tying the knot).

As marriage licenses become more readily available to same-sex couples, however, these traditions are relied upon less to ritualize the union and, instead, have been replaced with traditions like elopement trips to marry legally in City Hall and readings from the *Goodridge v. Department of Public Health* decision, the landmark ruling that validated same-sex marriage in Massachusetts in 2003.

behind the lens

For additional examples of more ceremony rites, including a ritual from a traditional Zoroastrian blessing ceremony called Sagan, see pages 184–85 of the inspiration gallery.

KRISTIN CHALMERS PHOTOGRAPHY
Nikon D700, 24–70mm lens, ISO 200, $\frac{1}{500}$ sec. at f/4.0

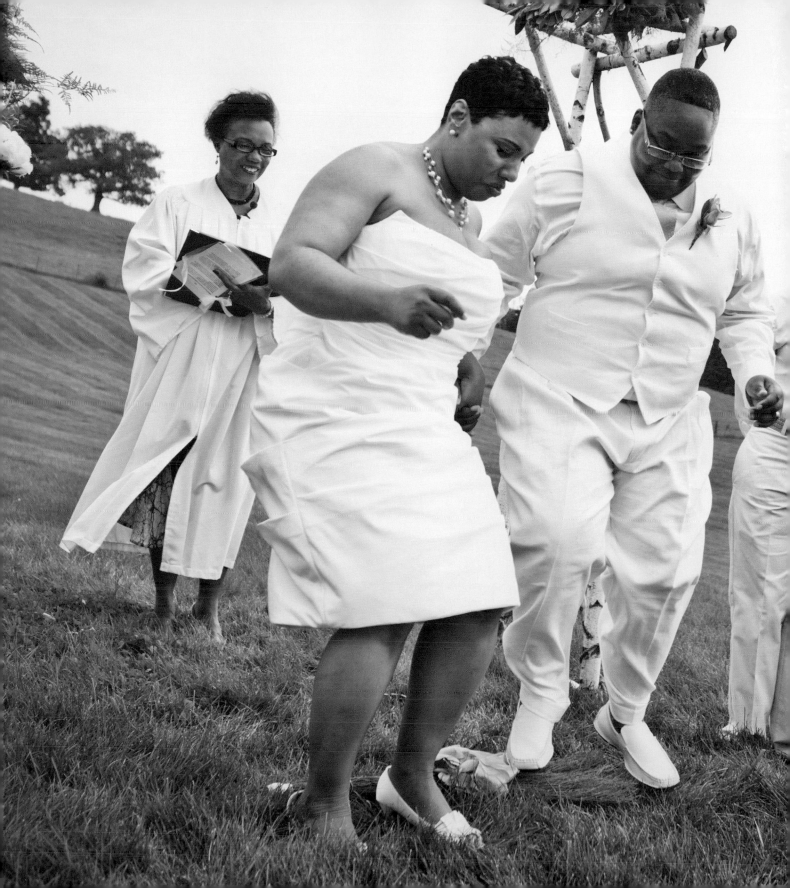

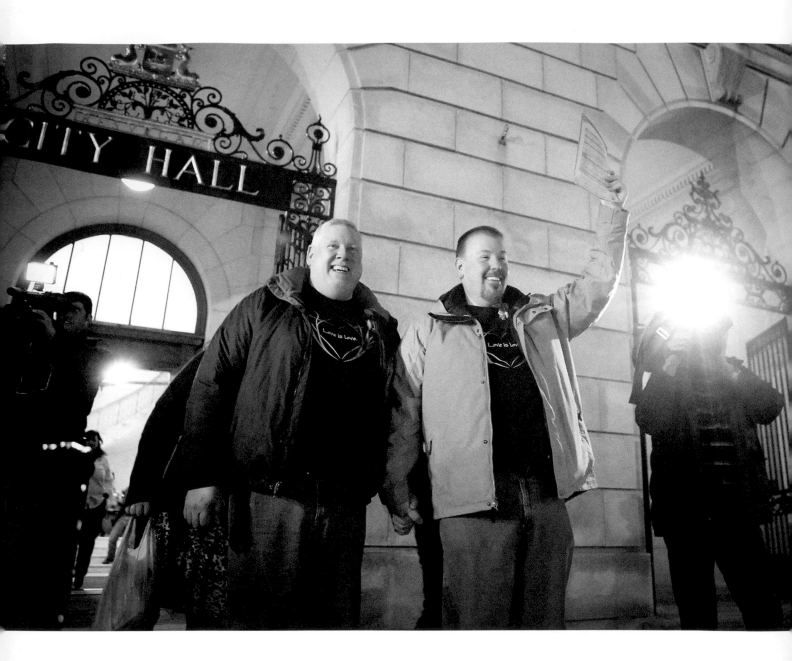

ELOPEMENT
from practical escapism
to legal practicality

A straight couple might choose to elope so as not to deal with family and wedding drama, but a same-sex couple might choose to elope because it's the only legal option they have. For photographers living in states where same-sex marriage is recognized (and especially in the bigger metropolitan areas), it's important to be prepared to support couples traveling across state lines with simple elopement-oriented wedding packages and an LGBTQ-friendly referral network. Though these events may not feature a wedding party, a large guest list, and emotional parents, they are nonetheless significant and emotional moments for the couple, whether they've been together for five years or fifty. These services will be especially important in the time period between the decision by the U.S. Treasury to recognize marriage equality for all legally married couples in its tax programs (2013) and the day that the Supreme Court (or each of our fifty states—whichever comes first!) recognizes marriage equality as the law of the land.

Featured here are Steven and Michael, with marriage license in hand at Portland City Hall, just after midnight on December 29, 2012; they were the first couple to legally marry in Maine.

behind the lens

In the early 2000s, same-sex couples in the United States eloped to Canada, which has recognized marriage equality in most of its provinces since 2003 and nationwide since 2005. In fact, it was Edith Windsor and Thea Spyer's legal elopement from New York to Canada in 2007 that set the stage for the dramatic result in 2013 when the United States Supreme Court overturned section three of DOMA (the Defense of Marriage Act), paving the way for marriage recognition rights at the federal level, even for couples living in states that do not yet recognize same-sex marriage.

AUTHENTIC EYE PHOTOGRAPHY
Canon EOS 5D Mark II, 24–70mm lens, ISO 3200, $\frac{1}{60}$ sec. at f/2.8

GETTING READY . . . TOGETHER
no surprises here

The rituals surrounding the process of getting ready for a wedding are an excellent example of the results of traditional wedding rituals intersecting with thoughtful photographers and sentimental same-sex couples. The more creative you and your clients wish to get during a preceremony session, the more you'll need to remember that there are also practical implications involved in photographing a wedding with two brides or two grooms.

Generally, at a heterosexual wedding, the primary photographer stays with the bride while she gets ready, and the second photographer (if there is one) covers the groom and his attendants. In the two-brides or two-grooms scenarios, you must consider how to best serve your clients. If the brides (or grooms) will be getting ready together, then it's much easier to work the event alone as a primary photographer. If each of the brides or grooms wants a preceremony session, each does not want to be seen by the other partner, and the logistics of the day do not allow for back-to-back sessions, then the couple will need to think seriously about booking two teams (i.e., one studio with two photographers, two makeup artists, and so on) to help them accomplish this goal on a tight time frame.

behind the lens

There is no right or wrong way to do the preceremony routine. It is well advised, however, that you have this conversation with your clients in advance of the wedding day.

DENVER SMITH PHOTOGRAPHY
Canon EOS 5D Mark II, 24–70mm lens,
ISO 1600, $\frac{1}{50}$ sec. at f/2.8

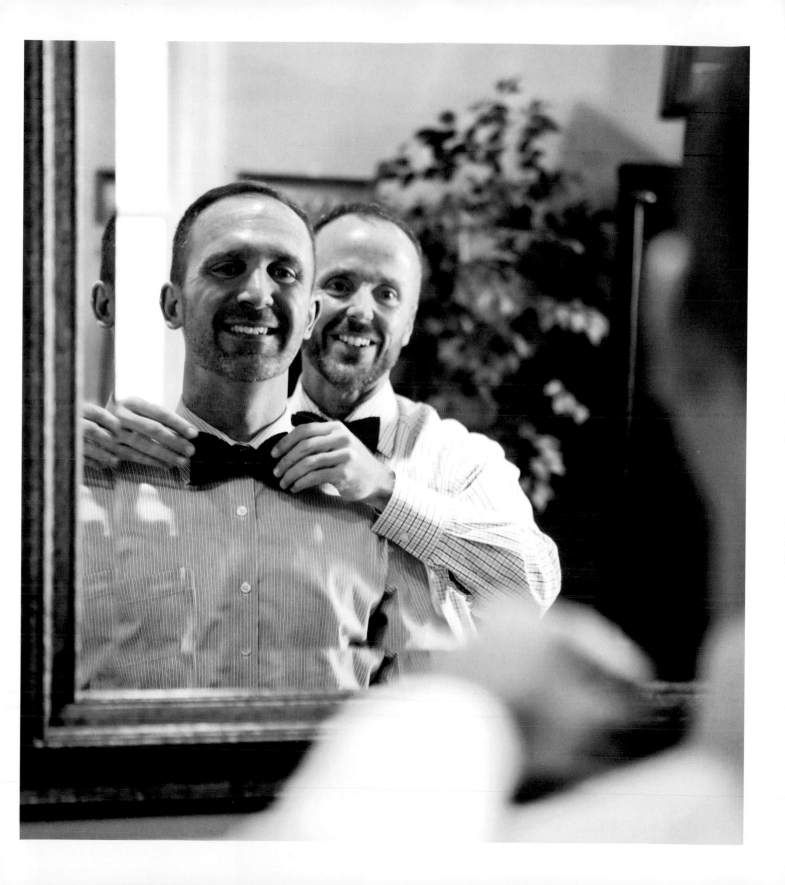

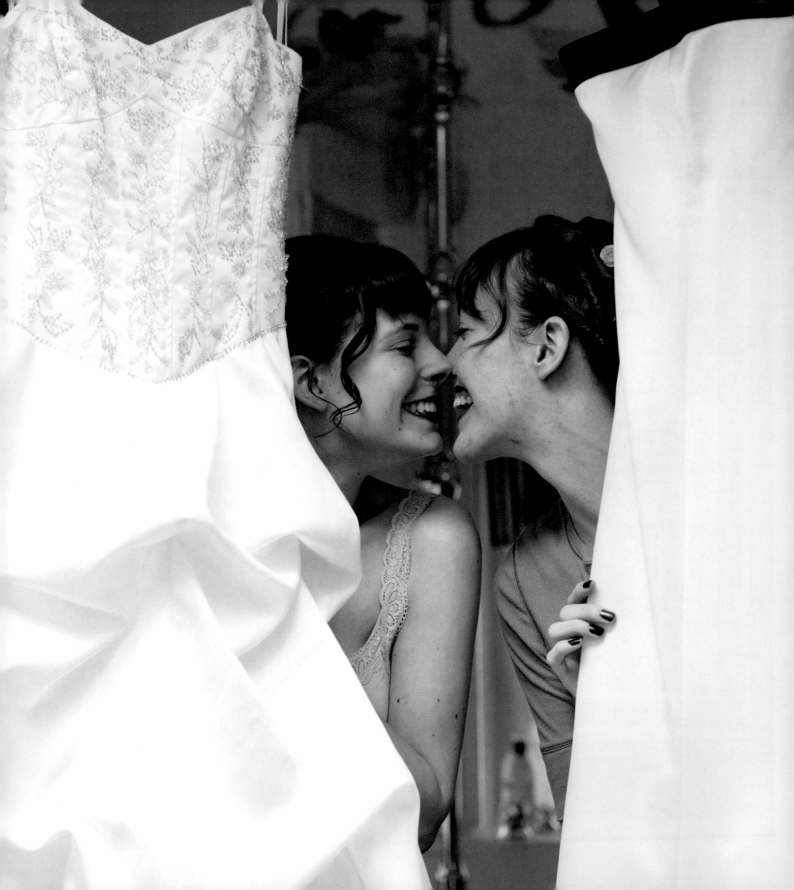

THE ALMIGHTY WEDDING GOWN
a double vision

The "average bride" spends over a thousand dollars on her wedding gown. No surprise, then, that the wedding dress has become such a ubiquitous symbol and hallmark of all things wedding. With a price tag like that, and with so much energy focused on what "the bride" will wear, it's fitting to expect that The Gown will have its own creative and featured place in the wedding album curated by the photographer for the couple.

But what do you do when you have two brides with two gowns? Feature them both? Feature them individually? Or what about two brides with no gowns? Or only one gown? Considering and capturing attire details presents a new challenge and opportunity for the creative professional—with or without those to be attired—that clearly celebrates the clothing choices a couple has selected for their wedding day. And these are important questions that are best asked in advance of the Big Day.

Here, photographer Maggie Winters captures a delightful moment between two brides that not only captures their attire in the obligatory "dress shot" but also adds a playful, personal, and romantic twist.

behind the lens

When working with two brides who want to capture their preceremony routines, consider adding at least one hour to the time you typically budget for photographing one bride, her attire, and the time it takes for her to get ready. You might want to add a bit more time if the brides haven't seen each other or their gowns and want to save that moment for a Big Reveal.

MAGGIE WINTERS PHOTOGRAPHY
Nikon D700, 24–70mm lens, ISO 200, $\frac{1}{160}$ sec. at f/4.0

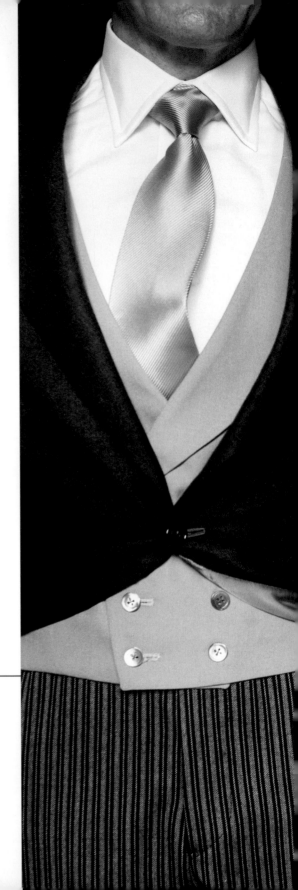

NO GOWN? NO PROBLEM!
let's hear it for the boys

The first thing most photographers do upon arrival at the wedding site is to find the bride (presuming that there is one) and photograph the wedding gown. Then the shoes, handkerchief, garter, jewelry, and so on. Notice a theme here? It's all women's attire. Traditionally, an overabundance of energy and emphasis is put on the bride and the almighty wedding gown, and suits (not to mention grooms!) are often relegated to bit players at straight weddings. But we say, "No gown? No problem!" A wedding without a gown provides the chance to give two suits the royal treatment.

It can be challenging to photograph a suit or tux without a person wearing it, because unlike a wedding gown, the suit won't necessarily hold its form on its own. Ideally, to underscore the point that this is a two-groom wedding, the attire should be photographed together, preferably overlapping to show the connection. Then, once the grooms are dressed, take a moment to capture their attire again. If the attire is similar, photograph it in a way that highlights that choice. If there are differences—even slight ones, like the pinstripe twist featured here—take care to accentuate those details through selective focus, spot lighting, or another creative technique.

behind the lens

Ask your clients if they have any clothing or attire choices that are personally meaningful or symbolic (beyond the typical something borrowed, something blue), and make sure to take pictures of those items during the preceremony, ceremony, and reception.

HUDSON RIVER PHOTOGRAPHER
Canon EOS 5D Mark III, 35mm lens, ISO 1600, $\frac{1}{160}$ sec. at f/3.5

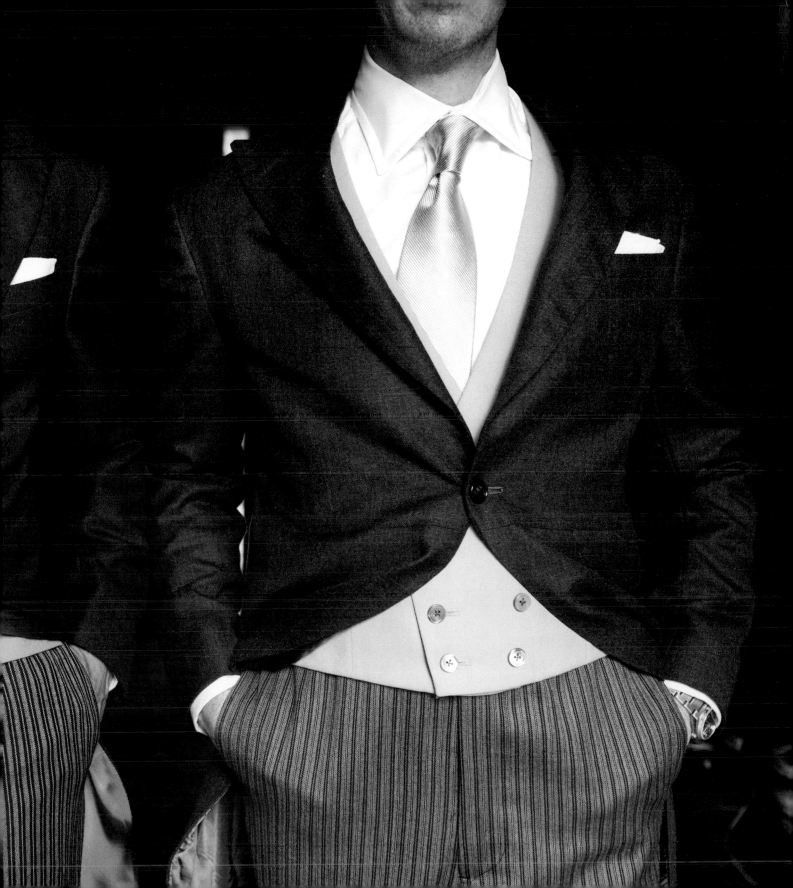

ATTIRE
outside the box

A couple who chooses to go with a dress and shirt (or suit) offers a fun challenge for photographers. How can you photograph their attire without losing the message that this couple is not your average straight couple?

Photographer Kristin Chalmers captures the beautiful detailing of Isabel's traditional dress shirt, which was made in the Philippines—her home country—out of pineapple fibers and serves as a beautiful complement to Amanda's dress. The setting of the bed in their bed-and-breakfast adds a taste of historical period and luxury, which, considered in the whole of the wedding album, rounds out the Boston City Hall elopement experience this Florida-based couple chose for themselves.

behind the lens

The usual attire and accessories "to photograph" checklist is a great place to start. But push yourself for creative interpretations or special ways to showcase the two-bride or two-groom twist. For more examples of details captured, refer to pages 192–93 of the inspiration gallery.

KRISTIN CHALMERS PHOTOGRAPHY
Nikon D700, 24–70mm lens, ISO 1000, $^1/_{100}$ sec. at f/4.0

MAKE IT A DOUBLE!
the little things mean a lot

behind the lens

Ars Magna Studio also offers a fabulous example of making it a double, while showcasing individuality, all with a nod to traditional black-and-white wedding attire (see page 192 in the inspiration gallery).

ARIELLE DONESON PHOTOGRAPHY
Canon EOS 5D Mark II, 24–70mm lens, ISO 800, $\frac{1}{100}$ sec. at f/2.0

Detail shots of attire offer a chance to capture the symbols and subtle touches of a wedding. Photographing a groom's cufflinks comes straight (ahem) from the traditional playbook. You can also play on the grooms' pairing of ties, shoes, pocket squares, and doting mothers, or on the brides' pairing of sashes, shoes, hair accessories, or proud grandmothers. Also remember that it's important to look for and showcase the complementary accessories (including any of the above for either gender) that a couple might have, especially if they identify as genderqueer or present as two brides in a suit and gown.

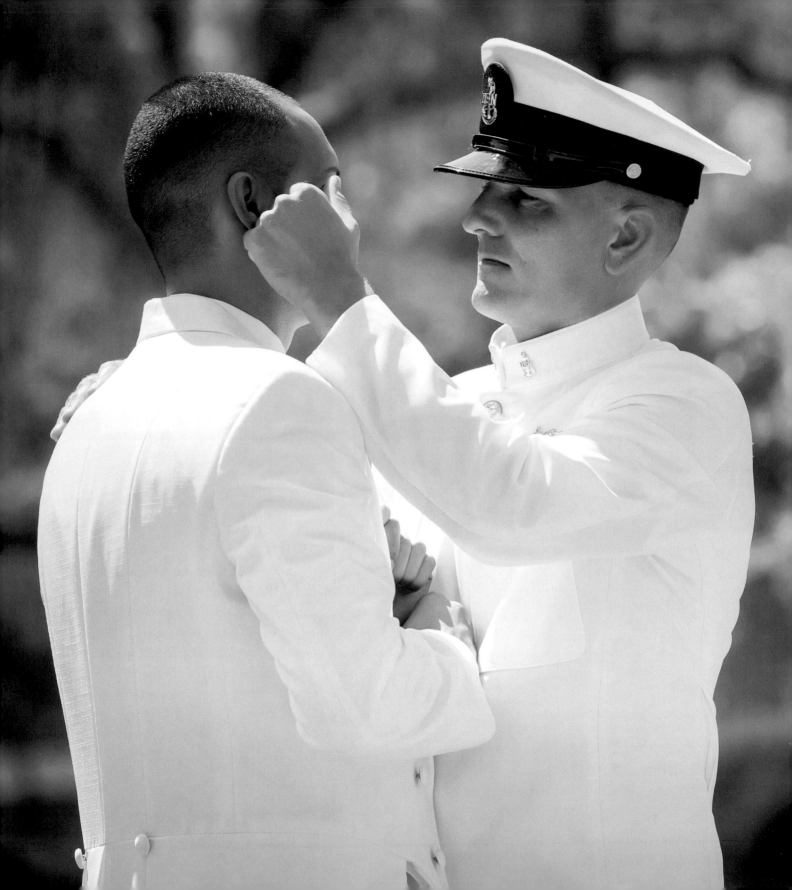

THE REVEAL
love at first sight

Interested in a different first-look approach to commemorate the occasion? Have a second photographer keep the lens trained on a parent or other expressive guest. Or be prepared to capture a moment when someone significant to the couple sees them for the first time. For many same-sex couples, the wedding commemorates so much more than a child leaving the nest or starting a new life with someone else. There are emotional stories to be told of the journey from coming out to getting legally married, and the anticipation of the start of the ceremony can offer a moment of "reveal" worthy of the photographer's attention.

RED STONE PHOTOGRAPHY
Canon EOS 5D Mark III, 70–200mm lens, ISO 400, $\frac{1}{1600}$ sec. at f/4.5

"First looks" have traditionally been reserved for that moment when a bride is revealed to her groom and have customarily taken place during the wedding ceremony. More recently, however, couples have chosen to stage a private "reveal moment" before the wedding or have avoided it altogether. Ultimately, that choice is up to the couple. As such, there's no reason that two grooms or two brides can't participate in this tradition as well. But first, make sure to discuss the option of a first look with the couple prior to the ceremony.

From a visual perspective, the reveal provides an excellent opportunity to capture strong emotional moments, like the one pictured here. It's a time that's full of excitement, joy, and sometimes a happy tear or two—all of which make for great photographs. From a practical perspective, having the opportunity to be with the couple before the ceremony also affords a private and unencumbered time to capture a few of the formal wedding-day portraits. This may allow the couple to enjoy more time at the cocktail reception if they're having one and give you more time to capture the reception details before guests enter the room.

JOINT REVEAL
two sides of the same coin

A reveal or first look can also happen simultaneously, so neither is revealed to the other but rather the couple is revealed to each other. A simple way to capture this is to have both individuals walk out from separate doors in a single hallway at the same time.

A solo photographer working on an event might feel a bit overwhelmed at the thought of catching two simultaneous reactions of a reveal, but a wide-angle lens can help you capture the very first mutual moments. Because the emotion of the moment lasts a bit longer than you might expect, a quick pivot for two different close-ups from the same position can also capture each person's reaction to the other to round out the album.

behind the lens

As you discuss the option of a first look with your couple, speak with them individually about what surprises one might have in store for the other. Perhaps one partner did the attire planning, so the other is more unaware of the final details. Perhaps one has a special gift to give. Learn what to expect—and when—so that you can prioritize where you'll train your lens when the moment matters most.

KAT FORDER PHOTOGRAPHY
Nikon D800, 24–70mm lens, ISO 2000, $\frac{1}{100}$ sec. at f/3.2

BALANCING WEDDING BANDS
put two rings on it

Once upon a time, rings were photographed side by side in their opened boxes and on the hands of the newly betrothed. Now we see images of rings defying gravity, delicately placed on wedding cakes and flowers, or splashing in a glass of champagne. So, yes, it's official: the creative wedding-ring photo has become a must-have in a wedding album, and same-sex couples love to have their combinations of bands and/or solitaires proudly featured as well.

How do photographers get those rings to stand like that? Easy, we use dental wax. Dental wax is this sticky, goopy stuff that makes braces more comfortable; it can also be used to bond a ring to another material. It's a must-have tool when you're photographing two rings that are the same style and size and don't fit inside each other as easily as two rings of different styles and sizes.

behind the lens

Not a fan of dental wax or gravity-defying tricks to display rings? Look for other handy props or nearby wedding decorations to serve as props that contribute to the story. See page 193 in the inspiration gallery for another look.

AUTHENTIC EYE PHOTOGRAPHY
Canon EOS 5D, 100mm lens, ISO 400,
$\frac{1}{25}$ sec. at f/10

SUCCULENTS
an unexpected pairing

behind the lens

Traditionally, a man wears a boutonniere on the left lapel, so it's important that a photographer consider how this accent appears to the camera. When standing in a classic shoulder-to-shoulder pose, one boutonniere is likely to be hidden. This can be an insignificant detail, but now that creative expression is common and the buttonhole more scarce on suit lapels these days, two grooms might want to reconsider boutonniere placement for maximum effect.

AUTHENTIC EYE PHOTOGRAPHY
Canon EOS 5D Mark II, 24–70mm lens, ISO 400, $\frac{1}{160}$ sec. at f/2.8

An image of two bouquets or two boutonnieres paired together is another example of telling the story of a same-sex wedding through its details. Options include emphasis on the pairing of the flowers, the choice of the flowers, and the style of presentation. If photographed well, these details can tell us a bit more about the couple and help to make it clear that this is not your run-of-the-mill wedding.

Typically, a straight groom's boutonniere gets ignored. Here, two boutonnieres made of succulents by Seaberry Farm are backlit by the sun, highlighting the soft, silver hair-like details.

MAKING AN ENTRANCE
who needs rice when you have glitter?

Deciding how or whether to walk down the aisle may be a more complicated decision for a same-sex couple than for a bride and groom who already have traditions prescribed for them. Some same-sex couples might not have parents at or participating in the ceremony; or the couple might have been together for many years and the ritual of being "given away" by a parent (or parents) doesn't feel organic to them. Some couples might not be interested in either the wedding formality of an aisle or the pomp and circumstance of a processional.

Some couples, however, might wish to come down the aisle (or two aisles!) together as a statement of mutuality or equal footing, or they might wish to avoid the aisle altogether. Some couples might also embrace a traditional wedding procession and follow it explicitly. Regardless of the circumstance, talk with your clients about the logistics of how they will enter and exit the ceremony, and learn more about what images they might wish to have of the ritual. Help them to understand that two brides and two aisles might require a second photographer, or otherwise work with them to design a few moments when, regardless of how they will enter and exit, you can capture the emotions of the moment.

behind the lens

Did something big just happen? Take a moment to see what's happening with the guests. How are they reacting? Sometimes capturing the guests' reactions to a moment in the ceremony can be as powerful—if not more so—as the moment itself.

HUDSON RIVER PHOTOGRAPHER
Canon EOS 5D Mark III, 135mm lens, ISO 800, $\frac{1}{1250}$ sec. at f/4.5

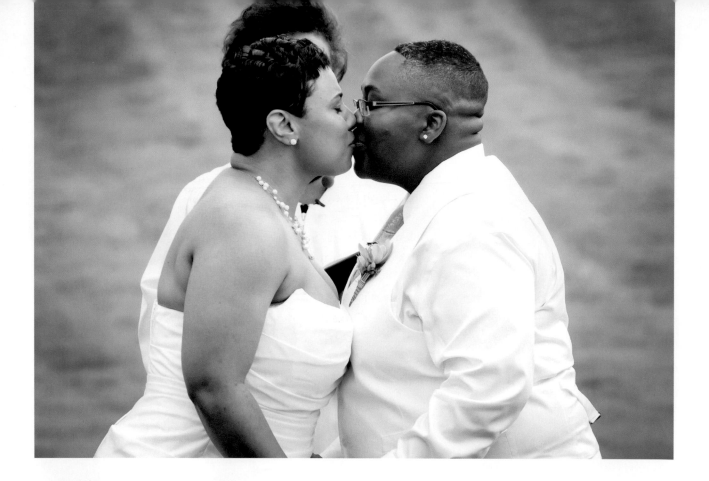

THE CEREMONY KISS
sealing the deal

You may now kiss the . . . bride. Whether you've got two brides or two grooms, it's a twofer, and any officiant who uses this line (or its other half: "You may now kiss the groom") usually gets a happy laugh from those assembled. Be sure to ask the couple if they will kiss at the end of the ceremony. There are some couples who haven't kissed in front of their families before and some whom you might need to break up so that you can get on with the reception. Either way, ask your couple in advance if they plan to "seal the deal" with a kiss, and make sure you're in position to capture it.

behind the lens

What kind of kiss should you expect at the end of the ceremony? Should you be expecting one at all? Check out page 186–87 for more examples of ceremony kisses.

KRISTIN CHALMERS PHOTOGRAPHY
Nikon D700, 70–200mm lens, ISO 200, $\frac{1}{500}$ sec. at f/4.0

THE RECEPTION
tweaking tradition

Although no two receptions are ever the same, most weddings follow a similar formula, adhering to certain traditions and skipping others. Same-sex weddings are no different in this regard, except that many traditions that are kept have to be tweaked to fit the two brides or two grooms who are celebrating. For example, two brides may choose to toss their bouquets at the same time, or they may choose to toss their bouquets separately. Some might even toss a bouquet to a crowd of single *men* and women. Similarly, the couple might choose to dance in various combinations (traditional and otherwise) or not at all. To be most prepared to photograph a same-sex couple's wedding reception, it's important to talk about the flow of the event in advance, understand what the couple (or the event planner) has in mind for the celebration, and remember that the "script" you've followed for most of the heterosexual weddings you've worked might not apply as a shorthand for effective preparation.

behind the lens

Just as you may have two brides tossing bouquets or two grooms dancing a first dance, you might also find some variation in the groups gathered to catch the bouquet or dance with the grooms. Ask your couple what their reception ritual plans are and offer them counsel as requested. In either case, feel free to embrace tradition or tweak it. View pages 188–91 of the inspiration gallery for more examples of first dances and other reception rituals.

HUDSON RIVER PHOTOGRAPHER
Canon EOS 5D Mark II, 24mm lens, ISO 800, $1/125$ sec. at f/3.5

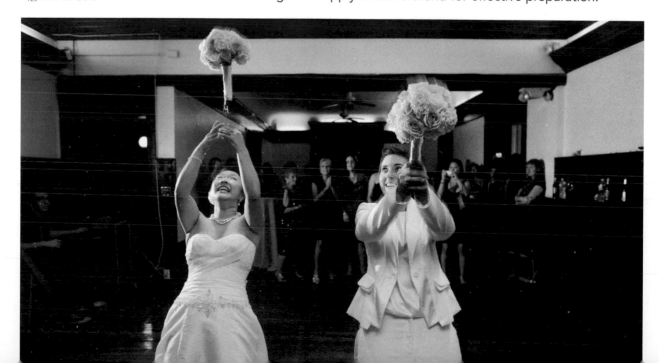

INSPIRATION GALLERY
additional event poses and ideas

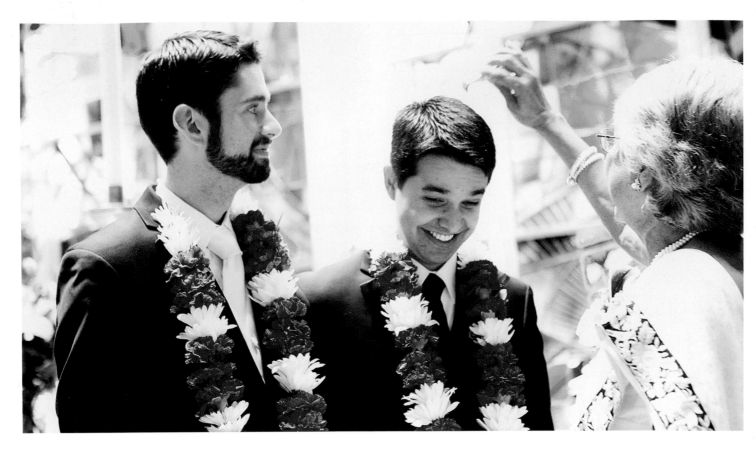

Marriage rites. Expect variation, personalization, and a blending of traditional and modern civil and religious elements at same-sex wedding ceremonies—including
the Zoroastrian blessing shown above and the candle lighting, handfasting, glass breaking, and vow exchange rites shown opposite.

[ABOVE] DAWN E. ROSCOE PHOTOGRAPHY
Canon EOS 5D, 24–70mm lens, ISO 800, $\frac{1}{60}$ sec. at f/2.8

[OPPOSITE, CLOCKWISE FROM TOP LEFT]
BRI MCDANIEL PHOTOGRAPHY
Canon EOS 5D Mark II, 100–300mm lens, ISO 5000, $\frac{1}{160}$ sec. at f/5.6

HUDSON RIVER PHOTOGRAPHER
Canon EOS 5D Mark III, 85mm lens, ISO 3200, $\frac{1}{200}$ sec. at f/2.2

ARIELLE DONESON PHOTOGRAPHY
Canon EOS 5D Mark II, 70–200mm lens, ISO 200, $\frac{1}{125}$ sec. at f/2.8

HUDSON RIVER PHOTOGRAPHER
Canon EOS 5D Mark II, 85mm lens, ISO 3200, $\frac{1}{800}$ sec. at f/2.2

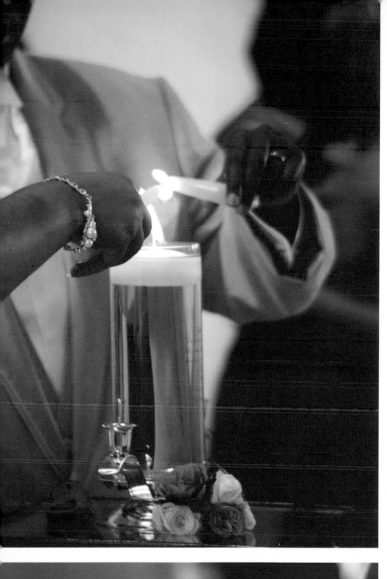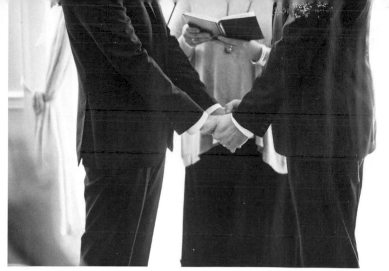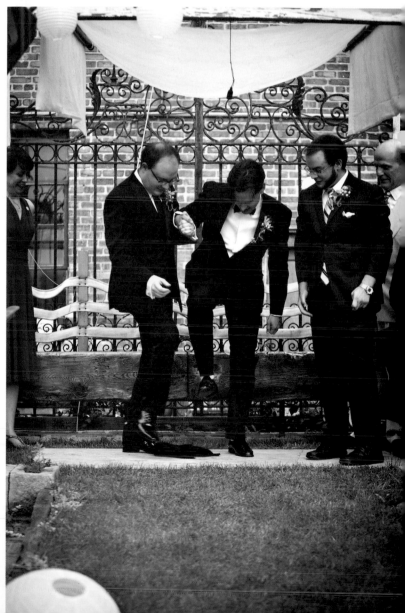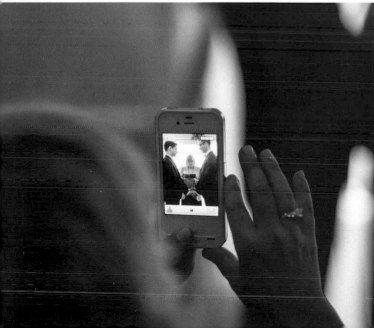

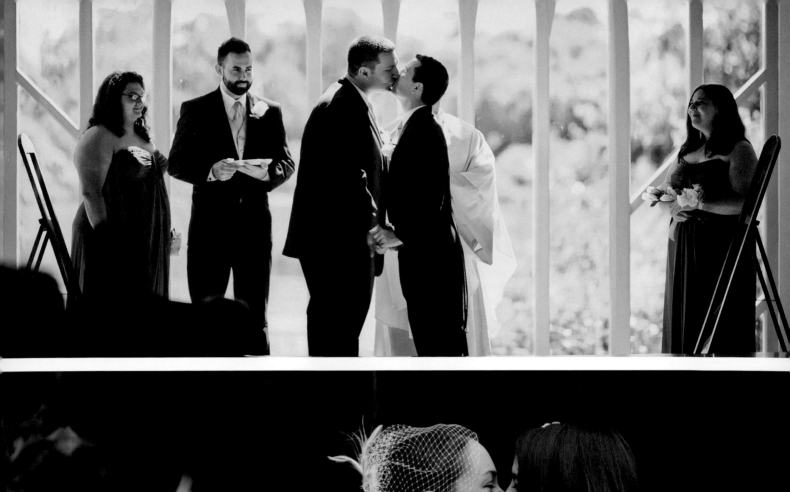

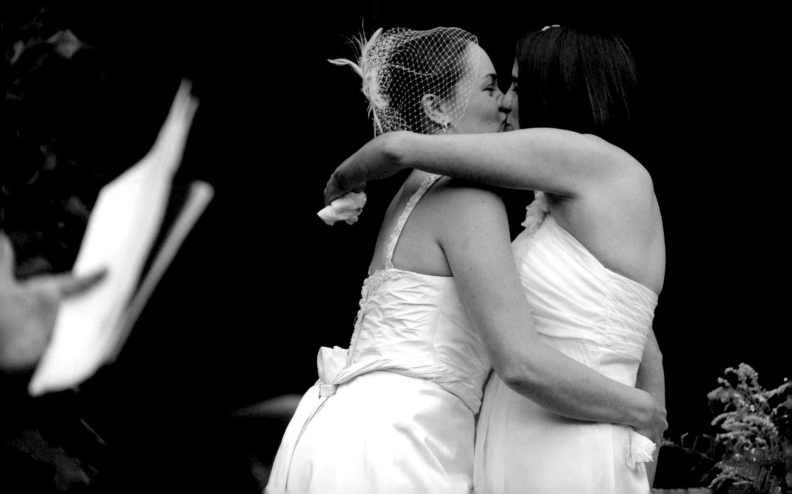

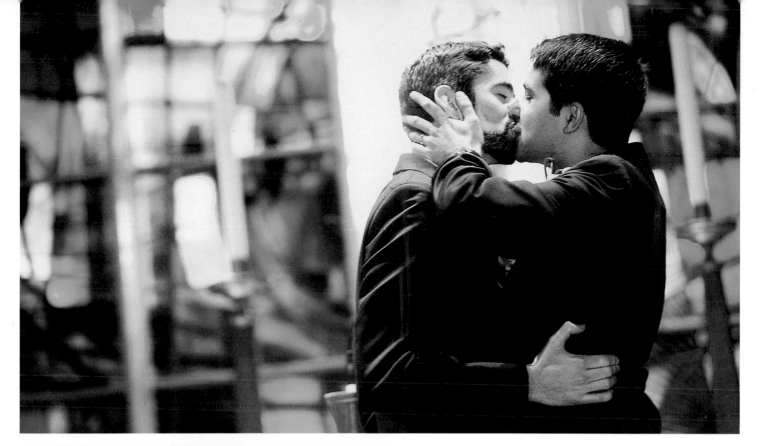

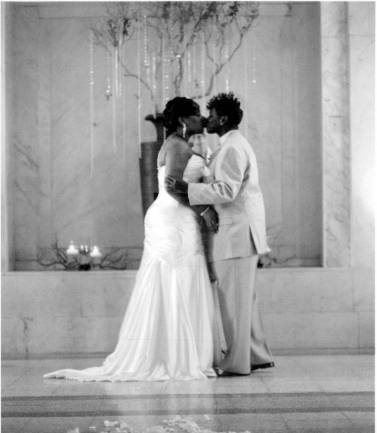

Sealed with a kiss. Most couples will complete the ceremony with a kiss, but not all will. Consider your options and their intentions prior to the ceremony so that you can be in position to capture the moment of shared celebration.

[OPPOSITE TOP] JIMMY HO PHOTOGRAPHY
Canon EOS 5D Mark II, 135mm lens, ISO 2000, 1/2500 sec. at f/2.0

[OPPOSITE BOTTOM] WHITMEYER PHOTOGRAPHY
Nikon D700, 140mm lens, ISO 1600, 1/1250 sec. at f/2.8

[TOP] DAWN E. ROSCOE PHOTOGRAPHY
Canon EOS 5D, 24–70mm lens, ISO 800, 1/60 sec. at f/2.8

[BOTTOM] BRI MCDANIEL PHOTOGRAPHY
Canon EOS 5D Mark II, 85mm lens, ISO 5000, 1/800 sec. at f/1.8

Let's dance. Some couples have a first dance. Some don't. Some dance with a parent. Some don't. Expect the unexpected, but be prepared for traditional reception moments as well.

[ABOVE] ARIELLE DONESON PHOTOGRAPHY
Nikon D700, 50mm lens, ISO 1000, $\frac{1}{100}$ sec. at f/1.4

[RIGHT] ANDREA FLANAGAN PHOTOGRAPHY
Canon EOS 5D Mark II, 50mm lens, ISO 1600, $\frac{1}{125}$ sec. at f/2.2

[OPPOSITE] KRISTIN CHALMERS PHOTOGRAPHY
Nikon D700, 24–70mm lens, ISO 800, $\frac{1}{60}$ sec. at f/2.8

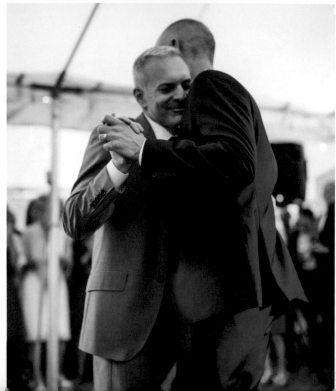

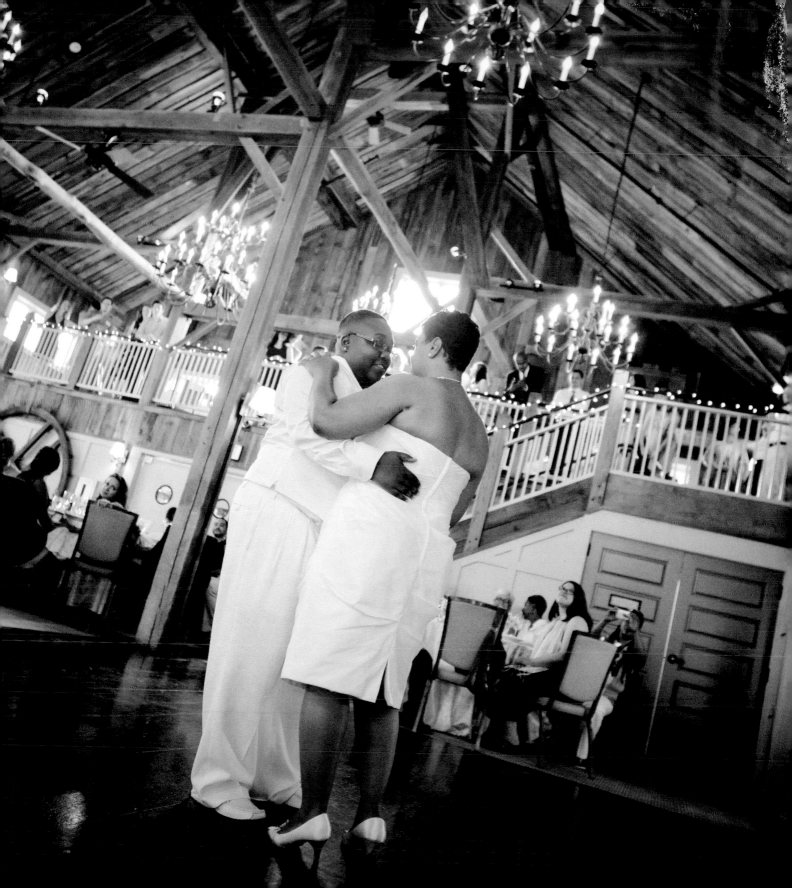

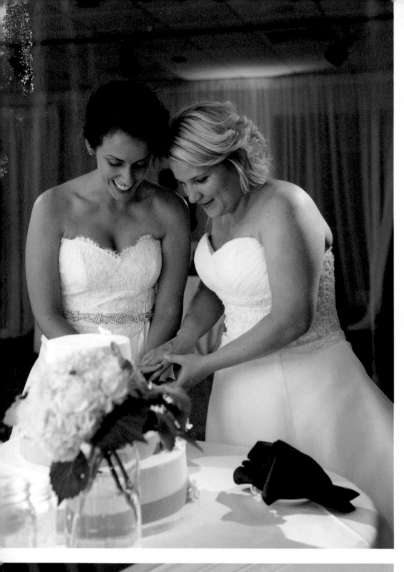

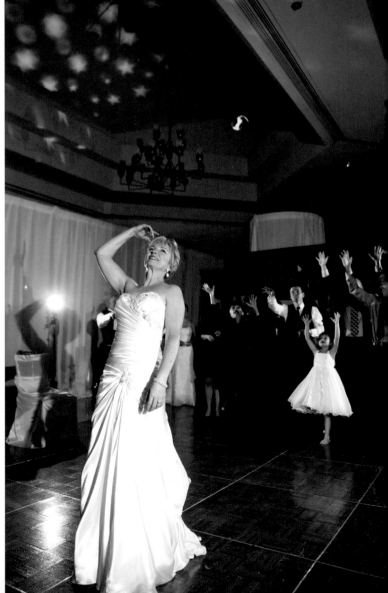

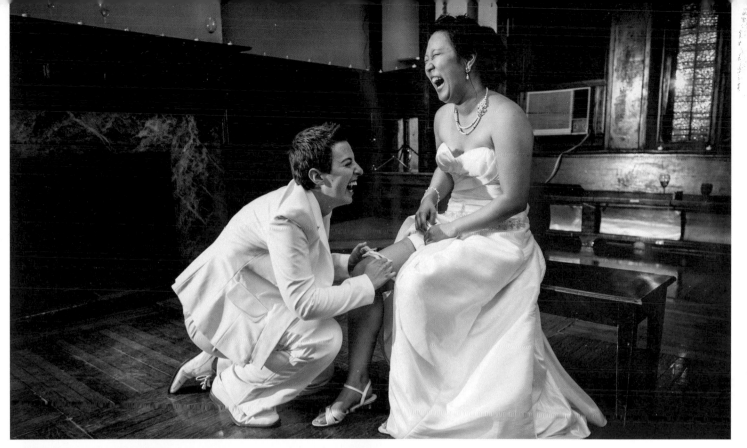

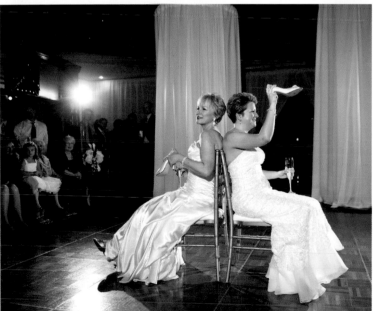

Reception routines. Even some of the most traditional wedding rituals can be applicable to same-sex couples. Depending on the couple, the expression may be decidedly traditional or playful or both!

[OPPOSITE, CLOCKWISE FROM TOP LEFT]
AUTHENTIC EYE PHOTOGRAPHY
Canon EOS 5D Mark III, 24–70mm lens, ISO 800, $\frac{1}{30}$ sec. at f/4.0

HUDSON RIVER PHOTOGRAPHER
Canon EOS 5D Mark III, 85mm lens, ISO 3200, $\frac{1}{800}$ sec. at f/2.5

LYNNCA HARVEY PHOTOGRAPHY
Nikon D700, 24–70mm lens, ISO 640, $\frac{1}{160}$ sec. at f/3.2

RED STONE PHOTOGRAPHY
Canon EOS 5D Mark II, 24–70mm lens, ISO 1600, $\frac{1}{200}$ sec. at f/4.0

[TOP] HUDSON RIVER PHOTOGRAPHER
Canon EOS 5D Mark III, 35mm lens, ISO 1600, $\frac{1}{40}$ sec. at f/3.5

BOTTOM] LYNCCA HARVEY PHOTOGRAPHY
Nikon D700, 24–70mm lens, ISO 640, $\frac{1}{160}$ sec. at f/3.2

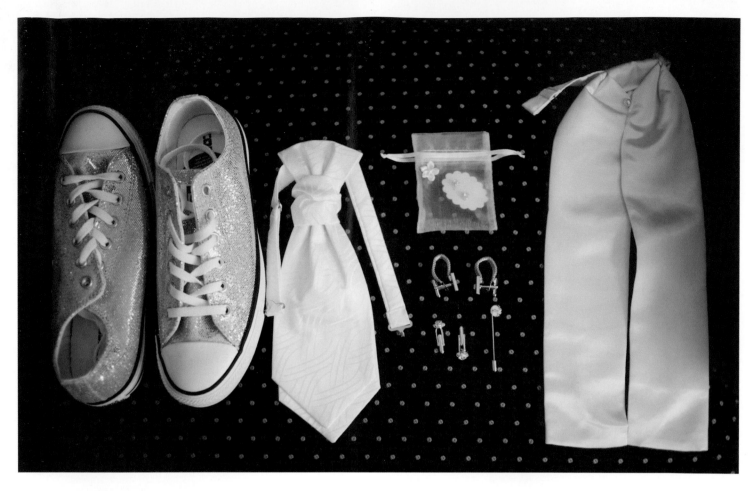

Get the details. Creative pairing of wedding details—with or without the couple involved—can tell more about the couple than you might expect.

[ABOVE] BRI MCDANIEL PHOTOGRAPHY
Canon EOS 5D Mark II, 35mm lens, ISO 1000, $\frac{1}{800}$ sec. at f/2.0

[RIGHT] ARS MAGNA STUDIO
Canon EOS 5D Mark II, 50mm lens, ISO 500, $\frac{1}{3200}$ sec. at f/2.0

[OPPOSITE, CLOCKWISE FROM TOP LEFT]
CEAN ONE STUDIOS
Canon EOS 5D Mark III, 50mm lens, ISO 400, $\frac{1}{200}$ sec. at f/1.2

ARIELLE DONESON PHOTOGRAPHY
Canon EOS 5D Mark II, 50mm lens, ISO 800, $\frac{1}{100}$ sec. at f/1.8

KRISTIN CHALMERS PHOTOGRAPHY
Nikon D700, 24–70mm lens, ISO 400, $\frac{1}{100}$ sec. at f/3.5

THE CHARLES STREET INN

PARTING THOUGHTS

To suggest that it's possible to summarize and conclude everything about LGBTQ engagements and wedding photography is probably a bit misguided. We are, after all, bearing active witness to a time when history is being made before our very eyes; in the span of a decade, popular opinion polls have shown a dramatic increase in an acceptance of marriage equality, and wedding ceremonies that were once taking place "off the grid" (if they were taking place at all) are now having an influence on the mainstream traditions from which they were once excluded.

It is possible, however, to stop, observe, and recognize what is taking shape in wedding traditions while evaluating what hasn't been working and what can be improved. Photographers have an amazing opportunity to break new ground and establish new precedent when capturing love—from same-sex weddings to family portraits and anniversaries. And similarly, couples have the opportunity to help the wedding industry rethink its assumptions about who is getting married, what that should look like, and what the meaning of family—chosen, biological, or otherwise—truly is.

This is, after all, the new frontier of weddings—one inclusive of all couples of all shapes, sizes, ages, ethnicities, religions, and orientations. It's a frontier where the only requirement is a public declaration of lifelong love. And it's a frontier where the families and friends of same-sex couples continue to be powerful allies, settling for nothing less than marriage equality. As a photographer, you're standing at the edge of this promising frontier—capturing love and history with each click of the shutter. Enjoy the journey!

Have you experienced a *Capturing Love* breakthrough, or do you want to recommend a tip or pose? Tell us about it! Submit your tips and portraits at www.capturingloveguide.com.

DENVER SMITH PHOTOGRAPHY
Canon EOS 5D Mark II, 24–70mm lens, ISO 2500, ⅛ sec. at f/5.0

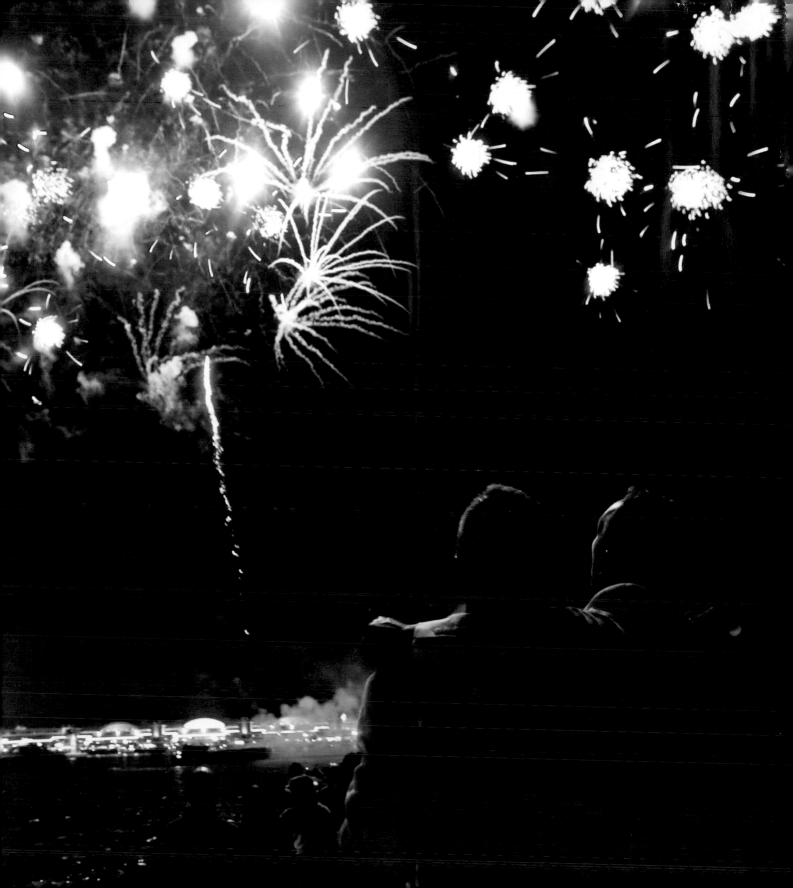

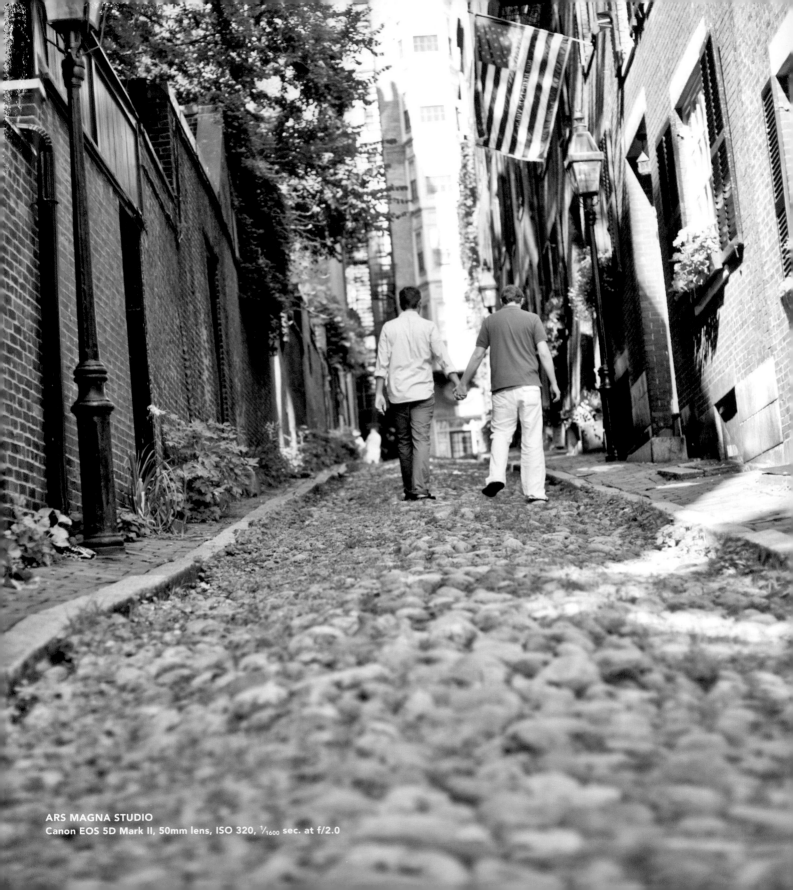

APPENDIX: THE BUSINESS OF SAME-SEX WEDDINGS

We believe strongly that the best way to expand your clientele to include same-sex couples is not just about knowing how to market to them effectively; it's about knowing how to serve them competently. Today, there's plenty of talk of the former in the wedding market and not enough about the latter.

Any wedding professional can change his or her language to be more inclusive of brides and grooms, can scour the headlines for marriage-equality updates to better understand the legal landscape, or can purchase advertising on a website catering to the LGBTQ niche. But not everyone understands the subtle differences of the context of what same-sex couples really need when planning their unions. And this, we believe, is the quintessential difference in what this book has to offer professional wedding photographers.

We spent the majority of this book outlining the ways in which you can more competently and respectfully serve same-sex couples and other members of the LBGTQ-identified community. We want you to walk the walk, not just talk the talk, as a way of expanding your outreach.

But, even so, it is important that you brush up on the window dressings to make sure that your marketing materials, contracts, conversations, and marriage-equality knowledge remain in step with your newfound, inclusive, and forward-thinking photography skills. Thus, we've assembled this special section as a means by which you can make sure that your understanding of the same-sex wedding market, marketing materials, and language are keeping pace with this emerging market.

MODERN WEDDINGS, NEW OFFERINGS

As we discussed, it's important to think about showcasing a comfort level with a variety of

DENUEVA PHOTOGRAPHY
Nikon D700, 35mm lens, ISO 640, 1/125 sec. at f/4.0

Lesbian A term defining one's sexual orientation, describing a female's romantic and/or sexual attraction toward someone of the same sex (i.e., female-female).

LGBT, LGBTQ Acronyms standing for "lesbian, gay, bisexual, transgender" and "lesbian, gay, bisexual, transgender, queer," respectively. May also be used in different combinations with additional letters to represent a broader spectrum of identities.

Marginalized A nonmajority group that is seen as and/or treated differently (i.e., legally or socially) from the majority group in a stigmatizing way.

Opposite-sex A modifier describing a couple as a male-female pairing. See also *heterosexual*.

Preferred gender pronoun (PGP) A pronoun (or set of pronouns) used when describing or talking to a person.

Queer A broad and general term used to describe persons who are not heterosexual or gender normative.

Same-sex A modifier describing a couple as a male-male or female-female pairing. See also *homosexual*, *gay*, *lesbian*.

Straight A modifier describing a couple as a male-female pairing. See also *heterosexual*.

Transgender Identifying with or expressing a gender different from the one that corresponds to the person's sex at birth. May also be used to describe a broader spectrum of nonconforming gender identities and expressions.

CONTRIBUTORS

Andi Grant Photography. Andi Grant (Virginia Beach, Virginia) has always had an appreciation for the arts. Her well-known style of wedding photography, both fresh and timeless, has made her one of the most sought-after photographers in the Hampton Roads area.
www.andigrantphotography.com

Andrea Flanagan Photography. Andrea Flanagan (Denver, Colorado) is a mom to two beautiful girls and a full-time professional photographer. She photographs weddings, kids, babies, bellies, seniors, models, and more.
www.andreaflanagan.com

Arguedas Photography. Johnny Arguedas (Boston, Massachusetts) is a documentary wedding and lifestyle portrait photographer. He strives to reflect in his work his clients' true emotions and personalities in an artful and unobtrusive way.
www.arguedasphotography.com

Arielle Doneson Photography. Arielle Doneson (Wooster, Ohio) is known for her stylish, emotional, and luminous images. She integrates photojournalism with editorial portraiture to tell the story of a wedding day.
www.AriellePhoto.com

Ars Magna Studio. Allana Taranto (Boston, Massachusetts) describes her style of photography as "blisswork." When not photographing or expounding on art and branding, she's traveling, eating, watching bad TV, or sipping whiskey.
www.arsmagnastudio.com

Authentic Eye Photography. Thea Dodds (Rumney, New Hampshire) is a wedding and portrait photographer. She has been photographing same-sex weddings since 2005 and is the coauthor of this book.
www.authenticeye.com

Brian Pepper & Associates. Brian Pepper (Orlando, Florida) has been a full-time photographer since 2007. His wedding photographs of country star Jake Owen were recently seen in *People* magazine and *US Weekly*.
www.OrlandoWeddingPix.com

Bri McDaniel Photography. Bri McDaniel (Atlanta, Georgia) loves to get to know her couples and turn their stories into artful images that reflect who they are as people in love. She studied art at the Savannah College of Art and Design.
www.brimcdanielphotography.com

Carly Fuller Photography. Carly Fuller (Washington, DC) loves the intensity, excitement, lavish details, and drama of a wedding. She loves to get to know her clients during sessions, inspiring them to laugh at or with her. www.carlyfuller.com

Cean One Studios. Jeremy Fraser (Los Angeles, California) has been photographing for Cean One Studios for four years, specializing in high-end weddings and lifestyle portraiture. www.ceanone.com

CHARD Photographer. Rich Lander (Ladera Ranch, California) is a portrait and wedding photographer. He enjoys capturing a couple's story through a series of beautiful images but loves to be able to tell that story in one single, amazing image. www.chardphoto.com

Chris Leary Photography. Chris Leary (New York, New York) aims to capture not only moments that will put a smile on your face or a tear in your eye but, ultimately, pictures that you will cherish forever. www.chrisleary.com

Dawn E. Roscoe Photography. Dawn Roscoe (Chicago, Illinois) specializes in photojournalism, cinema, and art. Her goal for every event is to provide her clients with modern and timeless images, with some artistic, spontaneous fun! www.dawnephoto.com

De Nueva Photography. Nicki Fietzer (New York, New York) is a Minnesota girl at heart. She likes to be creative and loves capturing what makes each couple unique. www.denuevaphoto.com

Denver Smith Photography. Denver Smith (Chicago, Illinois) is a wedding and portrait photographer. His work has been featured on such websites as Style Me Pretty, Destination I Do, Rocky Mountain Bride, and GayWeddings.com, and in *Get Married* magazine. www.denversmith.com

Diana Rothery Photography. Diana Rothery (San Anselmo, California) photographs weddings in an editorial fashion using a combination of digital, and black-and-white 35mm and medium-format films. www.dianarotheryweddings.com

Emily G Photography. Emily Garrick-Steenson (Portland, Oregon) is a wedding and child photographer. She has been published in *Oregon Bride* and *Wedding Pride* magazines, and on websites such as Style Me Pretty and So You're EnGayged. www.emilygphotography.com

Harper Point Photography. Kira Friedman (Fort Collins, Colorado) is the lead wedding and portrait photographer at Harper Point Photography, which has a fresh, people-driven style fueled by authentic connections. www.harperpoint.com

Holman Photography. Jody Holman Webster (Pacifica, California) grew up with a camera as a permanent fixture in her hand. She has traveled from Hawaii to Europe photographing same-sex ceremonies and portraits.
www.holmanphotography.com

Hudson River Photographer. Diane Stredicke (Rhinebeck, New York) works with fun, creative couples looking for modern storytelling photographs. Stredicke's work has been featured on Style Me Pretty, GayWeddings.com, On a Bicycle Built for Two, and A Vote and a Vow, and in *Westchester* magazine.
www.hudsonriverphotographer.com

It's Bliss Photography. Ann Walker (Schererville, Indiana) has a background in design, is a wife, mother of two, and loves photographing because it makes her feel good.
www.itsblissphotography.com

Jen Lynne Photography. Jen Badalamenti (Stamford, Connecticut) is an international photographer specializing in fine-art wedding photography. Her photographs have been published in many magazines and blogs, including *Professional Photographer* magazine, Style Me Pretty, and The Knot.
www.jenlynnephotography.com

Jimmy Ho Photography. Jimmy Ho Photography (Gainesville, Florida) specializes in lifestyle portraiture and photojournalistic wedding photography.
www.jimmyhophotography.com

Julian Kanz Photography. Julian Kanz (Diano Castello, Italy) lives by the sea and travels every weekend to capture amazing destination weddings. He specializes in documentary wedding photography with a creative approach.
www.juliankanz.com

Kandise Brown Photography. Kandise Brown (New Brunswick, Canada) might be a wedding crier, but her style is fun, relaxed, and a bit irreverent. She observes and documents history, traditions, love, and life.
www.kandisebrown.com

Kat Forder Photography. Kat Forder (Elkridge, Maryland) is a puddle jumper, fort maker, cookie baker, and visual storyteller who works in both still photography and cinematography to tell stories for families of all shapes and sizes.
www.katforder.com

Katie Jane Photography. Katie Jane Goulah (New York, New York) is an elopement photographer. She lives on the Upper West Side with her amazing husband, John, and their two cats, Olive and Boo Radley.
www.katiejanephoto.com

Kristina Hill Photography. Kristina Hill (New York, New York) is an award-winning wedding photographer. With a background in editorial portraits and music photography, her approach to capturing weddings is a balanced blend of photojournalism and creative portraiture.
www.kristinahill.com

Kristin Chalmers Photography. Kristin Chalmers (Arlington, Massachusetts) specializes in photographing weddings and families. In 2013, she founded the nonprofit-based Broad Spectrum Project, which provides free photography for families affected by autism.
www.kristinchalmersphoto.com

Leslie Barbaro Photography. Leslie Barbaro (North Bergen, New Jersey) has been photographing weddings since 2005. She served as both official witness and photographer to two grooms while photographing her first same-sex wedding at City Hall in Manhattan.
www.lesliebarbarophoto.com

Lyncca Harvey Photography. Lyncca Harvey (Fort Worth, Texas) is an international wedding and portrait photographer. She specializes in creating artistic and dramatic imagery.
www.lyncca.com

Maggie Rife Photography. Maggie Rife Ponce (Chicago, Illinois) is a wedding, portrait, and travel photographer. She captures magical moments in her subjects' lives to create a timeline of memories both beautiful and moving.
www.maggierife.com

Maggie Winters Photography. Maggie Winters (Washington, DC) is inspired by goofiness and love. Her work has been featured in publications including the *New York Times* and *Washingtonian* magazine.
www.maggiewinters.com

Mein Images. Mein Samala (Washington, DC) is an artist and a scientist. He loves photographing people, places, and things; teaches dance; makes kilts; and holds a PhD in chemistry.
www.MeinImages.com

Meredith Hanafi Photography. Meredith Hanafi (Washington, DC) is a lifestyle photographer who specializes in candid storytelling for couples, families, and weddings. Her work has been featured in *Brides* magazine, the *Washington Post*, and *Occasions* magazine.
www.meredith-hanafi.com

OffBEET Productions. Jimmy Brosius (Long Branch, New Jersey) says he has the best job in the world because he meets beautiful people and shares their happiest day with them.
www.offBEETproductions.com

Purple Apple Studios. Eddette Steynberg (London, England) has been photographing weddings, newborn babies, and families since 2009. She believes that each wedding is as unique as the couple arranging it and is honored to spend such a special day with her clients.
www.purpleapplestudios.co.uk

Red Stone Photography. Alexis Rubenstein (Navarre, Florida) loves to photograph families and children, but her primary focus is weddings. She has been fortunate to photograph beautiful weddings in the United States, Japan, Thailand, and Greece.
www.redstonephotos.com

Retrospect Images. Ginny Silver (Oakland, California) specializes in wedding and portrait photography with a whimsical, romantic, vintage-inspired feel.
www.retrospectimages.com

Sarah Tew Photography. Sarah Tew (New York, New York) is an award-winning wedding and portrait photographer. A bit of a perfectionist, her burning ambition is to make the best pictures that anyone will ever capture of her clients.
www.sarahtewphotography.com

Sean Kim Photography. Sean Kim (New York, New York) has been photographing gorgeous weddings in and around New York since 2002. Blending a photojournalistic and artistic look and feel, he creates natural and unscripted images that truly document the emotions and moments of the day.
www.seangallery.com

Sidney Morgan Photography. Sidney Morgan (Brooklyn, New York) loves to tell the stories of love, wedding days, families, and life.
www.sidneymorgan.com

Tammy Watson Photography. Tammy Watson (British Columbia, Canada) is inspired by the beautiful moments of life. With camera in hand, she loves to capture each milestone, along with the laughter and tears.
www.tammywatsonphotography.com

To learn more about the *New Art of Capturing Love* contributors and view the "Contributor Gallery," visit at our website: www.capturingloveguide.com.

Torie McMillan Photography. Torie McMillan (Chicago, Illinois) has a background in the fine arts and makes every effort to document life's important moments with a visual story that is both imaginative and personal. She is fascinated by love stories, fashion, faces, photojournalism, flowers, design, architecture, color, dancing, traveling, and cake.
www.toriemcmillanphotography.com

Unusually Fine. Max Freeman and Margaret Singer (New York, New York) are the artists behind this boutique photography studio. They accept a select number of commissions each season, allowing them to provide each client exclusive attention and unparalleled images.
www.unusuallyfine.com

Waldorf Photographic Art. Perry Smyre (Knoxville, Tennessee) has a BA in visual journalism from Brooks Institute of Photography and is driven by his passion to meet and spend intimate time with new people, and to have the honor of documenting their lives.
www.waldorfphotographicart.com

Weddings To The People. Sarah Deragon (San Francisco, California) specializes in engagement, wedding, civil ceremony, and event photography for members of the LGBTQ community and their allies.
www.weddingstothepeople.com

Whitmeyer Photography. Lauren Carroll and Tommy Penick photograph weddings as part of a team of North Carolina–based photographers led by studio owner Sarah Whitmeyer (Asheville, North Carolina).
www.whitmeyerphotography.com

ACKNOWLEDGMENTS

This book is nothing if not a celebration about the strength of community and the power of relationships and love. The heart of the *New Art of Capturing Love* lies in the vision of embracing and photographing love, regardless of its pairing, and in the gorgeous images shared so generously by our many contributing photographers and participating couples. This book would not be what it is without them.

Its foundation lies in the early advice and support we received from Elizabeth, Natasha, and Erica at Lulu, through which we self-published the first version of the book. And, there is no way we would be where we are today without the generous and galvanizing support of Kristy Buchanan of KN Design; she went above and beyond to help us with the layout and design of our first book.

Along the way, we also got a special assist from eagle-eye proofreaders and perspective-givers Jay Brown of the Human Rights Campaign, Christine Brennan of *USA Today*, and Joan Sherwood of *Professional Photographer Magazine*; and first reviewers Steven Petrow of the *New York Times*, Jill Dolan of Princeton University, and Shalyn Kettering of Two Bright Lights.

We are also grateful to the visionary and fun-loving team at WeddingWire, including Kate Hoffman, Kari Miller, Meg Cole-Karagory, Sonny Ganguly, Joe Holland, and Timothy Chi. And, of course, to those who supported our 2012 efforts, including Rocky Bowles of SmugMug; Sonsie Restaurant; Cabrin Kelly-Hale of Marriott and the team at the Renaissance Downtown Phoenix; Kat Forder, Carly Fuller, the Human Rights Campaign, Main Event Caterers, and GayWeddings.com; Lael and Peter Brodsky; and Tisha Scheifele of the Inn at Perry Cabin in St. Michaels, Maryland, and Seaberry Farm of Federalsburg, Maryland. Thanks also to Denise Oliviera for her real wedding story excerpts on GayWeddings.com. And a special hat tip goes out to Sarah Deragon and her queer-identified clients who helped us to sneak just that much more education into our book.

It's a little-known point of trivia that Martie Maguire was a great fit to write the foreword for this book not only because of her longtime support of the LGBTQ community and trailblazing role as an artist, but also because Kathryn credits Martie's mother—who was her sixth- and eighth-grade English teacher—as the reason for her strong writing foundation and her love of diagramming sentences.

We've saved a special little dance and high five for our mentor-turned-agent, Kathryn Beaumont of Kneerim, Williams & Bloom. She believed in our vision and helped us figure out how to fly this baby. And it was even more fun asking her to help us land it. Lots and lots of love, of course, to Julie

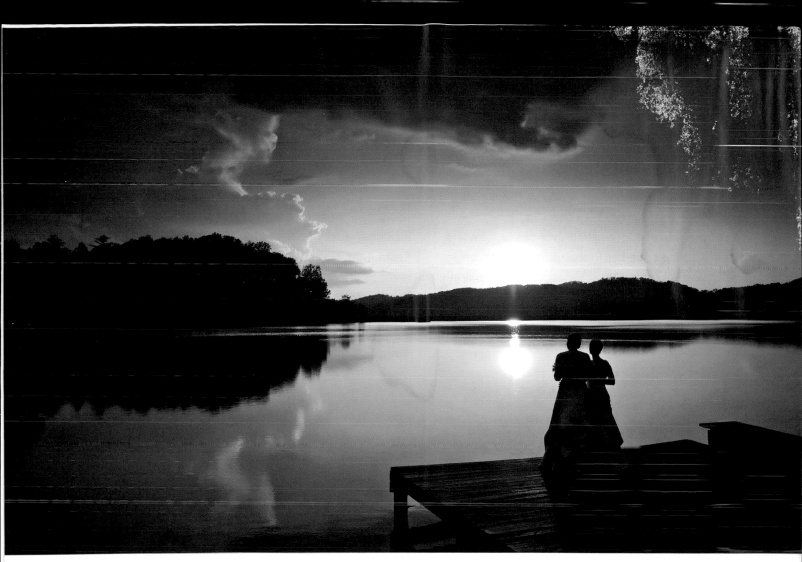

WALDORF PHOTOGRAPHIC ART
Canon EOS 1D Mark III, 16–35mm lens, ISO 400, $\frac{1}{1600}$ sec. at f/5.6

Mazur of Amphoto Books, who discovered us and was essential in helping to make our dream for *Capturing Love* a reality. She, along with Lisa Westmoreland and the rest of the team at Ten Speed Press, is responsible for shaping it to be now even more than it already was.

Finally, to those whom we love the most, and without whom this book could not have been written: our kids and our partners in love and life. They indulged our dream and desire to spread the Love, and supported us every single step of the way. Thea's honeybees, maple trees, daughters (Kyra and Aubrie), and husband, Bryan, are happy to have her back; and, Kathryn's son, Caleb, and wife, Amy, surely feel the same. We appreciate your humor, generosity, love, support, and patience during this amazing ride.

Originally published in the United States in somewhat different form by Authentic
Weddings as *Capturing Love: The Art of Lesbian and Gay Wedding Photography*
in Rumney, New Hampshire, in 2013.

Library of Congress Cataloging-in-Publication Data

Hamm, Kathryn, 1969–
 The new art of capturing love : the essential guide to lesbian and gay wedding
photography / Kathryn Hamm and Thea Dodds; foreword by Martie Maguire of the
Dixie Chicks and Court Yard Hounds. — First Amphoto edition.
 pages cm
 Includes index.
 1. Wedding photography. 2. Same-sex marriage. I. Dodds, Thea, 1978–
II. Title.
 TR819.D63 2014
 778.93925—dc23
 2013041295

Trade Paperback ISBN: 978-0-8041-8523-3
eBook ISBN: 978-0-8041-8524-0

Printed in China

Design by Amy Sly

10 9 8 7 6 5 4 3 2 1

First Amphoto Edition